Thyroid
disease

thefacts

Thyroid disease
thefacts

FOURTH EDITION

MARK P.J. VANDERPUMP MD, FRCP

Consultant Physician and Senior Lecturer in Diabetes and
Endocrinology, Royal Free Hampstead NHS Trust, London, UK

W. MICHAEL G. TUNBRIDGE MD, FRCP

Emeritus Physician, Nuffield Department of Medicine, Oxford

Honorary Consulting Physician, Oxford Radcliffe Hospitals
NHS Trust

Former Director of Postgraduate Medical Education and
Training, University of Oxford, UK

OXFORD
UNIVERSITY PRESS

OXFORD
UNIVERSITY PRESS

Great Clarendon Street, Oxford OX2 6DP

Oxford University Press is a department of the University of Oxford.
It furthers the University's objective of excellence in research, scholarship,
and education by publishing worldwide in

Oxford New York

Auckland Cape Town Dar es Salaam Hong Kong Karachi
Kuala Lumpur Madrid Melbourne Mexico City Nairobi
New Delhi Shanghai Taipei Toronto

With offices in

Argentina Austria Brazil Chile Czech Republic France Greece
Guatemala Hungary Italy Japan South Korea Poland Portugal
Singapore Switzerland Thailand Turkey Ukraine Vietnam

Oxford is a registered trade mark of Oxford University Press
in the UK and in certain other countries

Published in the United States
by Oxford University Press Inc., New York

British Library Cataloguing in Publication Data

Data available

Library of Congress Cataloging in Publication Data

Data available

Typeset by Newgen Imaging Systems (P) Ltd., Chennai, India
Printed in China
on acid-free paper by
Phoenix Offset

ISBN 978–0–19–920571–4 (Pbk.: alk pa

10 9 8 7 6 5 4 3 2 1

Whilst every effort has been made to ensι
accurate and-up-to-date as possible at the
to give any guarantee or assurance that su
qualified medical advice in all cases. The i
the general reader, but should not be usec
medication.

This edition of
THYROID DISEASE: THE FACTS
is dedicated to the memory of
Sir RICHARD BAYLISS
KCVO, MD, FRCP
1917–2006

Preface to the fourth edition

Sir Richard Bayliss was the sole author of the first edition of this book, published in 1982 at about the time of his retirement from the National Health Service. He had been a highly respected consultant physician at the Westminster Hospital and was also physician to the Queen for 11 years. Sir Richard kindly invited Michael Tunbridge, then a consultant physician in Newcastle upon Tyne, to join him as co-author of the second edition (1991) and subsequently, when in Oxford, for the third edition (1998), both of which were translated into Dutch. Sir Richard had decided to stand down as a co-author of this fourth edition, and it was agreed to invite Mark Vanderpump, a consultant physician in active practice at the Royal Free Hampstead NHS Trust to become the new co-author. The present authors are also general physicians and shared Sir Richard's interests in endocrinology and, in particular, diseases of the thyroid, that small but important gland which can affect so many aspects of physical and mental functions. It has been our privilege and pleasure to have cared for many patients with all aspects of thyroid disease and this book reflects our current practice.

This fourth edition is a tribute to Sir Richard Bayliss. We have retained as much as possible of his original text to reflect his erudition and ability to express his views clearly and briefly, while bringing the material up to date. We cannot pretend to imitate his paternalistic style and have changed from his form of address to the reader in the second person to the less personal third person, except for the question and answer sections, partly to appeal not only to the friends and relatives of the person affected with any thyroid disorder but also to a wider readership. We are also pleased to acknowledge our continuing debt to Mr Keith Duguid and Dr Christopher Bayliss who provided some of the illustrations for previous editions which are also reproduced in this edition.

Finally, as with the previous editions a word to the person who, having recently been diagnosed with some thyroid disorder, is reading this book for

the first time. We suggest that you start by reading the chapter relevant to your condition, and then go back to the beginning and read the first three chapters to help orientate you. We hope that this book will help you understand your condition and lead to a happier and less worrying outcome.

M.P.J.V., *London*
W.M.G.T., *Oxford*
2007

Contents

Answers to some of the more common questions that are asked by people about their thyroid disorder are given at the end of each chapter.

Contents

Introduction

In the decade since the publication of the third edition of *Thyroid Disease: The Facts*, there has been increasing recognition of thyroid disease as a common health problem. While there have been very few major new advances in treatment, there is greater understanding of why thyroid disorders occur and the long-term health effects of thyroid disease. As with all other aspects of medicine, there is increasing public and patient demand for information. The worldwide web and interactive websites are now widely accessible, but offer no indication of the accuracy of the information supplied. There is also recognition of the role of patient support groups worldwide, and the addresses of several national organizations are given in a glossary (p. 199). With the advent of the concept of evidence-based medicine, many guidelines have been published by various international medical thyroid organizations. In theory this should allow more uniformity of care, but often the conclusions are confusing as experts reviewing exactly the same issue do not always agree when presented with the same evidence. Nowhere is this more the case than in the definition and treatment recommendations for mild thyroid gland failure found following a blood test. This edition aims to provide a reader-friendly source of information and hopefully reassurance for those people with thyroid disorders and their families. It also aims to clarify the areas of current controversy in diagnosis and management.

How common are thyroid disorders?

The prevalence of thyroid disorders varies considerably in different parts of the world. This is related to the level of iodine in the diet which is vitally important to the function of the thyroid gland. Thyroid disorders are always more common in women than in men. In 1999 the World Health Organization estimated that 740 million people have an enlargement of their thyroid gland known as a 'goitre'. Most of these goitres occur in people who live in parts of the world where there is a relative lack of iodine in the diet. It is estimated that

despite a worldwide programme to eradicate iodine deficiency, lack of iodine still affects up to one-third of the world's population. Even in non-iodine-deficient areas such as the UK, enlargement of the thyroid so that it becomes visible occurs in 7 per cent of the population and is about 10 times more common in women than in men. As many as 10 million people in the USA, and perhaps as many as 200 million worldwide, are taking thyroid hormone for an underactive thyroid. There are now large studies in the USA that show that thyroid disease may be much more common in the White and Hispanic populations than in the Black population. It is now known that some degree of underactivity of the thyroid gland (called mild thyroid failure or subclinical hypothyroidism) may affect 10 per cent of all women over the age of 50 and, in a significant proportion, may go unrecognized for many years.

Why should you know about your condition?

It is now widely accepted that the more people know about their illness, the fewer are their fears. The greater their understanding of what is wrong, the better is their acceptance of, and their cooperation with, their treatment and the more they are able to help their doctor to help them. People now rightly expect their doctor to inform them fully about their condition and to be involved in choosing the correct treatment option for them, or indeed deciding on no treatment. Sometimes people are found to have thyroid conditions coincidentally following a blood test or scan and may not actually feel ill. However, treating or correcting the abnormality may have significant consequences and do more harm than good, so the choice to have no treatment may sometimes be the sensible option.

Thus this book is for those who have some recognized disorder of the thyroid gland as well as providing information for their relatives, as many thyroid problems can run in families. The sooner someone is aware of the possibility that they may be vulnerable to a thyroid disorder, the sooner medical help can be sought if symptoms or signs develop. Thyroid disorders often have a very gradual onset over many years so it is possible that no changes may be apparent. Occasionally evidence is found of only a mild abnormality which simply needs observation and monitoring. Sometimes it is an advantage to gain reassurance that symptoms are not due to thyroid disease but it is always important that any doctor is aware of a family history of thyroid disorders.

This book describes how the thyroid gland works, how it manufactures hormones, and how it is controlled. A glossary at the end provides a fuller explanation of medical and scientific words or concepts.

This is now the era of 'evidence based medicine', which means that the advice a doctor gives or the treatment that is prescribed should be justified from scientifically controlled studies and trials. Based on such evidence, a number of best-practice protocols have been published for specific thyroid diseases by authoritative bodies from the UK, Europe, and the USA. Increased adherence to these protocols by doctors has improved standards of care and standardized treatment as much as possible. However, medicine is not an exact science and these protocols are only there to guide doctors. No two people present in the same way, and there may be other biological and psychological factors which can influence recommendations for a particular treatment. Equally, doctors may have experience from their training and practice which influences the advice that they give their patients. Therefore it should not be surprising if the treatment prescribed does not follow the description in this book, and where possible the alternative strategies with their advantages and disadvantages will be discussed. The art of medicine is to embrace the particular needs and wishes of an individual, their age and occupation, environmental and social factors, any coexisting diseases, and the severity of the condition in order to achieve a successful outcome.

1

The thyroid gland

Where is the thyroid gland?

Normally the thyroid gland lies in the front of the neck just below the Adam's apple (Fig. 1.1). The gland is shaped like a bow tie or a butterfly and consists of two lobes joined together in the middle. The left and right lobes, each about the size and shape of half a plum cut vertically or about the size of the top segment of a person's thumb, lie on either side of the windpipe (trachea) and are connected by a bridge of thyroid tissue, known as the isthmus, which runs across the front of the windpipe.

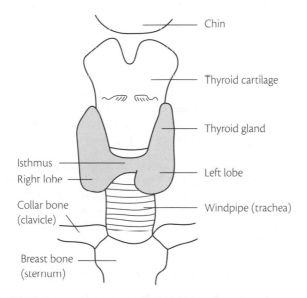

Figure 1.1 The anatomy of the thyroid gland

In men a normal thyroid gland is seldom sufficiently large to be visible, but in a young woman with a thin neck it may be just discernible, particularly when the chin is lifted up. If visible, the gland will be seen to move up and down when swallowing. A healthy gland is smooth and is not tender. It is not lumpy or hard. In some normal people the gland may extend downwards to lie wholly or partially behind the upper part of the breastbone or sternum (a retrosternal thyroid).

Where does the thyroid come from?

In the baby developing in the womb (the fetus), the thyroid gland has its origins at the root of the tongue. As the fetus grows, the thyroid moves down the neck and long before the baby is born it occupies the usual adult position. The path of this descent is marked by a narrow cord, the thyroglossal duct, running from the tongue (the glossus) to the neck. The bottom few centimetres of this duct may contain thyroid tissue and it is then called the pyramidal lobe. This extra lobe of the thyroid extends upwards from the isthmus and may lie in the mid-line or on one side of the larynx.

What happens if the thyroid does not descend properly?

In very rare circumstances in babies the thyroid gland does not descend properly and remains in its original position near the root of the tongue. A misplaced thyroid gland like this seldom functions properly, and it is an important cause of an underactive thyroid in a newborn baby (see Chapter 14).

What does the thyroid do?

The thyroid manufactures chemical substances (hormones) that are passed into the bloodstream and act on cells and tissues elsewhere in the body. Other hormone-producing glands (known as endocrine glands) include the pituitary, ovaries, testes, pancreas, and the adrenal glands.

The thyroid makes two hormones. One is thyroxine which, because it contains four atoms of iodine, is also called T_4. The other is triiodothyronine which contains three iodine atoms and is called T_3. Both these hormones are secreted into the bloodstream and carried round the body. In distant tissues the thyroxine is converted to triiodothyronine, and it is the triiodothyronine which actually influences the distant cells and is the so-called active hormone.

What do the thyroid hormones do?

The thyroid hormones control the metabolism of cells, which is their speed of activity. If there is too little hormone, the body cells work too slowly; too much

results in them working too fast. Thyroid hormones regulate the rate of oxygen consumption. This metabolic action influences the utilization of the main components of food: sugars, protein, and fat. Although thyroid hormones have a similar effect and influence the proper working of all body cells, their action is particularly evident in certain tissues and for certain functions. For example, the physical and brain development of a baby growing in the womb depends on the presence of the correct amount of thyroid hormones in the mother until the twelfth week of the pregnancy when the baby's own thyroid gland begins to function. In a child, too little hormone will slow up growth, whereas too much may make the child grow faster than normal. Thyroid hormones also have very noticeable effects on bone, fat, the heart, and muscle amongst other organs.

The manufacture of thyroid hormones

Thyroxine and triiodothyronine are formed in the cells of the thyroid gland. Both hormones contain iodine, which is essential for their manufacture or synthesis. This essential element is extracted from the bloodstream by the specialized thyroid cells. Inside the cells of the thyroid gland, the iodine is amalgamated with other substances in a number of chemical steps to form T_4 and T_3. Once formed, the two hormones are stored in 'parking areas' within the gland. The 'parked' hormones are released from storage into the bloodstream as and when the body cells need them.

Where does iodine come from?

Normally iodine is provided in food, particularly fish. Iodine is found in the soil from which crops grow and on which cows graze to produce milk, all of which contain iodine in minute quantities. The iodine is derived from the rain that falls on the soil, and this in turn comes from the water vaporized from the sea to form rain. In parts of the world far removed from the sea the soil is likely to be deficient in iodine. This happens in Central Africa, the Andes in South America, the Himalayas in the Indian subcontinent, Switzerland in Central Europe, around the Great Lakes in the USA, and in certain other landmasses such as Spain and Iran. Insufficient iodine in the diet in these areas may cause difficulty in making thyroid hormones and public health measures have to be taken to supplement the dietary intake of iodine (e.g. provision of iodized salt).

How is the secretion of thyroid hormones controlled?

Secretion of thyroid hormones is controlled by the pituitary gland. The pituitary is an endocrine gland the size of a grape which lies at the base of the brain.

It secretes many different hormones, but thyroid-stimulating hormone, also known as TSH or thyrotrophin, is the hormone that controls thyroid function. Other pituitary hormones control the testes, ovaries, and adrenal glands, as well as regulating growth and enabling women to produce breast milk.

Thyroid hormone secretion works like the control of the central heating in a home. Certain cells within the pituitary act like the thermostat sensing the temperature. If the temperature falls below a certain preset level, the thermostat activates the boiler to produce more heat, and when it rises, the thermostat turns the boiler off or reduces its heat production. Similarly, if thyroid hormone levels fall, the pituitary senses this by monitoring the levels in the blood and producing TSH, which stimulates the thyroid to increase production of thyroid hormone. If thyroid hormone levels rise, the pituitary reduces or switches off TSH production to reduce production of thyroid hormone. This is called a negative feedback mechanism (Fig. 1.2).

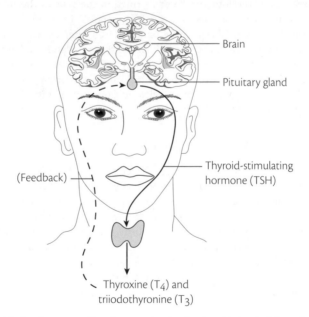

Figure 1.2 Mechanism controlling the secretion by the thyroid gland of thyroxine (T_4) and triiodothyronine (T_3). As the levels of T_4 and T_3 rise in the bloodstream, the secretion of thyroid-stimulating hormone (TSH) from the pituitary gland is reduced or switched off (feedback control mechanism). As the levels of T_4 and T_3 fall, the pituitary gland secretes more TSH so that activity of the thyroid gland is increased.

The pituitary gland is very sensitive to changes in thyroid hormone levels in the blood, which means that very subtle changes in TSH production are the earliest evidence that the thyroid is producing more or less hormone than previously. The pituitary also responds to hormones released from the higher centres in the brain, particularly from another small endocrine gland called the hypothalamus. This gland is important in functions such as the control of appetite and body temperature.

How do the thyroid hormones move around in the bloodstream?

Nearly all of both thyroid hormones T_4 and T_3 are loosely attached to certain proteins in the blood and therefore are biologically inactive. Only when the hormone is released does it become biologically active. A small fraction of the thyroid hormones (less than 0.1 per cent) are free in the circulation and are biologically active. The active thyroid hormone that can be used immediately is T_3 which influences nearly all the major body systems by entering into cells and controlling genes and enzymes. Approximately 20 per cent of the total amount of T_3 is produced and released directly by the thyroid gland, while the remaining 80 per cent is converted to T_3 from inactive circulating T_4 in tissues such as the liver, kidney, and brain by enzymes called deiodinases, which remove one iodine atom.

❓ Questions and answers

Q.1 What is the thyroid gland?

A. It is a small gland that controls the activities of the cells of the body.

Q.2 Where is the thyroid gland?

A. It lies in the front of the neck below the Adam's apple in the position where a man knots his tie.

Q.3 What does the thyroid do?

A. It produces the thyroid hormones, which are chemical messengers that circulate in the blood to the rest of the body.

Q.4 What controls the output of thyroid hormones?

A. The levels of thyroid hormones circulating in the blood are regulated by the thyroid-stimulating hormone (TSH) produced by the pituitary gland at the base of the brain. If the levels of thyroid hormones fall, TSH stimulates the thyroid to make more hormones. If the levels of thyroid hormones rise above normal, TSH is suppressed.

2

Things that go wrong with the thyroid gland

Certain conditions such as overactivity of the thyroid (hyperthyroidism), in which too much hormone is secreted, and underactivity (hypothyroidism), in which too little hormone is secreted, are specific to the thyroid and produce characteristic symptoms. Other disorders, such as infections, inflammation, and cancer, may occur in other organs as well as the thyroid, but the clinical picture is influenced by the fact that the disease process is taking part in the thyroid.

Increase in size

Enlargement of the thyroid gland from any cause is called a goitre. The whole gland may be enlarged uniformly, or only one part of it. The enlargement may result from a generalized swelling (diffuse goitre), a single nodule, or more than one nodule (multinodular goitre). A goitre may vary in size from a thyroid gland that feels slightly larger than normal (which is usually about the size of the top segment of the thumb), to one that is clearly visible (Fig. 2.1(a)) and even to one that is the size of an orange or even larger (Fig. 2.1(b)).

Many disorders of the thyroid gland may make it larger. The enlargement may be associated with a normal output of thyroid hormones, and the patient is then said to be euthyroid. The goitre may be associated with an increased secretion of thyroid hormone, and the person is then said to be hyperthyroid. It may also be associated with a decreased hormone output, when the patient is described as hypothyroid. The size of the thyroid gland bears little relationship to its secretory activity or function. A small goitre or even a thyroid gland of normal size may produce excess thyroid hormones, whereas a large goitre may be associated with deficient secretion.

A slight enlargement of a normally functioning thyroid gland is so common in women at the time of puberty and during pregnancy that it is looked upon as normal. In most situations goitres are painless but in some conditions the gland hurts and is tender on pressure. If the goitre is sufficiently large it may cause some discomfort on swallowing or produce a feeling of pressure in the

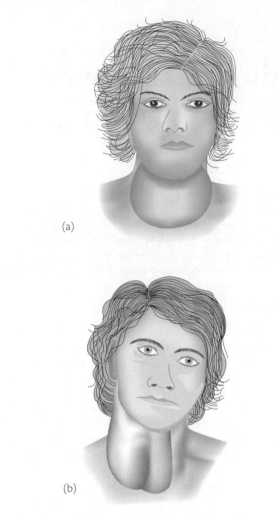

(a)

(b)

Figure 2.1 (a) A medium-sized goitre. (b) A large nodular goitre in a person living in an iodine-deficient area of the world.

neck, particularly when lying flat. If very large, the goitre is not only cosmetically unsightly but may press on the windpipe (trachea) and cause difficulty with breathing, especially when exercising. It may also press on veins in the neck carrying blood to the heart from the face and brain and cause a sense of fullness in the head. A more detailed account of goitres is given in Chapters 10 and 11.

Autoimmune disorders

The immune system protects the body from infection with commonly occurring bacteria and viruses. The blood contains certain white blood cells called lymphocytes, which target 'foreign' proteins that occur in micro-organisms and viruses that the body has not yet encountered. Once recognized as 'foreign', the lymphocytes produce chemical substances called antibodies which bind to the protein and neutralize or kill them. This explains why, following organ transplants from one person to another, the immune system mounts a response against the donated tissue and strong drugs such as steroids are required to prevent rejection. In normal circumstances, the immune system has methods of developing tolerance to tissues within the body. In autoimmune disorders an error occurs in which certain tissues lose their tolerance and are suddenly recognized as 'foreign' by the body's own immune system. Antibodies against the body (autoantibodies) are produced which attack cells within organs.

The thyroid gland is particularly prone to autoimmune disorders. The presence and strength of these antibodies can be measured in the blood. Whilst some antibodies are destructive and kill thyroid cells, others stimulate the thyroid cells to produce too much thyroid hormone. Rarely, there is evidence that destructive and stimulating antibodies occur together or operate one after the other, so that after producing an overactive thyroid gland, the thyroid gland becomes underactive or vice versa. Certain people and certain families are more prone to autoimmune diseases than others, and hence other autoimmune diseases (such as insulin-dependent (type 1) diabetes mellitus or pernicious anaemia) are associated with thyroid autoimmune disorders. Autoimmune thyroid diseases certainly run in families, as do other autoimmune disorders, although not all members of a family are necessarily affected in the same way (i.e. one relative may have an overactive gland whilst another has an underactive gland) as well as often seeming to skip a generation.

Hyperthyroidism

An increase above the normal level of thyroxine (T_4) or triiodothyronine (T_3), but usually both, causes thyroid overactivity (hyperthyroidism or thyrotoxicosis). The most common cause of this overactivity is an autoimmune disease called Graves' disease, named after the Dublin physician, Dr Robert Graves, who first described the condition in three young women in 1835. In Europe it is also known as von Basedow's disease after Carl von Basedow, who published a very clear account of the condition in 1840. The condition is characterized by the presence of goitre, palpitations of the heart, and changes in the eyes.

In hyperthyroidism or thyrotoxicosis, the metabolism of the cells in the body is increased. The clinical picture varies somewhat depending upon the age at onset, severity, and duration of the condition. The most common features are a rapid heart rate and palpitations, an increase in bowel activity, causing urgency or frequent loose motions or diarrhoea, sweating and intolerance of hot weather, tremor, agitation, and loss of weight despite an increased appetite. Graves' disease, in which antibodies stimulate the thyroid cells to secrete excess thyroid hormones, is considered in more detail in Chapter 4. The commonly associated eye changes are discussed in Chapter 5. Other less common causes of hyperthyroidism are dealt with in Chapter 6.

Hypothyroidism

A reduction in the amount of thyroid hormones results in thyroid underactivity (hypothyroidism). Worldwide, iodine deficiency is the most common cause of thyroid deficiency at any age, but in non-iodine-deficient countries the most common cause of hypothyroidism is chronic autoimmune thyroiditis or Hashimoto's disease, named after the Japanese surgeon who described the appearance of the gland in 1912 (see Chapter 8).

In hypothyroidism the metabolism of cells is reduced and therefore they work sluggishly. Clinical features include a slow heart rate, a reduction of bowel activity leading to constipation, dryness and thickening of the skin, intolerance of cold weather, depression and intellectual dullness, loss of hair, pins and needles in the hands, croakiness and deepening of the voice, swelling around the eyes, and weight gain. The clinical features are discussed in detail in Chapter 7.

Thyroiditis

Infection or inflammation of the thyroid gland is not uncommon. The usual cause of obvious acute thyroid inflammation is a virus. This subacute viral thyroiditis, also called de Quervain's thyroiditis after a Swiss physician who first described it, is 'subacute' because the degree of discomfort in the neck due to inflammation of the thyroid gland is usually not severe but tends to persist for several weeks or months if left untreated. The gland is painful and very tender to the touch and on swallowing. The inflammation may temporarily cause excessive amounts of thyroid hormones to be released from the gland and for some weeks the person may initially experience symptoms of thyroid overactivity. Later in the natural history of thyroiditis, there may be a period of hypothyroidism before the gland recovers normal function (see Chapter 9). Sometimes a virus or an autoimmune reaction causes no discomfort at all in the thyroid gland, and the associated thyrotoxicosis is then attributed to 'silent thyroiditis' (see Chapter 15). Very rarely the thyroid is

attacked by bacterial micro-organisms, such as the common streptococcus which may cause an acute sore throat, a staphylococcus which commonly causes skin infections, or the bacilli causing tuberculosis.

Cancer

Thyroid cancer is rare among thyroid disorders and even rarer as a cause of malignant growths in the body as a whole. Most thyroid tumours are composed of cells which look and behave like relatively normal thyroid cells (termed well-differentiated). Hence the tumours often do not grow rapidly and remain responsive to the action of thyroid-stimulating hormone (TSH), and they continue to extract iodine from the blood. This means that in addition to surgical removal of the growth, which is the usual initial treatment, thyroid tumour cells can also be eliminated by treatment with radioactive iodine. Provided that the condition is diagnosed early, the treatment of a well-differentiated thyroid cancer is usually very successful (see Chapter 12).

❓ Questions and answers

Q.1 What does the term goitre mean?

A. It is the word used to describe any enlargement of the thyroid gland, whatever the cause (see Chapters 10 and 11)

Q.2 If I have a goitre, does it mean I've got cancer?

A. That is unlikely because thyroid cancer is very rare and there are a great many more common benign conditions which cause enlargement of the gland.

Q.3 What is an autoimmune disease?

A. It is a disorder of the immune system, which normally protects the body against infection. It can mistakenly believe that some organ or tissue is 'foreign' and can therefore mount an immune attack using autoantibodies against the body's own cells.

Q.4 Are autoantibodies always destructive?

A. The autoantibodies in autoimmune thyroid disease can destroy the gland, as in Hashimoto's disease (see Chapter 8), but can also stimulate the thyroid to increase its secretory activity as in Graves' disease (see Chapter 4)

Q.5 Why is the thyroid gland affected by autoimmune disease?

A. The thyroid gland is one of the most common organs or tissues to be affected by autoimmune disease, but it is not known why the immune system loses its tolerance of thyroid cells. Understanding how and why the autoimmune system attacks the thyroid is key to producing new and better treatments in the future.

3

How the doctor finds out what is wrong

People with thyroid disease can present to doctors in various ways.

> 1. They may themselves suspect that certain symptoms or signs may be caused by a thyroid disorder.
>
> 2. They may present with symptoms or signs but be unaware that they may be caused by a thyroid disorder.
>
> 3. The doctor may have received the results of a blood test or scan which suggest a thyroid problem, but the person may be asymptomatic.

The medical consultation will include a detailed history of the potential symptoms of thyroid disease, past medical history, and family history of relevant diseases. In addition to the general physical examination, including weight, heart, lungs, abdomen, nervous system and muscles, all of which can be affected by thyroid disease, the focus will be on the findings in the neck and the eyes if there are symptoms.

Investigations will usually be performed which can be divided into two main groups.

> 1. Thyroid function tests to establish whether the gland is producing the correct amount, too much, or too little hormone.
>
> 2. Tests designed to provide information as to what is wrong with the thyroid gland.
> (a) Why is the thyroid gland enlarged?
> (b) Why is the thyroid gland over- or underactive?
> (c) Why is there a lump in the thyroid gland and is it serious?
> (d) Why is the thyroid gland painful?

Direct tests of thyroid function

Over the years many different methods have been used to determine whether the thyroid gland is producing the correct amount of thyroid hormones. Modern tests are carried out on a simple blood test taken from a vein, and the results are usually available within a few days. No one test is always 100 per cent diagnostically reliable because a result that is too high or too low may occur for a number of different reasons. However, modern laboratories now use very sophisticated and sensitive blood tests of thyroid function.

When interpreting blood tests, doctors need to know how a person's results compare with the range of values found in a group of individuals who are considered healthy. These 'healthy' individuals are known as the 'reference population'. Once the results of the blood tests in the reference population are known, the 'reference range' is defined as the range of values found in the middle 95 per cent of this population. Thus a reference range, by definition, excludes the values for the test found in 2.5 per cent of people with the highest values and 2.5 per cent of people with the lowest values. This means that one person in 20 (5 per cent) of the healthy normal population will have a test result that is either slightly above or slightly below the reference range. It also means that if a doctor does 20 different blood tests in a healthy person, there is a statistical chance that one of these tests will be outside the reference range and appear to be abnormal even though the person is 'healthy'. However, a result that is very much higher or lower than the reference range is highly likely to be abnormal and warrants further investigation.

Thyroid-stimulating hormone (thyrotrophin or TSH) level

TSH in the blood can be measured very accurately with modern techniques. The level of TSH is not exactly the same in every healthy person and will also vary slightly when measured in different laboratories. TSH levels in the blood are changing all the time as TSH is released by the pituitary in pulses with higher values found at night. The level also changes quite markedly (by as much as two- to threefold) in healthy individuals throughout the year. Diet, environmental temperature, and illness can also influence TSH levels.

The reference range for TSH is regarded as being approximately 0.5–4.5 milliunits/litre. It has been argued that this range is derived from a reference population which probably includes individuals who have very mild thyroid disease that is not detectable on clinical grounds. It has been suggested that, if the reference population were very carefully selected to ensure that individuals with very mild disease were excluded, the reference range would be

0.5–2.5 milliunits/litre. However, recent large population studies have applied strict selection criteria to ensure that subjects with only the mildest evidence of thyroid disease, including the presence of thyroid antibodies or a family history of thyroid disease or evidence of other autoimmune disease, were excluded. These studies did not support the reduction of the upper reference limit for TSH from 4.5 to 2.5 milliunits/litre.

In hypothyroidism, when the secretion of thyroid hormones is reduced, the pituitary gland responds by secreting more TSH in order to try and increase the activity of the failing thyroid. The TSH level is increased approximately in proportion to the decrease in the thyroid hormone blood level. Thus in established hypothyroidism, with all the characteristic clinical symptoms and signs, the TSH level is very high. When the degree of thyroid underactivity is more marginal, before any florid evidence of it may have appeared and the thyroxine level is at or just below its lower normal range, the TSH will be increased to a lesser degree but this confirms that the thyroid gland is beginning to fail. The TSH level is the most sensitive test in the diagnosis of a failing thyroid.

When the thyroid is overactive and increased amounts of thyroid hormones are being secreted, the pituitary gland is switched off by the feedback mechanism and the TSH falls below normal. Therefore this test is of value in helping to confirm a diagnosis of hyperthyroidism when the TSH will be below the bottom of the reference range and may be undetectable. However, low levels of TSH may also occur in circumstances other than hyperthyroidism, such as failure of the pituitary gland, and in the response to an acute severe illness, such as pneumonia or influenza, and other acute and chronic non-thyroid illnesses.

Thyroxine (T_4) level

Both the total amount of thyroxine in the bloodstream, which is largely bound to carrier proteins, and the free thyroxine, which is the tiny amount floating free in the circulation, can be measured. Nearly all laboratories now measure the free T_4 as this level is less influenced by changes in the amount of the transport proteins and most closely reflects the thyroid status. The reference range is 9–25 picomole/litre (pmol/L). Occasionally the free T_4 test gives misleading results if certain interfering antibodies are present in the blood, and low levels may be found in a variety of non-thyroidal illnesses.

The total serum thyroxine (T_4) level measures the total amount of thyroxine per unit of blood which comprises the T_4 bound to various proteins that carry most of the thyroxine. The result can be expressed in terms of the weight of thyroxine per 100 millilitre of blood (micrograms per 100 millilitre or µg/100 ml) or in terms of the number of molecules of thyroxine per litre (nanomoles

per litre or nmol/litre). The normal reference ranges may differ slightly from one laboratory to another, depending on the exact chemicals (reagents) used and the population of 'healthy' people from whose results the normal range has been derived.

The snag about measuring the total serum T_4 level is that the result depends on the amount of thyroxine bound to the transport proteins. It is the tiny amount of thyroxine which is unbound and floating free in the water of the blood (the serum), which determines the thyroid status. Thus the result of the total thyroxine assay is influenced by two factors: the amount of T_4 present, and the amount and binding capacity of the different carrier proteins.

Under certain circumstances, for example in pregnancy or if a woman is taking the contraceptive pill containing oestrogens or hormone replacement therapy (HRT) during the menopause, the amount of carrier protein is increased. This increases the total T_4 level but does not make a person hyperthyroid because the free non-protein-bound thyroxine remains normal. Certain drugs (e.g. aspirin and many others) may occupy the binding sites on the carrier proteins normally reserved for thyroxine. Therefore these drugs will tend to lower the total T_4 level by displacing the protein-bound thyroxine (Table 3.1).

Table 3.1 Situations which increase or decrease the level of carrier proteins or otherwise influence the levels of total T_4 and/or T_3

Increased total T_4 and/or total T_3 may be associated with:
◆ Pregnancy
◆ Oestrogen therapy
◆ Oral contraceptive pill
◆ Drug therapy with amiodarone, clofibrate, or phenothiazines (e.g. chlorpromazine)
◆ Hereditary increased thyroxine-binding globulin
Decreased total T_4 and/or total T_3 may be associated with:
◆ Kidney diseases or other causes of low plasma proteins
◆ Acromegaly (increased growth hormone secretion)
◆ Cushing's syndrome (high levels of adrenal hormones)
◆ Hereditary low or absent thyroxine-binding globulin
◆ Androgenic, anabolic, or corticosteroid therapy
◆ Fenclofenac therapy
◆ Phenylbutazone therapy
◆ Phenytoin therapy
◆ Aspirin therapy
◆ Anti-depressive therapy

Because variations in the amount of the carrier proteins and in the number of their binding sites may be induced by hormones, drugs, many non-thyroid diseases, and by genetic factors, most physicians nowadays prefer to measure the free T_4.

Raised levels of thyroid hormones occur in most cases of hyperthyroidism, but sometimes only the triiodothyronine (T_3) is raised. The more severe the over-activity of the gland, the higher are these hormone levels. Reduced levels of T_4 occur in most cases of hypothyroidism, but not always to a marked degree in the early stages.

Triiodothyronine (T_3) level

Both the total (protein-bound) and the free T_3 levels can be measured, with the measurement of total bound T_3 concentration having the same disadvantages as measuring the total T_4 level. Usually the total T_3 and total T_4 levels move in parallel because about one-third of the T_3 is derived from the conversion of T_4 to T_3 in peripheral tissues.

High levels of both T_3 and T_4 occur in an overactive thyroid. The reference range of free T_3 is of the order of 3–9 pmol/litre. In some people with hyperthyroidism the T_3 level rises some weeks or months earlier than does the T_4 level. Occasionally, people with thyrotoxicosis with a raised T_3 level never develop a raised T_4 level; this is known as T_3-toxicosis. The T_3 level has no role in the diagnosis of hypothyroidism as the failing thyroid gland preferentially produces T_3 rather than T_4 and so T_3 levels only fall below the reference range in a severely underactive thyroid gland and the TSH level is the best test and is even more sensitive. Low levels of T_3 can be found in patients suffering from acute physical and psychiatric illnesses unrelated to the thyroid gland. This reflects a so-called non-thyroidal illness (formerly called the sick euthyroid syndrome) in which much of the thyroxine is converted to the inactive form of T_3 known as reverse T_3, because it is the mirror image of the active form and its formation is increased in non-thyroidal illness. The T_3 level returns to normal as the person recovers (see Chapter 15, p. 149).

Combined tests

Combining two different types of thyroid function tests, i.e. TSH level plus the T_4 or T_3 level, can provide a more complete assessment as to whether the thyroid is over- or underactive. Table 3.2 summarizes some of the results which may be obtained by measuring the TSH, free T_4, and free T_3 levels.

Table 3.2 A summary of some common results of tests of thyroid secretory function and their significance

Free T$_4$ level	Free T$_3$ level	TSH level	Significance
High	High	Low	Hyperthyroidism
Normal	High	Low	Early hyperthyroidism; T$_3$-toxicosis
Normal	Normal	Low	Subclinical hyperthyroidism
Normal	Normal	Normal	Normal (euthyroid)
Normal or low	Normal or low	Normal or low or raised	Generalized ill health, 'non-thyroidal illness'
Low or normal	Normal	High	Subclinical or mild hypothyroidism
Low	Normal or low	High	Hypothyroidism

However, in most circumstances the finding of a TSH level that is within the reference range excludes a disorder of the thyroid gland.

Tests to determine the cause of thyroid disease

Once the initial blood tests have established that the thyroid is not functioning normally, a number of further blood tests and scans are available to determine the cause, which may affect the treatment. Alternatively, the thyroid may be functioning normally but a goitre or nodule may be present and investigations may be required to provide reassurance. Not all the tests are likely to be required or necessary and the order in which they are done will vary according to the clinical circumstances.

Thyroid antibodies

As explained in Chapter 2, antibodies which act on the thyroid gland in different ways develop in the body. Detection of these antibodies and assessment of their level may be useful in deciding the cause of the thyroid disorder.

Thyroid peroxidase and thyroglobulin antibodies

A variety of different antibodies may impair thyroid function. The two most commonly measured are the thyroid peroxidase (TPO) antibodies and the

thyroglobulin antibodies. The thyroid peroxidase antibody (previously known as the thyroid microsomal antibody) is the most important as it is cytotoxic, which means that it destroys thyroid cells. It is usually found in the blood of people with Hashimoto's thyroiditis and is directly responsible for the gradual destruction of the thyroid with the subsequent development of hypothyroidism. This autoimmune destruction is a slow process and takes place over many months and years. At present there is no way that this destructive process can be arrested. However, a knowledge of the presence of antibodies may help to plan the follow-up of those people found to have the earliest evidence of thyroid failure as these antibodies can predict the development of the need for thyroxine replacement. Both types of antibody may also be found in people with Graves' disease, in which case they represent a general autoimmune reaction against the thyroid.

Another implication of the diagnosis of autoimmune thyroid disease is the association with the development of other autoimmune diseases. An example is pernicious anaemia in which the absorption of vitamin B_{12}, which helps in the production of red blood cells, is prevented by an antibody which destroys cells in the stomach. If this kind of antibody is found to be present in the blood, a check can be kept on the haemoglobin levels and injections of vitamin B_{12} given at the earliest evidence of the development of anaemia (see Chapter 16).

Thyroid-stimulating antibodies

Graves' disease is caused by antibodies which increase thyroid activity. Thyroid-stimulating antibodies mimic the stimulatory signal TSH from the pituitary. This results in the thyroid cells continuing to produce thyroid hormones despite the pituitary gland trying to switch off the thyroid gland by not producing TSH. Thyroid-stimulating antibodies can be detected in almost all people with Graves' disease and are also present in approximately two-thirds of those who have the eye complications of Graves' disease but are not yet thyrotoxic (see Chapter 5).

Radio-isotope thyroid scan

In this investigation a radio-isotope, either technetium or iodine, is given that is taken up by the thyroid gland. The gland becomes temporarily radioactive and this is charted by a counter placed over the neck. The amount of radioactive exposure is very small and is not dangerous. A record of the uptake called a scintigram can be charted on X-ray film or in colour on paper (Fig. 3.1).

A normal isotope scan will show that the gland is located in the right place in the neck with two lobes of equal size and uniform activity throughout. If the

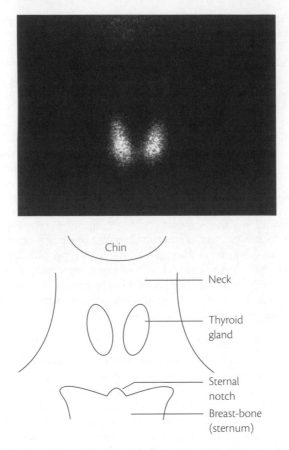

Figure 3.1 Technetium isotope scan of a normal thyroid gland. The outline of the gland is clearly shown. The person's right lobe is slightly larger than the left. The degree of uptake of the isotope is greatest in the centre of each lobe, where there is most thyroid tissue. The 'sternal notch' is the small hollow at the upper end of the breast-bone. (Note that 'right' and 'left' in the diagram refer to the person's right and left.)

gland does not develop normally or its descent into the neck from its origins at the base of the tongue is abnormal, the scintigram will show little radioactivity in the usual place but the activity may be located high in the neck, under the chin. These findings are mainly of importance when investigating the cause of hypothyroidism in a baby or child.

When there is overactivity of the thyroid the scan may show one of four appearances.

1. In Graves' disease the whole gland is overactive, and the scan shows high activity uniformly throughout both lobes, which are usually enlarged.

2. When the thyrotoxicosis is caused by overactivity in just one group of cells (a toxic adenoma), the radioactivity is almost totally confined to this area of hyperactivity (Fig. 3.2). This is referred to as a 'hot' nodule because of the excess uptake of isotope in this one area. The rest of the gland takes up little or no isotope and is 'cold' because it is inactive as a result of the excess thyroid hormones formed by the hot nodule depressing the pituitary secretion of TSH through the normal feedback mechanism.

3. In a multinodular toxic goitre the isotope uptake is largely confined to a number of different areas which vary in size and 'hotness'. Thus the scan shows multiple 'hot' nodules separated by areas of relatively inactive 'cold' tissue.

4. When hyperthyroidism is caused by viral thyroiditis or a silent auto-immune thyroiditis, the working of the thyroid gland is so disrupted that it temporarily ceases to function and the scan shows little or no uptake. The thyrotoxicosis is caused by discharge of preformed hormones from the inflamed gland. With recovery from the inflammation, the gland will show a normal uptake again some months after the initial illness.

Most medical physics departments will now insist on a scan being performed prior to radio-iodine treatment for thyrotoxicosis to confirm the cause of the overactivity and also to ensure that the person does not have thyroiditis, in which case the radio-iodine will be ineffective and unnecessary. However, an isotope scan is not necessary in all cases of hyperthyroidism because the diagnosis may be obvious. For example, there may be the classical eye signs characteristic of Graves' disease or a history of a painful neck pre-dating symptoms of thyrotoxicosis which will indicate a viral thyroiditis. However, in other cases the symptoms and signs may not be so obvious and a scan will help identify the cause of hyperthyroidism or even suggest that the overactivity may be only temporary when caused by a silent thyroiditis.

Previously, isotope scans were often used to differentiate between 'hot' and 'cold' areas in a normally functioning gland. The rationale was that malignancy, although rare, was more common in the 'cold' nodules (Fig. 3.3). However, it is now recognized that ultrasound of the thyroid gland and

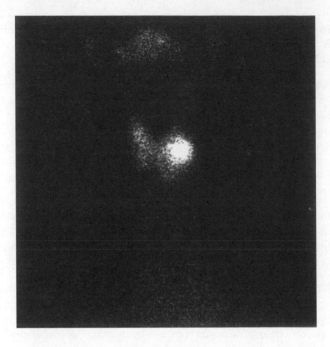

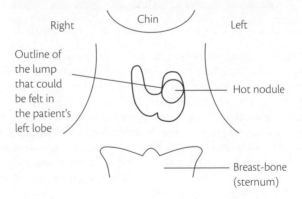

Figure 3.2 Technetium isotope scan of a thyroid gland containing a toxic adenoma. The 'hot' nodule in the left lobe takes up most of the isotope, and there is little radioactivity in the other lobe because it is inactive as a result of suppression of the secretion of TSH from the pituitary gland by T_4 from the nodule (see text). (Note that 'right' and 'left' in the diagram refer to the person's right and left.)

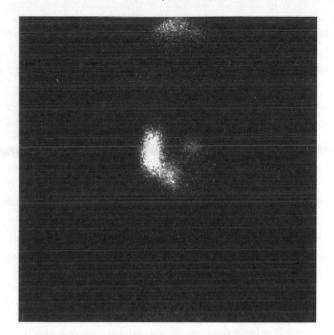

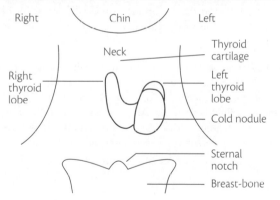

Figure 3.3 Technetium isotope scan of a thyroid gland containing a 'cold' nodule. The nodule in the lower part of the left lobe could easily be seen and felt. There is no radioactivity in this nodule; therefore it is 'cold'. Some radioactivity can be seen in the area of the chin because the isotope has also been taken up in the salivary glands. (Note that 'right' and 'left' in the diagram refer to the person's right and left.)

fine-needle aspiration biopsy of thyroid nodules are the investigations of choice to confirm that a nodule or nodules are benign.

Ultrasound scan

This is a painless technique in which jelly is spread over the neck and a smooth probe is moved backwards and forwards across the thyroid gland. This probe sends inaudible 'sound' waves through the skin into the thyroid gland, which are reflected back to a receiver in the probe. As the probe is moved from side to side a pattern emerges which is recorded on a screen (Fig. 3.4). The ultrasound scan shows the size of the thyroid gland, whether a lump is a solid nodule or a hollow cyst filled with fluid, and whether there is a single nodule or several, but it does not usually indicate the cause of the nodule(s).

Fine-needle aspiration

Fine-needle aspiration (FNA) is the removal of thyroid cells for examination under the microscope. A careful study of these cells can provide a diagnosis and tell whether a lump is benign or malignant. FNA is a virtually painless procedure carried out in a few minutes on an outpatient basis. This test is now crucial in helping to decide the management of nodular swellings of the thyroid. Thyroid tissue or fluid containing some cells is sucked through a fine needle into a syringe and then examined by a pathologist in the laboratory. The procedure can be performed in a clinic or by ultrasound guidance in a radiology department.

The person is asked to lie down on a couch with their neck stretched back. Some doctors use local anaesthetic but many people find that is not necessary. There is a slight prick as a fine needle is inserted into the thyroid gland and a small amount of tissue or fluid is removed. After the procedure, which may need to be performed on more than one occasion, a small adhesive dressing is put over the puncture mark and the person is allowed home after a short rest.

Following FNA, there are four possible answers.

1. An inadequate sample has been obtained from which no diagnosis can be made. This can happen in up to 20 per cent of samples and a repeat procedure is necessary.

2. The cells are clearly malignant and urgent treatment by removal of the whole thyroid gland is required.

3. The cells and surrounding tissue clearly indicate that the lump is benign (usually indicated by plentiful amounts of a protein called colloid which is normally found within the thyroid and contains stored thyroid hormones) and the patient can be reassured. In this situation, some doctors elect to repeat the test in a further 3–6 months to confirm this finding to provide complete reassurance.

4. The cells and surrounding tissue look benign (usually the presence of thyroid follicular cells with little colloid protein) but there is some doubt and the pathologist suggests that a repeat of FNA or an operation, usually a hemithyroidectomy to remove one lobe of the thyroid, is required to provide a firm diagnosis and excision of the lump in question. (See Chapters 11 and 12 on nodules and thyroid cancer.)

X-rays

Conventional plain X-rays are still sometimes performed to see whether an enlarged thyroid gland is pressing on the trachea (windpipe) or, if the goitre is larger on one side than the other, whether the trachea is being displaced. In the management of a large goitre (usually a benign multinodular gland), the surgeon will usually request a computer-assisted tomography (CAT or CT) or magnetic resonance imaging (MRI) scan of the neck, which provides a much clearer image.

CT or MRI scans of the eyes and the bony sockets in which they lie are sometimes helpful to establish the nature of the eye changes that may be associated with Graves' disease. This is helpful if the changes affect only one eye and there is some doubt about the diagnosis. Scans also determine if there is significant compression of the nerve supplying the eye (the optic nerve), which can be a rare complication of severe Graves' eye disease (Fig. 3.5).

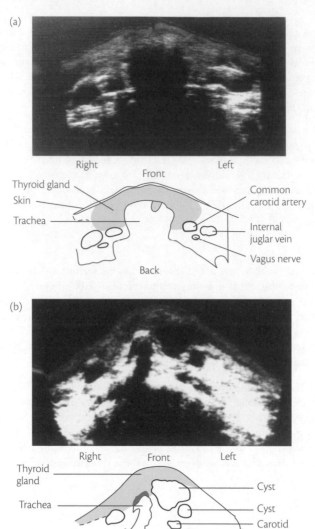

Figure 3.4 Ultrasound scans of the thyroid gland: (a) normal; (b) a large and a small cyst in the left lobe are causing some thyroid enlargement.

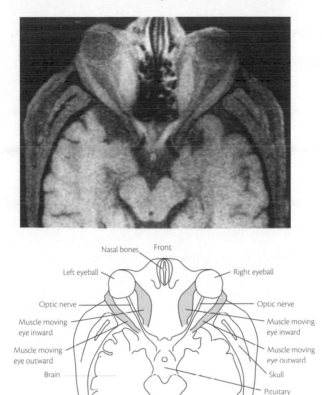

Figure 3.5 Magnetic resonance imaging (MRI) of a person with impaired movements of the eyes and double vision. The eyeballs are clearly seen. The muscles that move the eyeballs inwards are much thicker than the normal muscles that move the eyes outward. (Note that the left and right orientations refer to the person's left and right.)

❓ Questions and answers

Q.1　Why do I need to have blood tests?

A.　Many different tests can be done on one blood sample, including measurement of thyroid hormones, thyroid-stimulating hormone (TSH), and thyroid antibodies, which are all useful in assessing the state of the thyroid.

Q.2　How will the tests show that I have an overactive or underactive gland?

A.　When the thyroid is overactive the levels of thyroid hormones in the blood are high. When the thyroid is underactive the circulating thyroid hormone levels are reduced for the affected individual and the TSH level rises.

Q.3　Can I have an underactive thyroid but normal thyroid function tests?

A.　Many of the clinical features of hypothyroidism are not specific to that condition and similar symptoms may be found for various other reasons. If the thyroid function tests are in the normal reference range (see text), it is highly unlikely that the symptoms are due to an underactive thyroid and other possible causes should be sought.

Q.4　Is TSH invariably raised in thyroid underactivity?

A.　TSH rises when the thyroid gland itself fails to produce enough thyroid hormones for the affected individual. It is a response by the pituitary gland signalling to the faulty thyroid to try to produce more thyroid hormones. When the pituitary gland is itself damaged (e.g. by a tumour), the TSH level is low but there is usually also evidence of other pituitary hormone failures in this relatively rare condition.

Q.5　What are thyroid autoantibodies?

A.　They are chemicals produced by the body which influence thyroid cells. They may destroy the thyroid cells (p. 18) or they may stimulate them (p. 19).

Q.6 Is thyrotoxicosis the same thing as thyroid overactivity and hyper-thyroidism?

A. Yes. All these terms mean that the thyroid is producing too much thyroid hormone, but there are several different causes for such overactivity (see Chapters 4 and 6). Thyrotoxicosis is used in a clinical context when a person has symptoms and signs of thyroid overactivity. The term hyperthyroidism is usually used to reflect the underlying biochemical abnormalities which are not necessarily accompanied by clinical features, for example when due to excessive thyroxine ingestion or a destructive thyroiditis.

Q.7 Why is the hospital doctor so keen on finding out why I have an overactive thyroid?

A. Because the most effective treatment differs depending on the cause (see Chapters 4 and 6).

Q.8 Is there a risk of thyroid cancer if I have a radio-isotope scan or radio-iodine therapy for an overactive thyroid?

A. There is no evidence of any increased risk of thyroid cancer after a diagnostic radio-isotope scan. The dose of radiation is less than that given when a simple chest X-ray is done. Larger doses of radio-iodine for thyrotoxicosis have also been used for over 60 years without any evidence of an increased risk of cancer.

Q.9 What is a fine-needle aspiration of the thyroid?

A. This is a procedure usually undertaken in the clinic to obtain a small piece of tissue or fluid from the thyroid using a fine needle and a syringe. It is similar to having a blood sample taken and is relatively painless. The sample is then examined under a microscope to determine the types of cells seen, particularly to indicate or exclude any form of thyroid cancer.

Q.10 Shouldn't I have had some X-rays taken?

A. X-rays are of limited value in the investigation of thyroid disease and most information is gathered from the blood tests and, where necessary, from fine-needle aspiration of thyroid tissue.

4

Thyroid overactivity caused by Graves' disease

Overactivity of the thyroid gland, also known as hyperthyroidism or thyrotoxicosis, is a disease in which increased amounts of thyroid hormones are present in the bloodstream. Usually the levels of both thyroxine (T_4) and triiodothyronine (T_3) are increased above normal; however, in some people with thyroid overactivity only the T_3 level is raised but the symptoms and the findings are just the same in this so-called T_3-toxicosis as when both T_4 and T_3 levels are raised.

The causes of thyroid overactivity

There are several causes of overactivity of the thyroid (see Chapter 6) but in practice more than 80 per cent of cases are due to the gland being subjected to excess stimulation by thyroid-stimulating antibodies. This condition is called Graves' disease or toxic diffuse goitre. It is 'toxic' because the person is usually ill as the body's cells are being overstimulated by the increased circulating levels of thyroid hormones in the bloodstream, and 'diffuse' because the whole gland is overactive, as can be shown by an isotope scan (see Fig. 3.1). Graves' disease is considered in this chapter, and the other less common causes of thyroid overactivity are discussed in Chapter 6.

The cause of Graves' disease

Several factors are involved in the causation of Graves' disease.

1. Often there is a familial or hereditary factor because autoimmune diseases of the thyroid gland and other organs or tissues tend to run in families (see Chapter 16).

2. The dietary intake of iodine is relevant because the disease may follow an increase of iodine intake. A temporary increase in the incidence of Graves' disease has been observed in iodine-deficient communities after supplemental iodine has been added to their diet.

3. Women of all ages are about 10 times more likely than men to develop the condition. It has been suggested that the presence of female sex hormones may make the antibody attack more likely to occur; however, it can rarely occur in children of any age.

4. The fundamental cause of Graves' disease is the formation of antibodies that stimulate the thyroid cells to excess activity.

5. An environmental factor, such as a viral infection or a stressful life event, is thought to trigger the immune system in those who are genetically susceptible, resulting in the production of the stimulating antibodies in Graves' disease.

6. Very rarely transient Graves' disease may occur in a baby born to a mother who has Graves' disease, or has had it in the past, as the antibodies can cross the placenta and stimulate the baby's thyroid.

What are the symptoms?

The condition usually comes on slowly, and it may be several months before the person is ill, although rarely the onset is rapid over a few days or weeks. Tiredness is often an early symptom, followed by weight loss, palpitations or increased awareness of the heart beat, nervousness, and particularly irritability so that patients or their partners notice they have a 'short fuse', tremor, and sweating. Looseness or increased urgency of the bowels is not uncommon and sometimes diarrhoea may be a prominent symptom, causing diagnostic problems unless the other features are detected. The person may feel hot and be uncomfortable in hot weather. They may complain that the central heating is set too high, throw off the bedclothes, or open the window at night, yet their partner complains that it is not too hot. There may be itchiness of the skin but no rash. The tiredness becomes worse and shortness of breath may be present, particularly if carrying shopping or climbing stairs. Physical weakness is common and is often not realized; the upper muscles of the arms and legs are most likely to be affected. There may be difficulty in getting up from a squatting position or lifting a heavy package down from a shelf. Appetite may be better than usual and some people feel hungry all the time. Even with this voracious appetite there may be a considerable weight loss but this

is very variable. Women may notice that their periods become less heavy, less frequent, or stop completely, as failure to ovulate is common. This will usually be corrected once the thyroid overactivity is brought under control. Men may experience loss of sex drive and erectile dysfunction.

In the older person, typically over 55 years, these characteristic features may be less apparent, with symptoms related to the heart often dominating. Often there is shortness of breath, particularly on lying flat, resulting in difficulty sleeping, swollen ankles, and a fast irregular heart beat known as atrial fibrillation which is a risk factor for stroke. Overactivity of the thyroid as a cause of this heart failure may not be immediately apparent.

Apathetic hyperthyroidism

Occasionally, some older people with Graves' disease become bloated, slowed down and depressed. This is a very rare and rather mysterious condition which occurs in elderly people whose hyperthyroidism has usually been neglected or undiagnosed and therefore untreated for several years. The clinical picture is such that apathetic thyrotoxicosis may easily escape recognition because it is so different from the familiar clinical picture of hyperthyroidism seen in younger people.

The person is emotionally flat and depressed in contrast to the usual picture of anxiety. Instead of being restless, the person with apathetic thyrotoxicosis is lethargic and underactive, and often has a poor appetite. Although there may be a history or evidence of weight loss, the patient appears bloated. There is seldom marked thyroid enlargement or any eye complications. The pulse may be slow or normal as opposed to the expected increase in rate. Sometimes the illness is mistakenly attributed to the person growing old, to some hidden cancer, or to clinical depression.

Apathetic hyperthyroidism responds well to anti-thyroid drugs and sometimes this treatment is continued for many years unless it is more appropriate to induce a permanent cure with radio-iodine.

Eye complications

The first symptom noticed may be something wrong with the eyes. The person may notice themselves or be told that one or both eyes have become 'starey'. The upper lids are pulled upwards and the whites of the eyes are more obvious (so-called 'lid retraction'). Because of this upper lid retraction, the eyes appear

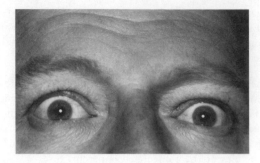

Figure 4.1 Lid retraction. Note how the upper eyelids are retracted so that the eyes have a staring quality and more of the white of the eyes than normal is visible.

larger and as if 'startled' (Fig. 4.1). These mild eye changes may occur in thyroid overactivity from any cause, not only in Graves' disease, and improve as the overactivity is controlled or cured. However, further eye symptoms and signs may arise in Graves' disease and these are discussed in Chapter 5.

Skin changes

Rarely, people with Graves' disease, particularly those in whom the eye changes are marked, develop changes in the skin on the lower legs. Patches develop that are slightly reddened and thickened so that they stand up above the surrounding skin (see Fig. 4.3). Hair growing in the affected areas may become coarser. The areas tend to increase in size and may spread to the foot. This condition is called pretibial myxoedema. This term may be confusing because the word myxoedema is used to describe the generalized thickening of the skin seen in hypothyroidism (see Chapter 8).

What are the examination findings?

People are likely to show evidence of weight loss or be thin. They are usually restless, anxious, have difficulty sitting still, and probably fidget (Fig. 4.2). Children tend to be clumsy and may have grown faster than their contemporaries so that their height is greater than normal for their age (see Chapter 14). Even on a cold day, people will only wear light clothing. Their hands will be hot, with moist palms, and the pulse will be bounding. The pulse rate is likely to be fast, which may be related to anxiety but is also usually persistent and present even when asleep. A fine tremor of the fingers may be noticed when patients hold their arms outstretched.

Figure 4.2 Representation of a person with thyroid overactivity (thyrotoxicosis). Notice the restlessness. The person cannot sit still and fidgets.

The thyroid gland may be normal in size but is usually slightly enlarged, sometimes sufficiently so for the goitre to be the presenting complaint or noticed by family or friends. Because the gland is overactive, the blood flow through the gland is increased and this may be audible, using a stethoscope, as a swishing noise known as a 'thyroid bruit'.

Often the eyes have a staring quality and this may be the first outward visible sign that alerts the doctor. Although the person may be unaware that their muscles are weak, this can be demonstrated in the most affected muscles round the shoulder and pelvic girdles. The weakness is more common in men

than women. Raising outstretched arms against slight resistance or getting up from a squatting position may be difficult.

Atrial fibrillation

A completely irregular and often fast beating of the heart, called atrial fibrillation, is common in elderly people with hyperthyroidism. There are many other causes of atrial fibrillation including ischaemic heart disease (coronary heart disease) and rheumatic heart disease. The more easily treated hyperthyroidism may be missed if its symptoms and signs are not prominent, as often happens in older people. Thus cardiologists usually check the thyroid hormones and TSH levels in any person who develops atrial fibrillation. In thyrotoxicosis, correction of atrial fibrillation may occur spontaneously when the thyroid overactivity is brought under control, particularly in the younger person without any other cardiac abnormality. Atrial fibrillation carries a high risk of stroke and people often have to have their blood thinned with either aspirin or warfarin therapy before the abnormal rhythm is corrected. If the atrial fibrillation persists despite correction of the hyperthyroidism, further measures may be required, such as drugs or even a low-dose electric shock to the heart to convert the rhythm to a normal regular one.

Confirming the diagnosis

In its earliest stages, overactivity of the thyroid may not be easy to diagnose or indeed be clinically evident. Later, when the picture is more florid, it is easier. In the younger person, thyroid overactivity is virtually always accompanied by some feelings and evidence of anxiety, so that distinguishing between anxiety alone and hyperthyroidism plus anxiety may be difficult. The physical accompaniments of thyroid overactivity such as weight loss, fine tremor of the hands, and other evidence of increased metabolism are usually more pronounced than in uncomplicated anxiety and laboratory tests will make the distinction. The older hyperthyroid person who presents with heart failure must be recognized as suffering from thyroid overactivity because with prompt treatment the outlook is good and often much better than for certain other forms of heart failure.

Laboratory tests usually give clear-cut confirmation of the diagnosis. The free or total T_4 and the free or total T_3 levels are raised above normal and the TSH level is usually undetectable. When the laboratory results are only marginally abnormal (so-called 'subclinical hyperthyroidism'), nothing is lost if the person is kept under observation and the test repeated a month or two later when the clinical picture and laboratory tests will usually become more obvious.

Once a diagnosis of hyperthyroidism has been made, the next step is to determine whether the person has Graves' disease or one of the other causes discussed in Chapter 6. The diagnosis of Graves' disease may be obvious if the characteristic eye changes are present (see Chapter 5) and is more likely if there is a history of thyroid disease in the family. A typical history of a viral illness and the presence of marked thyroid tenderness may be diagnostic of subacute viral thyroiditis (see Chapter 9). However, difficulties may arise if the diagnosis is silent thyroiditis (see Chapter 14). Examination of the neck may suggest other causes if, instead of the uniform enlargement of the thyroid found in Graves' disease, one or more nodules are found in the gland.

In Graves' disease an isotope scan will show an increased uptake of the radio-isotope uniformly throughout both lobes. Furthermore, the majority of people with Graves' disease will have anti-thyroid antibodies (either TSH receptor stimulating antibodies (TSH-RAb) or thyroid peroxidase antibodies (TPO)) in their blood. However, TPO antibodies are not diagnostic of Graves' disease since they are also present in a variety of other autoimmune thyroid disorders.

Psychological problems in hyperthyroidism

Stress

Many people ask whether stress is the cause of autoimmune thyroid disorders because they note that the onset of Graves' disease, in particular, often seems to occur following some major stress such as bereavement, loss of a job, an accident, or some other major psychological upset. Indeed, the second ever case of hyperthyroidism, described by Parry in 1825, was a 21-year-old woman whose symptoms began 4 months after she had been accidentally thrown down the stairs in a wheelchair. This association with stress has also been noted in patients who develop hypothyroidism caused by Hashimoto's thyroiditis.

There is some evidence to support this from studies that have compared people with Graves' hyperthyroidism with healthy people in the general population without thyroid disease and those people with a toxic nodular goitre which is not due to an autoimmune cause. Those with Graves' hyperthyroidism more often give a history of some type of psychological stress, in particular negative life events such as loss of a spouse, before the onset of their hyperthyroidism. These reports have led to the evaluation of the influence of psychological stress on the immune system. In general, stress appears to cause a state of immune suppression. Suppression of stress may be followed by rebound activity of the immune system, which could precipitate autoimmune thyroid disease in genetically susceptible subjects.

Anxiety state

Most people with Graves' disease admit to being anxious. Indeed, anxiety is a prominent feature in many people with this condition. They have a fast pulse rate and tremor, they are conscious of the beating of their heart, and they sweat excessively. In addition they are anxious about what would normally be everyday events. This anxiety state usually remits when the hyperthyroidism is treated but in some people it persists to a lesser degree. This psychological disturbance often responds to treatment with a beta-blocker.

What are the treatment options?

Curative treatment

Treatment is essential for Graves' disease. Many years ago, before treatment options were available, about 20 per cent of untreated people died and the remainder ran a long fluctuating course with temporary remissions and relapses.

There are three main methods, not mutually exclusive, of treating Graves' disease.

1. Anti-thyroid drugs for 12–18 months which suppress the ability of the thyroid gland to make thyroid hormones.

2. Radio-iodine (^{131}I) which is concentrated in the thyroid cells and, by irradiation, destroys them.

3. Surgical removal of most of the thyroid gland (subtotal or near-total thyroidectomy).

Which of these methods is used depends on several factors and circumstances, which must be discussed between the patient and their specialist. These include:

1. The cause of hyperthyroidism.

2. Age.

3. Gender.

4. Size of the thyroid gland, whether it is cosmetically unsightly, or whether it is causing compression or displacement of the trachea (windpipe).

5. Position of the thyroid gland behind the sternum.

6. Choice and convenience for the person to remain for 12–24 months under medical supervision for treatment with anti-thyroid drugs or whether a rapid once-and-for-all cure is preferable.

7. Social considerations such as whether the person is pregnant or living with young children.

8. Availability of an experienced specialist thyroid surgeon.

9. Presence and severity of any eye complications.

10. Previous treatments that have been given for the condition. For example, if a person has relapsed after a previous course of medical treatment a further course of anti-thyroid drugs is unlikely to achieve a permanent cure. If they have already had surgery then further surgery is usually contraindicated because the incidence of post-operative complications is too high.

Non-curative treatment

Two forms of treatment are available which will improve symptoms but will not permanently cure the overactive thyroid.

Beta-blockers (e.g. propanolol and atenolol) are drugs which reduce the effects of excess thyroid hormone on the nervous system. They reduce sweating, anxiety and restlessness, palpitations, and heart rate, and can make people feel more comfortable until a proper cure can be achieved. In general these are very safe drugs but they should be avoided in people with a history of asthma. Once thyroid hormone levels have returned to normal, the beta-blocker can be withdrawn after reducing the dose gradually over a week.

Iodine has a temporary suppressive effect on the thyroid gland by blocking the release of thyroid hormones but this effect only lasts for 3–4 weeks. It is mainly reserved for those being prepared for urgent surgery and is taken in the form of drops of iodine (Lugol's iodine) in milk three times daily or tablets of potassium iodide for 7–14 days before the operation. It should not be taken for longer than 14 days because the desired suppressive effect can be lost and the thyrotoxic

effect can then be enhanced. If thyroid hormone levels are reduced by anti-thyroid drugs in preparation for elective surgery, iodine may not be necessary.

Anti-thyroid drugs

Drugs called thionamides suppress the synthesis of the thyroid hormones and reduce hormone production to render a person euthyroid. The three most commonly used are carbimazole, methimazole, and propylthiouracil. These drugs work by preventing the uptake of iodine into the thyroid gland, inhibiting enzymes involved in thyroid hormone production, and suppressing the auto-immune process. Carbimazole and methimazole are closely related and the former is quickly converted to the latter in the body. Their dosage in milligrams (usually between 5 and 60 milligrams) is approximately equivalent and they can be taken once daily. Carbimazole is widely used in the UK and methimazole is used in other European countries and in North America. Propylthiouracil (often abbreviated to PTU) is usually a second-line drug that is used if side effects occur with one of the other two as it has to be taken two or three times daily. PTU is also preferred if a woman is pregnant or breast-feeding. The dose of PTU is 50–600 milligrams, usually divided into three daily doses.

Two regimens, which have been shown to be equally effective, are used for treatment with anti-thyroid drugs. The regimen used will depend on the personal preference of the specialist and the individual's circumstances.

Titration regimen

An initial high dose is used (usually carbimazole or methimazole 30–40 milligrams) to bring the hyperthyroidism under control, after which the dose can be reduced according to the clinical response and the blood level of thyroxine. This will be tested every 6 weeks until the clinical situation has stabilized when the necessity for tests of thyroid function will become less frequent, perhaps every 3–6 months. This regimen uses the lowest dose of anti-thyroid drug necessary, which may reduce the risk of side effects and also allows the doctor to judge the aggressiveness of the disease and the likelihood of remaining in remission. It is the only regimen that can be used in pregnancy or breast-feeding.

If anti-thyroid drugs alone are given in too large a dose over too long a period the person will become hypothyroid.

Block–replacement regimen

Some specialists argue that after the initial high dose has brought the hyper-thyroidism under control it is easier to block the thyroid by taking a moderate

dose of the anti-thyroid drug continuously and to prevent the possibility of hypothyroidism by adding a replacement dose of thyroxine. This works well in some people as it prevents the ups and downs of being over- and underactive as may happen if the dosage of the anti-thyroid drug needs frequent readjustment. There is a suggestion that anti-thyroid drugs have a beneficial suppressive effect on the autoimmune process that is going on in the thyroid gland. This effect is greater if larger doses are used. Therefore some specialists use this treatment regimen for those with severe active eye disease.

Although anti-thyroid drugs will usually render the person euthyroid, they may not provide a permanent cure. When the drug is stopped, the thyroid overactivity may gradually return over the next 3–24 months. In Graves' disease, treatment for 12–18 months is associated with remission of 40–50 per cent in the 12–24 months after the end of a course of treatment. Most relapses occur within the first year and most of the remainder happen within 5 years, but relapses may continue many years after the episode of Graves' disease. It is also estimated that 5–20 per cent of those treated with anti-thyroid drugs develop spontaneous hypothyroidism in the years after their hyperthyroidism has settled. Those who achieve permanent remission often have only mild thyrotoxicosis, tend to be older, with a normal-sized or slightly enlarged gland, and are treated from an early stage.

Those who relapse usually have the following characteristics.

1. Persistent levels of thyroid-stimulating antibodies at the end of the course of anti-thyroid drug therapy.

2. Delayed treatment.

3. Presence of a large vascular goitre.

4. Severe hyperthyroidism at the time of diagnosis.

6. Presence of thyroid eye disease and pretibial myxoedema.

7. Genetic factors that predict relapse.

Therefore relapse after medical treatment is common but can seldom be predicted either at the start or end of treatment. Relapse should not be considered a disaster but simply a reason for prolonging medical supervision until the person is rendered euthyroid, usually by either radio-iodine or thyroidectomy. Which of these is used largely depends on individual preference. In many instances radio-iodine may prove the treatment of choice, depending on a variety of factors which will be discussed later. A further course of

anti-thyroid drug therapy is possible but experience has shown that failure to induce a permanent remission after the first course is likely to be followed by a relapse. Continuation of anti-thyroid drug therapy indefinitely is also possible but has disadvantages including the persistent but low risk of side effects from the anti-thyroid drugs and the need for continuous medical supervision because the intensity of the underlying disease fluctuates from time to time.

Anti-thyroid drugs are used for those rare cases of hyperthyroidism that occur in newborn babies. It is also the best treatment for children or adolescents with Graves' disease, although they seldom experience a permanent remission and either radio-iodine or surgery will be required at some stage (see Chapter 14).

Anti-thyroid drugs and pregnancy

Anti-thyroid drugs are commonly used for treating women aged 20–40 who have developed mild Graves' disease with a normal-sized gland or a small goitre and who have a 50 per cent chance of having a permanent remission. However, this may not be the optimal treatment if a woman is contemplating starting a family in the near future. Although hyperthyroidism often reduces the frequency of menstruation and induces temporary subfertility, anti-thyroid drugs will quickly correct the situation. Thus pregnancy can occur while taking anti-thyroid drugs. This does not present an insurmountable problem because during pregnancy anti-thyroid drugs can be given in low dosage without danger to the growing fetus. Pregnancy results in suppression of the body's immune system, including the antibodies that cause Graves' disease. It is common for anti-thyroid drugs to be withdrawn in the final 1–2 months of the pregnancy. The block–replacement regimen using an anti-thyroid drug and thyroxine is not appropriate in pregnant women because the thyroxine does not cross the placental barrier as easily as the anti-thyroid drug does and the baby is likely to become hypothyroid. After the pregnancy the immune system is reactivated and anti-thyroid medication is usually restarted within a few weeks. This reactivation of the immune system may explain why many women present with Graves' disease either for the first time or relapse following a previous course of anti-thyroid drug treatment in the first few months after a pregnancy. Anti-thyroid drugs may be secreted in breast-milk but in such tiny quantities that breast-feeding is not contraindicated. There is some evidence that the anti-thyroid drug propylthiouracil is safer in pregnancy and secreted less in breast-milk so it is often preferred in these situations, particularly if high doses of anti-thyroid drugs are required. As it can be difficult to look after a young baby while requiring treatment for Graves' disease, women may be advised and choose to have definitive treatment with radio-iodine or surgery before pregnancy is contemplated. Men and women are advised that pregnancy is to be avoided for the next 6 months after radio-iodine treatment

and this treatment can only be considered in women if reliable contraception is guaranteed during this time.

Side effects of anti-thyroid drugs

Anti-thyroid drugs are generally well tolerated but side effects do occur. Rash is common, occurring in 5–10 per cent of people. Other common side effects include nausea and mild indigestion while less commonly pain in the joints can occur. They usually occur within the first 2 months of treatment and disappear quickly when the drug is stopped and may not recur if propylthiouracil is used as an alternative. Rarely, however, a person may be sensitive to carbimazole/methimazole and PTU.

The most serious side effect of any of these three preparations is a reduction in one type of white blood cell. It is very rare, occurring in approximately three per 10 000 people per year. For unknown reasons the anti-thyroid drug may prevent the bone marrow making a particular type of white blood cell, the granulocyte or neutrophil, and the number of these cells may fall, causing neutropenia, or the neutrophils may disappear from the blood almost completely, causing agranulocytosis. Neutrophils are essential for fighting off micro-organisms which invade the body. Usually the first manifestation of neutropenia or agranulocytosis is a sore throat but it can present with features similar to a viral illness. People are warned that if they develop such symptoms it is essential to stop the tablets immediately and have a blood test to check their white blood cell count as quickly as possible. If this test shows that the neutrophils are depleted, antibiotics may need to be given to kill off any possible invading organisms until such time as the bone marrow has recovered and the white blood cells have returned to the bloodstream in normal numbers. Agranulocytosis can develop very rapidly so routine measurement of the white cell count is usually not helpful in predicting its occurrence. Hyperthyroidism itself may also cause some degree of bone marrow suppression so it can be difficult to distinguish between the effects of the condition that will improve once treated and a potential side effect of an anti-thyroid drug.

Radio-iodine treatment

Radio-iodine (^{131}I), a radioactive isotope of iodine, is increasingly being used as a first-line therapy for Graves' disease and as the treatment of choice in those who relapse after a course of anti-thyroid drug therapy or after surgery. Radio-iodine is available as a capsule or a drink and is usually administered on an outpatient basis. After taking radio-iodine orally it is predominantly taken up by the thyroid, with the amount depending on the size of the thyroid gland and the activity of the gland. Radio-iodine causes death of thyroid cells with no effect on the surrounding organs but may rarely cause slight soreness of the neck for a few days as the thyroid becomes inflamed. After a person

has received radio-iodine treatment, the amount of radio-iodine in the body decreases through excretion in the urine and decay of the radioactivity in the thyroid over the next 2–4 weeks depending on the dose received.

In many respects radio-iodine is very convenient treatment for Graves' disease, although it takes about 2 months to be effective. Radio-iodine is probably best avoided if the person has active eye disease as there is some evidence that it may cause the release of antibodies from the thyroid gland which can aggravate severe eye complications. In this group, anti-thyroid drugs are often used initially for up to 12 months before deciding whether to proceed with definitive curative treatment in the form of radio-iodine (see Chapter 5).

The advantages of radio-iodine are as follows.

1. It is a single treatment taken by mouth, in the form of a capsule or rarely as a drink, performed as an outpatient procedure.

2. Compared with surgery, people avoid the need for a general anaesthetic, the pain of an operation, the scar on the neck, or the potential risks of thyroid surgery.

3. Depending on the dose given and their occupation, people need only a day or two away from work as long as they are not working with or having prolonged contact with children (see below).

4. It is cheaper than surgery or a prolonged course of anti-thyroid drugs.

Radio-iodine has been used for the treatment of Graves' disease for over 60 years and has proved itself safe. There have been no adverse effects from the irradiation, such as the later development of leukaemia, no lack of fertility, and no genetic abnormalities in subsequent offspring. Nevertheless it is not given in pregnancy, because the growing fetus takes up iodine from the third month of pregnancy and hence its thyroid would also be irradiated, or if breast-feeding.

The main disadvantage of radio-iodine is the inconvenience that the person is radioactive after being given the therapeutic dose of radio-iodine. Although most of the radioactivity will be eliminated within the first week, people are asked to avoid close (less than 1 metre) and prolonged (more than 1 hour) contact with young children and pregnant women for up to 4 weeks after the treatment. People are also advised to avoid close or prolonged proximity to other adults during that time. Exposure depends on how long other people are

with them, how close they get, and the dose of radio-iodine given. Women and men are advised not to attempt conception for 6 months after radio-iodine treatment. Specific instructions to each person are given by the medical physics department administering the radio-iodine. For example, special care is needed for a person with urinary incontinence. It is emphasized that avoidance of contact is a social responsibility and if simple rules are observed then the risk of exposure to radioactivity is negligible to any other person. Clearly, the restrictions can present practical difficulties, especially if the person is the sole or main carer of a small child, in which case it may be necessary for the child to stay with relatives or friends during the period of restricted contact, or perhaps the treatment should be delayed until the child is older.

Another surmountable disadvantage is that although radio-iodine has some early effect on the production of thyroid hormones by the thyroid cells, its maximum effect is not apparent for about 2 or 3 months, although occasionally a more rapid effect is seen in some people. Therefore its action is slower than that of anti-thyroid drugs, which produce a noticeable improvement in a week or two. While waiting for the radio-iodine to work, patients can be kept asymptomatic using beta-blockers. In severe cases of thyrotoxicosis, anti-thyroid drugs can be given before and after the radio-iodine and continued until the radio-iodine has produced its maximal effect. In this circumstance, anti-thyroid drugs must be stopped at least 5 days before the radio-iodine and not restarted for at least 5 days afterwards because they can stop the radio-iodine working. If people are on a block–replacement regimen (p. 40), both drugs may have been stopped for a longer period, which can be up to 4 weeks because of the longer period of effect of thyroxine in the body (i.e. its half-life).

The main disadvantage of radio-iodine, which must be weighed against its many advantages, is the probability that the thyroid gland will become underactive in subsequent years. Within the first year after radio-iodine treatment approximately 20–50 per cent of those treated become hypothyroid and require thyroxine therapy. Over a period of 20 years after radio-iodine treatment more than 80 per cent of those with Graves' disease become hypothyroid. The incidence of thyroid deficiency is not materially influenced by the dose of radio-iodine given, although the larger the dose the earlier the underactivity is likely to commence.

This potential 'disadvantage' is perhaps less of a problem than at first thought. People are naturally concerned regarding the prospect of becoming fat and bloated as a result of thyroid hormone deficiency. This will not be allowed to happen provided that people are kept under regular observation and treated for thyroid hormone deficiency as soon as there is evidence in the thyroid function blood tests, which often occurs before symptoms or

physical changes are noticed by the individual. Follow-up by a family doctor with an annual blood test is required for those treated by radio-iodine. Some centres use a computerized system with an annual blood test and question-naire for follow-up.

Judging the correct dose of radio-iodine is difficult for the doctor and the medical physics department. If too little is given, the person remains thy-rotoxic and will need a second or even a third dose. Approximately 1 in 10 people will require a further dose of radio-iodine because they have not been cured following the initial dose. If larger doses are given the sooner those so treated are more likely to become hypothyroid but with close observation this will be countered by thyroxine replacement. In some centres an attempt is made to calculate the correct dose from the size of the thyroid gland and its avidity in taking up a tracer dose of isotope shortly before treatment. In others the philosophy is to accept that sooner or later after treatment people are likely to become hypothyroid and therefore a sizeable dose of radio-iodine is given and thyroxine prescribed as soon as they become hypothyroid. This has the advantages that people know about becoming hypothyroid early and that, once treated appropriately, follow-up is less frequent.

Surgery

In skilled hands surgical removal of most of the thyroid gland is a very effect-ive form of treatment for Graves' disease. Before the operation the person is first rendered euthyroid with anti-thyroid drugs and sometimes Lugol's iodine and beta-blockers. It is dangerous to operate on an unprepared person who is still thyrotoxic because this might provoke a thyroid crisis (see Chapter 15). The length of stay in hospital is usually no more than 3 days. Depending on the difficulty of the operation, the surgeon will occasionally leave a small drain in the edge of the wound for 24–48 hours to drain the thyroid bed after the procedure. Although the appearance of the scar cannot be guaranteed, the incision in the skin is made across the neck in one of the natural skin creases. In most instances it eventually becomes a fine line that looks like a normal crease and the techniques of plastic surgery are used to close the wound. Most surgeons now aim to remove as much of the thyroid gland as possible so that hypothyroidism is usually inevitable and thyroxine can be commenced imme-diately after the operation. Some surgeons used to leave sufficient thyroid tissue behind to achieve euthyroidism after surgery. However, this practice results in a significant risk of recurrence, and second surgery, although pos-sible, carries an increased risk of complications. If there is a post-operative recurrence of thyrotoxicosis, which should be less than 1 per cent in the best

surgical hands, radio-iodine is used as the treatment of choice to cure the condition in people of any age or gender.

Surgical treatment is usually preferred if the goitre is:

1. Retrosternal.

2. Very large and cosmetically unsightly.

3. Compressing or displacing the windpipe (trachea).

If there is pressure on the trachea, people can experience difficulty in breathing and make a curious crowing noise called stridor when asleep. Stridor occurs when the head slumps forward or to one side when asleep and the relaxed neck muscles allow the enlarged thyroid gland to compress the trachea even more. Prolonged courses of anti-thyroid drugs or radio-iodine are best avoided under these circumstances because either form of treatment may temporarily increase the size of the goitre and aggravate the degree of compression.

Complications of surgery

There are complications of any operation such as the very small risks of a general anaesthetic, which cannot be predicted, and bleeding or infection. The three main risks specific to thyroid surgery are hypothyroidism (and possible risk of recurrence of hyperthyroidism), damage to the nerves that supply the vocal cords, and damage to four glands within the thyroid gland called the parathyroid glands which control the level of calcium in the blood.

As previously discussed in relation to the outcome of radio-iodine treatment, it can be contentious to describe hypothyroidism as a complication of surgery. Surgical practice now has changed so that hypothyroidism can be considered to be the almost inevitable outcome following surgery as it guarantees that hyperthyroidism will not recur. Hypothyroidism is easily treated by taking thyroxine tablets by mouth to make good the deficit. It is usually evident within the first few weeks that hypothyroidism is going to develop as a direct consequence of surgery. Thyroid hormone deficiency may also develop later because of autoimmune destruction of thyroid cells so it is important to ensure that an annual check of thyroid function is performed thereafter.

Running on either side of the neck, in or near the thyroid gland, are the nerves that activate the vocal cords (the recurrent laryngeal nerves). If these are bruised at the time of the operation, people can have a temporarily hoarse

voice afterwards, although some huskiness is not uncommon for a day or two simply as a result of the anaesthetic. Permanent hoarseness will only occur if one of the nerves to the vocal cords is actually cut but this seldom happens with an experienced thyroid surgeon.

The other possible post-operative complication is related to damage to the parathyroid glands. Usually there are four of these pea-sized glands (two on each side) which lie towards the back of the thyroid gland or sometimes embedded in it. The surgeon makes every endeavour not to damage these parathyroid glands and it is most unusual for the blood supply to all four to be permanently cut off. However, they may be bruised during the operation and therefore may not function normally for some days or weeks afterwards.

The parathyroid glands regulate the level of calcium in the blood. If they do not function properly (hypoparathyroidism), the level of calcium falls and this may give rise to a condition called tetany. This is a feeling of numbness in the lips and around the mouth with later symptoms including cramp in the hands and sometimes in the feet. These symptoms are corrected by giving calcium and vitamin D or one of its related compounds, which restore blood calcium levels to normal. Usually this treatment is only necessary for a short time.

Thyroid crisis or storm

This is a rare condition in which a person with thyrotoxicosis, usually Graves' disease, has a sudden and severe exacerbation of their hyperthyroid symptoms. This usually comes about as a result of some intercurrent illness such as pneumonia or other acute medical illness, trauma, or an acute emotional stress or psychiatric disturbance in a person who does not know that they are thyrotoxic or whose hyperthyroidism is not being adequately controlled. Historically, a thyroid crisis or storm was not uncommon when surgeons operated on people who had not been properly prepared by modern methods for the operation and had not been rendered euthyroid. An excess of thyroid hormones was released into the bloodstream as the surgeon handled the incompletely prepared thyroid gland during its subtotal removal. It has also been described as a complication of radio-iodine therapy or following high-dose iodine administration, for example following injection of an iodinated contrast agent for a CT scan.

What happens in a thyroid crisis?

The excess of thyroid hormones in the blood induces a fever, a very rapid heart beat which is often irregular due to atrial fibrillation, cardiac failure, profound sweating with loss of body water and dehydration, a state of shock

with a low blood pressure, and mental confusion or delirium. If left untreated the outcome may be fatal.

How is a thyroid crisis treated?

The best treatment is prevention but this is not always possible if the person does not know nor does not show evidence that they are thyrotoxic. If a thyroid storm does occur, treatment is with potassium iodide, propylthiouracil, and beta-blockers. Prompt replacement of fluid by intravenous infusion is also required as well as treatment of the underlying cause, if known. Other drugs are occasionally necessary such as cholestyramine, which removes thyroid hormones from the serum, and lithium, which blocks thyroid hormone secretion.

Treatment of pretibial myxoedema

The course of pretibial myxoedema is unpredictable. Almost invariably it occurs in those who have severe eye problems (ophthalmopathy). As the hyperthyroidism responds to treatment, so the skin changes on the legs may improve. However, in some people pretibial myxoedema may pre-date hyperthyroidism or it may not occur until after the thyrotoxicosis has been cured.

The most effective treatment is to apply and rub in a potent corticosteroid ointment on the affected areas on the legs each night and then wrap pieces of polythene film (e.g. Clingfilm) around the parts of the leg involved. This treatment may have to be continued for some time (Fig. 4.3).

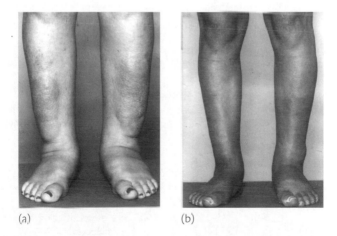

(a) (b)

Figure 4.3 Pretibial myxoedema: (a) before treatment and (b) the appearance of the legs 18 months after the local application of corticosteroid ointment.

Summary

Graves' disease can be a troublesome condition for anyone (Table 4.1). Whether treatment is with anti-thyroid drugs, radio-iodine or surgery, there is no immediate or instant cure. It can be upsetting to take anti-thyroid drugs for up to 18 months with only a 50 per cent chance of being cured. Radio-iodine may not produce its maximum effect for 3 months or more. Preparation with anti-thyroid drugs to achieve a euthyroid state prior to the operation is necessary for those who elect to have surgery. Even if cured, follow-up at least annually is required for life. The emotional or psychological accompaniments of Graves' disease are very real. People report that it can take many months, once cured, before they feel they have returned to normal. Feeling unduly anxious or irritable is common. Matters are made worse if the person suffers from the eye complications of Graves' disease

Table 4.1 Choice of treatments for Graves' disease

Treatment	Procedure	Disadvantages
Thyroidectomy	Once and for all treatment	Risks of general anaesthetic
	Preparation with anti-thyroid drugs	Post-operative discomfort
		Scar
	Three days in hospital	Hypothyroidism
	One week convalescence	Rare complications of vocal cord injury or parathyroid injury
	Two 6-weekly follow-up visits	
	Annual review	
Radio-iodine	Out-patient treatment	Hypothyroidism
	Off work a few days depending on occupation	May worsen thyroid eye disease
		Not suitable if pregnant or if pregnancy is contemplated in next 6 months or if breast-feeding
	Three or four follow-up visits over a year	
	Annual review	Social responsibility re relative isolation after treatment for up to 4 weeks
Anti-thyroid drugs	Treatment for 12–18 months with regular visits to GP or hospital every 3 months	No guarantee of cure with 50 per cent of patients relapsing within 12 months
		Side effects including rash and agranulocytosis
		Problems if starting a family

(see Chapter 5). These can be more worrying than any other aspect of the condition. It is possible for skilled eye surgeons to improve the appearance using modern surgical techniques but this is usually not contemplated until the thyroid overactivity has been cured.

? Questions and answers

Q.1 If my Graves' disease is treated with radio-iodine does it mean that I have cancer?

A. No. Graves' disease is not a malignant or cancerous condition and the radio-iodine is given to knock out thyroid overactivity.

Q.2 I have four children. Will they also develop thyroid overactivity?

A. Not necessarily, but there is a chance that one or other of them could develop some form of autoimmune thyroid disease, either Graves' disease or Hashimoto's thyroiditis, later in life (see Chapter 8 as well as above).

Q.3 Will I get fat after I'm treated?

A. If you've lost weight you will probably regain it when you become euthyroid again. If you were not fat originally there is no reason for you to become fat after you've been treated for thyroid overactivity whichever treatment you choose.

Q.4 Will radio-iodine have any effect on any babies I might have later on?

A. No, but we advise women in their reproductive years who are recommended to have radio-iodine treatment to take precautions to ensure that they do not become pregnant for the next 6 months while the radio-iodine decays. Radio-iodine will not affect your fertility.

Q.5 Does radio-iodine have any effect on my sperm count?

A. Radio-iodine is excreted via the bladder but as far as we know it has no adverse effect on sperm. Nevertheless, men are advised not to attempt conception for 6 months after radio-iodine treatment.

Q.6 I am aware of my heart pounding away, especially at night. Can anything be done about this?

A. Yes. Treatment with a beta-blocker will probably help to control this symptom until the treatment of the thyroid overactivity is effective.

Q.7 I used to love hot weather but now I can't stand it. We've booked a family holiday in Spain this summer. Should we cancel it?

A. The treatment of your thyroid overactivity should be effective within a few weeks and by then you will be able to enjoy the good weather in Spain so don't cancel your holiday if it is more than a month away.

Q.8 I'm very short-tempered with the kids and snap at my husband all the time, whereas I used to be a tolerant and calm sort of person. Can you give me anything to help?

A. Yes, you can take a beta-blocker for a while but as your thyroid overactivity responds to treatment you will stop being irritable and edgy.

Q.9 Will surgery leave a nasty scar?

A. Almost certainly not. Usually it fades to become like another crease in the neck.

Q.10 Which of the various treatments would you recommend me to have for my Graves' disease, doctor? I am 25 years old and hope to marry next year and then start a family.

A. This depends very much on your particular circumstances and the advantages and disadvantages of the three treatments we've already discussed. These different treatments, the procedures, and their complications are summarized in Table 4.1.

Q.11 If I take anti-thyroid drugs can I become pregnant without risk to the baby?

A. We do not recommend the block–replacement regimen for someone who might become pregnant. By using the smallest possible dose of carbimazole or propylthiouracil needed to keep the thyroid hormone levels in the normal range there is very little risk to the fetus and no reason not to breast-feed if you want to. However, we usually advise women to complete their chosen form of treatment before becoming pregnant if possible.

Q.12 Will radio-iodine or surgical treatment inevitably mean that I will become underactive?

A. Both radio-iodine and surgery largely or completely destroy the thyroid so it is highly likely that you will become hypothyroid

in due course. You should be monitored carefully so that when the TSH begins to rise you can be started on thyroxine in a full replacement dose immediately so as to keep you euthyroid. You will then need to continue thyroxine for life.

Q.13 I have just had radio-iodine treatment for thyrotoxicosis. Will I set off the alarms at the airport when I go through security next week for my trip to the USA?

A. The sensitivity of airport detectors varies from airport to airport and from country to country, but it is possible for even a modest therapeutic dose of radioactive iodine to trigger off a sensor up to several weeks after treatment until the radioactivity has almost completely decayed. It would be a good idea for you to carry a letter from the doctor who authorized or administered the radio-iodine to say what dosage you received and when, to show to the airport authorities if necessary.

Q.14 I have been on treatment for Graves' disease for the past 2 months. I had planned to take part in a marathon race next month but my training has been interrupted. Is it all right for me to restart training and go in for the race?

A. Your overactive thyroid is responding to treatment but is not yet fully controlled and your muscles are still not as strong as they were. I would advise you not to take part in such a strenuous activity because it could also cause a thyroid crisis which can be life threatening. Better to have the thyroid treated properly and take part in the marathon next year when you should be fine.

5

Eye changes associated with Graves' disease

Eye changes in thyroid overactivity generally

Certain eye changes are found in thyroid overactivity irrespective of its cause, but fortunately in most people with hyperthyroidism these are not too troublesome, although they can cause concern. Two distinct types of ophthalmic disorder may occur. One type is due to overactivity of the sympathetic nervous system and may occur in hyperthyroidism, whatever its cause. The other type occurs only in Graves' disease and may be present to some degree in up to half of people with this condition.

In hyperthyroidism of whatever cause there is likely to be a tendency for the upper eyelids to be pulled upward, exposing more of the whites of the eyes. Thus the person or their relatives or friends comment that the eyes have developed a staring quality due to eyelid retraction (see Fig. 4.1). When they look down, the upper eyelids may be slow to follow the downward movement of the eyeballs, a condition called lid lag (Fig. 5.1). These changes get better as the thyroid overactivity is brought under control.

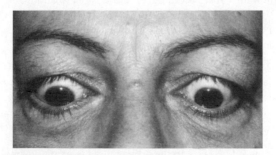

Figure 5.1 Lid lag. As the person looks downwards, the upper lid lags behind the eyeball.

Eye changes due to Graves' disease

The most troublesome eye changes occur in Graves' disease and also, but very seldom, in Hashimoto's thyroiditis. The relationship in time between the thyroid disease and the involvement of the eyes varies. Usually the eye changes occur simultaneously with the onset of the thyroid overactivity, but sometimes they precede it by several weeks or months. Less often eye problems arise months or even years after the thyroid overactivity has been treated and cured.

When associated with thyroid disease, whether past, present, or future, the condition is known as dysthyroid eye disease or Graves' ophthalmopathy. However, sometimes the eye changes occur before or even without there being any overactivity of the thyroid gland at all; this condition is called ophthalmic Graves' disease. The changes usually affect both eyes, but sometimes only one eye is involved, or one eye may be worse than the other.

What causes the eye changes in Graves' disease?

There is inflammation of the tissues surrounding the eyeballs, which lie in rigid bony sockets in the skull. The cause of this inflammation is an autoimmune reaction, mainly directed at the muscles that move the eyes from side to side and up and down (the extra-ocular muscles). The reason the autoimmune condition affects both the eyes and the thyroid seems to be that they share a common molecule, the TSH receptor. The antibodies causing the inflammatory response may not be exactly the same as those stimulating the thyroid gland because the eye changes may occur independently of changes in thyroid function.

What may happen to the eyes?

The inflammation causes swelling of the tissues around and behind the eyeballs and increases the pressure in the rigid bony sockets. This leads to a number of problems which may occur separately or together and do not progress in any predictable manner.

1. The eyes may be pushed forwards, known as proptosis or exophthalmos, which makes them more prominent and staring (Fig. 5.2). The hospital specialist may measure painlessly how far the eyes are pushed forward using an instrument called an exophthalmometer (Fig. 5.3).

2. The increased pressure in the orbits may impair the normal drainage of fluid from the eyes so that the upper eyelids become puffy and even

more swollen if there is involvement of the glands above the eyes that form tears (Fig. 5.4). Impaired drainage from the lower lids may lead to the formation of 'bags' under the eyes.

3. Because the eyes are pushed forward, they are less protected by the eyelids and therefore more exposed to irritation from dust, wind, and infection. There may be a feeling of grittiness or soreness in the eyes which water a lot so that people almost unconsciously keep dabbing their eyes with a handkerchief. The outer membrane covering the eyes may become inflamed and this increases the discomfort. Often the eyes appear as if they are waterlogged and they may become bloodshot at the outer corners (Fig. 5.5). In the earliest phases, if there are no features of hyperthyroidism, the appearance of the eyes may be mistaken for conjunctivitis.

4. The muscles that move the eyeballs in different directions may be affected so that the eyes cease to move as well as they do normally (ophthalmoplegia). Usually upward gaze is affected first and patients cannot look up without tilting the head back, which may explain an aching discomfort in the back of the neck. Later, movement of the eyes from side to side may be limited. Because the eyeballs no longer move exactly in parallel with each other, double vision (diplopia) may develop. When looking straight ahead people see a pencil held up straight in front of them as one, but as two when the pencil is moved upwards or to one side.

5. Rarely, the increased pressure in the bony orbits may affect the optic nerves that carry the visual image from the eyes to the brain.

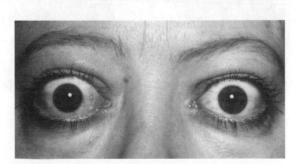

Figure 5.2 Exophthalmos or proptosis. Both eyeballs are more prominent than normal and protrude forwards. There is some swelling of the soft tissues above the upper eyelids. Note also that the eyes are somewhat bloodshot, the right more than the left.

Figure 5.3 An exophthalmometer being used to measure the degree of protrusion of the eyes.

Figure 5.4 Appearance before (left) and after (right) the development of Graves' thyrotoxicosis.

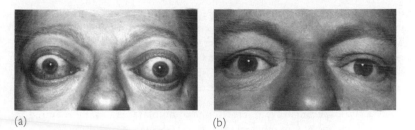

(a) (b)

Figure 5.5 (a) Marked ophthalmopathy showing exophthalmos, lid retraction, and increased redness. (b) The same person after two years' treatment, including decompression of both orbits.

(a) (b)

Figure 5.6 (a) Severe ophthalmopathy in Graves' disease before treatment. The eyeballs are protruding forwards but the extent of this exophthalmos is in part masked by the swelling in and around the eyelids. (b) Ten days after treatment with prednisolone (a corticosteroid drug) the ophthalmopathy is much improved. The eyes are less "angry" and uncomfortable. The swelling of the eyelids is much reduced, but upward movement of the eyeballs is still defective, which explains why the person holds their head tilted back.

Severe ophthalmopathy, which may affect the vision, is sometimes called 'malignant exophthalmos' (Fig. 5.6). This term does not mean that the condition is due to cancer but is used to reflect the seriousness of the condition which, unless treated, could lead to blindness.

How does the doctor know what is wrong?

The cause of the eye changes is usually obvious when the doctor confirms the diagnosis of thyrotoxicosis. The diagnosis may be difficult if there is no evidence of thyroid overactivity and particularly if the changes involve only one eye, because other disorders behind the eye may produce the same appearances. The presence of thyroid autoantibodies in the blood favours ophthalmic Graves'

disease. Approximately two-thirds of people with this condition have thyroid peroxidase antibodies and over 90 per cent have thyroid-stimulating antibodies. The TSH level is often below the reference range, although the levels of T_4 and T_3 may not be raised in ophthalmic Graves' disease unless hyperthyroidism develops later. Occasionally a CT or MRI scan is required to confirm the diagnosis, particularly if only one eye is affected.

Referral to a specialist eye doctor (ophthalmologist) is usually required to carry out any one of a number of tests to:

1. Be sure that the person has the ability to see different colours.

2. Be sure that the membranes covering the eyeball are not damaged.

3. Measure the pressure in the eyeballs.

4. Assess whether the fields of vision are normal.

5. Chart the movements of the eyes to see that the eyeballs are moving properly in all directions and in parallel.

Treatment

For unknown reasons, eye changes are often worse in older men. They are also often worse in smokers because of either a direct toxic effect on the eyes from the cigarette smoke or a toxin that enters the bloodstream. It is vital to stop smoking.

If the eye problems are mild and do not become worse, often no treatment is necessary. In two-thirds of people the staring appearance of the eyes caused by lid retraction diminishes as the thyroid overactivity is brought under control. The elevation of the upper lids may also be reduced by treatment with a beta-blocker. If the lid retraction and lid lag persist, surgery to lower the position of the eyelids has a strikingly beneficial effect.

There is evidence that treatment of the thyroid overactivity in Graves' disease with radio-iodine may aggravate the eye changes more than treatment with an anti-thyroid drug or surgery, but not if the ophthalmopathy is mild. Although this has not been proven conclusively, many specialists believe it prudent to treat Graves' disease medically to start with and see what effect this has on the eyes. If radio-iodine is used in people with moderate ophthalmopathy, it is usually wise to do so under the protection of corticosteroids. Specialists use different regimens of the corticosteroid prednisolone with doses ranging

between 20 and 60 milligrams for up to 10 days and then either stopping or reducing the dose over 6 weeks. It is also important to avoid severe hypothyroidism as this may aggravate eye problems. Recognition and treatment with thyroxine as soon as the person becomes thyroid hormone deficient following radio-iodine or any anti-thyroid treatment is important.

When the eyes are swollen and feel gritty, methylcellulose eye drops by day and a lubricating ointment at night often help. Eyes may be less puffy if people sleep propped up with several pillows. Sometimes the temporary use of a diuretic tablet which increases the elimination of fluid from the body helps. Dark glasses with sidepieces may make the eyes feel more comfortable and protect them from wind and dust.

Double vision tends to improve in two-thirds of people when thyroid overactivity is brought under control. However, persistent double vision can be very disabling. During the early phases, reading or watching television can be made tolerable by wearing a patch over one eye. Special prisms can be supplied or fitted to existing spectacles to correct the double vision and ensure safety when driving. Later, when the condition of the eyes has stabilized, an eye surgeon may correct the muscle imbalance so that the double vision is permanently cured or at least much improved.

A reduction in the protrusion of the eyes occurs spontaneously, but slowly, in about 20 per cent of people as the thyroid overactivity is controlled. In more than half it remains unchanged and in about 20 per cent it becomes worse unless special treatment is given.

To reduce the protrusion of the eyes, corticosteroids (in the form of high-dose prednisolone given orally or methylprednisolone given via an intravenous infusion weekly for up to 6 weeks) which reduce inflammation, can be effective (Fig. 5.6). Other drugs which suppress the autoimmune reaction in the orbits may be used in conjunction with steroids. Some eye specialists use low-dose radiotherapy to the eyes. This is often effective and in experienced hands side effects, such as the development of cataracts, are minimal. Sometimes people are advised to have the outer parts of their eyelids sewn together under a local anaesthetic. By narrowing the opening between the eyelids, better tear coverage and protection of the eyeballs is obtained and the cosmetic appearance is improved. Rarely, it is necessary to protect the optic nerves and prevent blindness by enlarging the bony orbits to allow the swollen tissue behind the eyeballs to expand and thus reduce the pressure. Various surgical techniques to achieve this have been devised with little visible external scarring. The improvement from ocular discomfort and threatened vision, and in the appearance of the eyes, can be striking (Fig.5.5).

The eye changes which may occur in Graves' disease are without doubt most upsetting for any person. Ophthalmopathy is difficult to treat and, sadly, despite the best treatments available at present, a proportion of patients may have persistent eye problems. Some people experience considerable psychological difficulties as a result of changes in their appearance, which may result in loss of self-esteem and a lack of self-confidence as well as anger at the changes. Sympathy and understanding from professionals and carers are vital. Help is also available from patient support groups (see Glossary, p. 199). Surgeons are becoming increasingly skilled at correcting disfigurement once the disease has reached the stable uninflamed stage. However, surgery is not easy and often more than one operation is needed.

❓ Questions and answers

Q.1 Does everyone with Graves' disease have eye problems?

A. No, or only minor or temporary ones. The majority of people with thyrotoxicosis have no major complaints about their eyes throughout the whole course of their illness. It is important not to smoke as this can make the eye problems worse.

Q.2 My eyes are really troubling me. Why aren't you doing more to help me?

A. We need to get your thyroid overactivity under control first and it is too early to tell whether or not the eyes are going to get better. Hopefully your eyes will improve as the thyroid comes under control. In the meantime we can give you drops to reduce the gritty feeling and recommend protective glasses.

Q.3 I have puffiness over my eyes and bags under my eyes. What can I do about this?

A. If you can, sleep propped up with more pillows. A diuretic, which will increase your urine output, may also help to reduce the fluid around your eyes. When your thyroid problem has been put right we can do something more about your eyes if there is still a problem. If necessary, surgery may be helpful later.

Q.4 Will my eyes get better when you have cured my hyperthyroidism?

A. Almost certainly yes, but it will take time. The condition of your eyes is likely to fluctuate and it is too early to say what the final appearance is going to be. When you are euthyroid and everything else has settled down we can recommend some minor surgery to improve the appearance of the eyes; this is usually very successful.

Q.5 I am troubled with double vision which is interfering with my everyday life and work. What can you do about it?

A. We recognize that this is a very distressing condition for which help is available. First, we need to control the thyroid overactivity, which takes time. In the meantime wearing an eye patch over either eye will relieve some of the stress, while it is hoped that the condition settles down. If the condition is more severe, the ophthalmologist may prescribe a prismatic lens to help correct the problem. Later, surgery may be necessary to correct a squint, but this is not usually undertaken until the thyroid overactivity has been corrected for some time to allow the inflammation behind the eyes to settle down.

Q.6 I am feeling very low and unable to go out because of my persistent eye problems, which are very disfiguring despite medical treatment. What other help is there?

A. Graves' ophthalmopathy is difficult to treat and, sadly, despite the best treatments available at present, a proportion of people of whom you are one, have persistent eye problems. Understanding and support from family, friends, and professionals are important. Help is also available from support groups (see Glossary, p. 199). Surgeons are becoming increasingly skilled at correcting disfigurement once the disease has reached the stable non-inflamed stage. You should not give up hope that the disfigurement will become less obvious in due course.

6

Other causes of thyroid overactivity

Although Graves' disease is the most common cause of thyroid overactivity, thyrotoxicosis may occur under a number of other circumstances which are listed below roughly in the order of their frequency, although this varies in different parts of the world.

1. A toxic multinodular goitre (p. 66).

2. A solitary toxic 'hot' nodule or adenoma (p. 66).

3. As a result of having subacute viral thyroiditis (see Chapter 9).

4. Post-partum thyroiditis (see Chapter 13).

5. In association with Hashimoto's thyroiditis, so-called Hashitoxicosis (see Chapter 8).

6. As a result of taking too much thyroxine, triiodothyronine, or thyroid extract by mouth (p. 67).

7. Thyroid overactivity induced by taking iodine or iodine-containing substances (p. 68).

8. Drug induced by medications such as amiodarone and lithium (p. 68).

9. Pregnancy and hyperemesis gravidarum or gestational thyrotoxicosis (see Chapter 13).

10. A very rare disorder of the pituitary gland which results in excess production of thyroid-stimulating hormone and hence thyroid over-activity (p. 145).

11. A very rare tumour of the reproductive system in men or women, which secretes a hormone that stimulates the thyroid gland (p. 70).

In any of these situations the symptoms are likely to be much the same as in Graves' disease (see Chapter 4) except that the major eye changes (ophthalmopathy) peculiar to autoimmune thyroid disease do not occur.

Toxic multinodular goitre

This condition, also known as Plummer's disease after the American physician who described it in 1913, tends to arise in the older person, aged 50–70, who for many years has had a goitre which has gradually become larger and lumpy or nodular. The symptoms of thyrotoxicosis develop insidiously and resemble those of Graves' disease. Because of the person's age, heart failure may be the presenting symptom. An isotope scan shows that some nodules are overactive ('hot') and separated by areas of inactivity. Radio-iodine is the preferred treatment for most because it is taken up by the hot areas, reducing their activity, and the gland is likely to shrink in size. Pretreatment with an anti-thyroid drug, before the radio-iodine is given, is advisable in some people. Those with toxic nodular disease are just as likely as those with Graves' disease to be cured of hyperthyroidism after one dose of radio-iodine but are less likely to become hypothyroid even several years after treatment. This is because suppressed extra-nodular thyroid tissue is unable to take up radio-iodine but recovers to function normally after treatment, which has knocked out the overactive areas only. Surgical removal after due pre-operative preparation is an alternative method of treatment. Long-term anti-thyroid drug therapy is a further treatment alternative, particularly in frail elderly people if compliance with therapy can be assured.

A solitary toxic 'hot' nodule (adenoma)

In this condition a clump of cells, a nodule which is a benign tumour (an adenoma), becomes overactive and in effect takes over the function of the whole gland. The result is that all the activity is located in one area and the rest of the gland goes into a resting state because, through the feedback mechanism, the secretion of TSH from the pituitary is switched off by the hormone output from the 'hot' nodule. The offending solitary nodule can usually, but not always, be found during physical examination. The rest of the thyroid may not be enlarged and indeed may be smaller than normal. The condition is most commonly seen in middle-aged and older women. In its early stages the adenoma may not produce an excess of thyroid hormones but gradually over a period of years the levels of T_4 and particularly T_3 are likely to rise and the TSH becomes suppressed. The key to the diagnosis is a radio-isotope scan showing uptake in the solitary nodule (see Fig. 3.2), which is therefore 'hot', and little or no uptake by the rest of the gland.

Anti-thyroid drugs are effective but do not induce a permanent cure of hyperthyroidism. 'Hot' nodules can be removed surgically but the most effective treatment is a fairly large dose of radio-iodine. This destroys the 'hot' nodule, and the remaining normal, but previously suppressed, gland usually gradually resumes its normal function.

Taking too much thyroxine or triiodothyronine

For a number of reasons, people may take too much thyroxine, triiodothyronine, or sometimes thyroid extract. The thyroid hormone levels in the bloodstream depend upon which of these drugs is being taken in excess. If there is too much thyroxine, the T_4 and probably the T_3 levels will be raised. If too much T_3 is being taken, T_3 will be raised and T_4 will be low. Irrespective of which compound is being taken to excess, the TSH levels will be low or undetectable. Some people like being thyrotoxic as it gives them a 'high' feeling and so they treat themselves with thyroid hormones. When they deny doing this, it is termed 'thyrotoxicosis factitia'.

In the past people were sometimes told they were obese because they were suffering from thyroid hormone deficiency without proof of the diagnosis. They have been given or have taken thyroid hormone as it was believed that this encouraged weight loss even though most evidence suggests that it is usually ineffective for this purpose. If the dose is small, all that happens is that the output of TSH is reduced by the feedback mechanism. The thyroid gland then secretes less hormone but the thyroid hormones in the bloodstream remain normal because of the hormone being taken by mouth. If the dose is larger, the thyroid hormone level will rise and the person will become hyperthyroid, which may have an adverse effect on the heart and bones. The most sensitive test currently available for confirming thyroid underactivity is the measurement of TSH (see Chapter 3). If a person has been taking thyroxine for many years it is important to know whether this is necessary and beneficial. If there is doubt regarding the validity of the original diagnosis, stopping thyroxine for 4–6 weeks and then measuring the TSH level will establish whether thyroxine is really necessary (see Chapter 7).

Mild thyroid hormone excess/subclinical hyperthyroidism

When tested for thyroid disease, people are sometimes found to have evidence of mild thyroid hormone excess or subclinical hyperthyroidism on their blood test. This is a biochemical diagnosis made on the basis of an isolated low or undetectable TSH with normal T_4 and T_3 levels and symptoms

are usually absent. The tests usually return to normal when repeated within a month or two after recovery from a presumed non-thyroidal illness or thyroiditis. Commonly a suppressed TSH is found in people on a slightly excessive dose of thyroxine and the doctor will adjust the replacement dosage (see Chapter 7). In the remainder it may be due to early evidence of Graves' disease or a nodular goitre, which can sometimes be diagnosed following an isotope scan. In addition to the risk of progression to more clinically obvious hyperthyroidism, there may be a risk of heart complications such as an irregularity of the heart beat (atrial fibrillation) or reduced bone density (osteopenia or osteoporosis). No consensus exists between specialists regarding the treatment of subclinical hyperthyroidism but any potential benefits of therapy must be weighed against the potential disadvantages of treatment. If no treatment is considered necessary, regular follow-up is required to ensure that the thyroid hormone levels do not rise to levels requiring treatment for hyperthyroidism.

Iodine-containing substances

Contrast substances ('dyes') used in special X-ray procedures, such as CT or MRI scans and some 'health' foods, such as kelp extract, which is obtained from seaweed, contain a lot of iodine which may induce thyroid overactivity in susceptible individuals.

In some instances the thyroid overactivity remits if the increased intake of iodine is stopped and until this happens a beta-blocker can be used to control any symptoms. Occasionally the hyperthyroidism persists and the condition is treated in the same way as Graves' disease or a toxic multinodular goitre.

Drug-induced hyperthyroidism

Amiodarone, which is a drug useful for controlling certain irregular heart rhythms, may disturb thyroid function. It contains 75 milligrams of iodine per 200 milligram tablet (up to 200 times the normal daily iodine requirement) and is frequently associated with thyroid dysfunction. Amiodarone-induced hyperthyroidism occurs in two forms. One is an iodine-associated form often found in those with a history or current evidence of thyroid disease, which can be prolonged. The second form is a thyroiditis-associated hyperthyroidism which is usually temporary, lasting up to 2–3 months. Many people have few symptoms and are identified following a routine blood test by their doctor as is recommended every 6 months for those on amiodarone. Their hyperthyroidism is usually mild and any symptoms may be overshadowed by those of their heart condition or masked by drugs for that condition such as beta-blockers. It

may be difficult to distinguish between the two forms and usually people are initially treated with anti-thyroid drugs such as carbimazole as radio-iodine cannot be used. Most improve with therapy and those with a thyroiditis are likely to improve without any specific therapy. Amiodarone has a long life within the body (up to 6–9 months) so stopping the drug will make no immediate difference. In any case, people may be advised to continue amiodarone as there may be no alternative effective heart drug available. Occasionally, in more persistent cases, corticosteroids and other treatments such as radio-iodine or even thyroidectomy are considered. Amiodarone can also cause thyroid hormone deficiency (see Chapter 7).

Other iodine-containing medications such as cough medicines can cause hyperthyroidism and hypothyroidism. Lithium, which is a treatment used for manic depression or other depressive disorders, can also cause either hyper- or hypothyroidism.

Pregnancy and gestational thyrotoxicosis (hyperemesis gravidarum)

These are discussed in Chapter 13.

Tumours causing thyroid overactivity

These conditions are extremely rare but thyroid overactivity may occur in association with a number of different types of cancer. Treatments are directed at the primary underlying cancer.

Cancer of the thyroid gland

In very rare cases, thyroid cancer which has spread to other parts of the body may cause hyperthyroidism. The presence of these overactive cells can be shown by a whole body radio-iodine scan and they can then be killed off with radio-iodine treatment (see Chapter 12).

Tumour of the pituitary gland

A pituitary gland tumour which secretes excess TSH will stimulate the thyroid gland to increase activity. The blood test will show a normal or high TSH level instead of being suppressed, as with the usual causes of thyroid overactivity such as Graves' disease. In both circumstances high thyroid hormone levels will be found (see Chapter 15).

Tumour of the ovary

Rarely an ovarian tumour can contain thyroid-like tissue which may secrete excess T_4 and/or T_3. An isotope scan of the thyroid will show little or no uptake whereas a scan of the offending ovary will show a high uptake.

Tumour of the testis or ovary

A hormone called human chorionic gonadotrophin (hCG) which stimulates the thyroid gland can be produced by both the testis and ovary. An isotope scan shows increased uptake within the thyroid gland, but usually the underlying tumour in the testis or the ovary will already have produced local symptoms of which the person and their doctor need to be aware.

❓ Questions and answers

Q.1 What exactly is a solitary 'hot' nodule?

A. It is a cluster of cells that have taken over the function of the rest of your thyroid gland. These cells are now producing too much thyroid hormone, which is why you feel as you do.

Q.2 Does having a hot nodule mean that I have cancer in my thyroid?

A. Almost certainly not, and we would expect it to disappear after treatment with radio-iodine or surgery.

Q.3 I've been taking 300 micrograms of thyroxine ever since my thyroid operation 30 years ago. Are you telling me to stop after all this time?

A. 300 micrograms is a large dose and you probably don't need so much. We know that because your TSH level is suppressed and the free thyroxine level in your blood is way above normal. You may be used to this and feel all right but this is not good for your heart or for your bones, which may be getting thinner now anyway since you have passed the menopause. I suggest that you slowly reduce the dose to 250 micrograms of thyroxine daily over several weeks and see how you feel when we repeat the tests after 6 weeks on the lower dose.

Q.4 But I thought that iodine was good for you. That's why I'm taking kelp and a lot of my friends get it from the health food shop too. Can kelp cause a goitre?

A. Iodine in the right quantities is essential for everyone but in excessive amounts it can cause your thyroid to become overactive and to become enlarged.

Q.5 Will my thyroid stop being overactive when I stop taking kelp?

A. It might or it might not. We shall have to wait and see but you can take a beta-blocker in the meantime to control some of the symptoms of overactivity. If the thyrotoxicosis does not disappear then we can still treat it.

Q.6 You say that I have an enlarged thyroid which is overactive and contains many nodules. The swelling is unsightly and I think it is getting bigger. What can you do about it?

A. Radio-iodine will stop the gland being overactive and in a year's time your multinodular goitre will have reduced in size too. Surgery is an alternative if preferred or if the gland is very big.

Q.7 You tell me that the amiodarone I was given for my heart condition has caused me to become thyrotoxic. Why can't I simply stop the amiodarone?

A. If there were a suitable alternative effective heart drug available we would stop the amiodarone but your cardiologist advises that there isn't a better alternative to control your heart rhythm. We must treat your thyrotoxicosis appropriately in any case because it takes several months for the amiodarone to clear the body completely even if it were possible to stop it today.

7

Underactivity of the thyroid and its causes in adults

Causes

There are many causes of thyroid deficiency in the adult (see Chapter 14 for children and adolescents). Worldwide, the most common cause is probably lack of dietary iodine (p. 101). Deficiency of this essential element prevents the thyroid cells from obtaining enough raw material to make sufficient thyroid hormones and is usually associated with the development of a sizeable goitre.

Autoimmunity is the most common cause of hypothyroidism in the developed world (see Chapter 8). A significant number of people develop hypothyroidism within 2–3 months after radio-iodine therapy (p. 43) or surgery (p. 46) for the correction of thyroid overactivity. This thyroid deficiency may be transient but is likely to become permanent and the incidence increases as the years pass.

Other less common causes of thyroid underactivity, which in some cases may only be transient or resolve when the cause is removed, include the following.

1. Anti-thyroid drugs such as methimazole or carbimazole, if given in too large a dose over too long a period of time, will induce thyroid hormone deficiency by impeding the manufacture of thyroid hormones by the thyroid cells. People who have been previously treated for Graves' disease by anti-thyroid drugs also have a risk of developing hypothyroidism many years later.

2. Temporary underactivity of the gland caused by silent thyroiditis. This is caused by release of auto-antibodies against the thyroid and is said to occur in about 1 in 10 women after childbirth (Chapter 13). It may also occur transiently after viral thyroiditis (see Chapter 9).

3. Thyroid failure may result from external radiotherapy treatment to the neck for tumours such as lymphomas or follow a combination of surgery and radiotherapy for cancer of the larynx.

4. Over-the-counter medicines, particularly for coughs, may contain iodides and in some people their prolonged usage causes underactivity of the thyroid.

5. Other medicines prescribed by doctors may interfere with the function of the thyroid gland. Lithium, which is used for certain psychiatric disorders is one such, and amiodarone used for stopping irregularity of the heart is another.

6. Certain foods, such as cabbage, and other green vegetables such as kale (notably in Tasmania) and seaweed (particularly in Japan), have an anti-thyroid effect. However, the concentrations of these anti-thyroid substances in food and drinking water are too low to induce hypothyroidism if dietary iodine intake is sufficient.

7. A rare congenital abnormality in the chain of chemical processes in the thyroid gland which prevents it making T4 and T3 properly (see p. 103).

8. Sometimes thyroid failure occurs secondary to disorders that stop the pituitary gland from secreting the thyroid-stimulating hormone (TSH). Usually other hormones normally formed by the pituitary are also deficient in pituitary failure or hypopituitarism. A major finding in this situation is a low or absent level of TSH in the blood compared with the raised level found when the problem is confined solely to the thyroid gland.

What happens if the thyroid gland is underactive?

Hypothyroidism is the name given to the clinical condition that develops when there is inadequate secretion of thyroxine (T4) and to a lesser extent triiodothyronine (T3). Irrespective of the cause of the thyroid underactivity the symptoms are in general the same and their severity depends upon the degree of thyroid failure and its duration. Myxoedema is the word used to describe untreated hypothyroidism of advanced degree and long standing, and was originally used to describe the thickened, cold skin often found in this state.

Table 7.1 The grading of thyroid failure

Grade	Symptoms of hypothyroidism	Free T$_4$	Free T$_3$	TSH
Subclinical	None or non-specific	Normal	Normal	Slightly raised
Mild	None or mild	Slightly low	Normal	Raised
Overt	Mild or marked	Low	Normal or low	Very raised

Hypothyroidism should be looked upon as a graded condition ranging from a slight impairment of thyroid function, as shown by a rise in the TSH level and few if any symptoms (mild thyroid failure or subclinical hypothyroidism), progressing through a greater reduction of thyroid hormones with more likelihood of symptoms, to complete thyroid failure which makes people feel very ill and is often obvious to a doctor and associated with very abnormal laboratory tests (Table 7.1).

In most instances thyroid underactivity, particularly in Hashimoto's thyroiditis, creeps up on a person. The changes are so imperceptibly slow in their development that for some time they are not recognized by the person or those closest to them.

Overt hypothyroidism in the adult

The first thing that may be noticed is tiredness, which becomes progressively worse. People feel run down and sluggish. They may feel the cold more, wear thicker clothes, and want more domestic heating later in the spring or earlier in the autumn than those around them.

Women may notice that their periods become heavier and last longer. People may gain some weight but seldom more than a few kilograms. Skin becomes drier and thicker, and scalp hair may come out more than it used to. Eyebrows may become sparse, classically described as affecting predominantly the outer third, and the hair on forearms becomes short and stubbly. The hands can become podgy and the voice deeper in pitch. Hearing can become dulled, unbeknown to the affected person. Constipation is common (Fig. 7.1). Aches and cramps in the muscles are also common, and people may experience pins and needles in their fingers and hands during the night or on waking in the morning. This is caused by trapping of a nerve at the wrist (carpal tunnel syndrome), which is a condition that may improve when the thyroid deficiency is corrected.

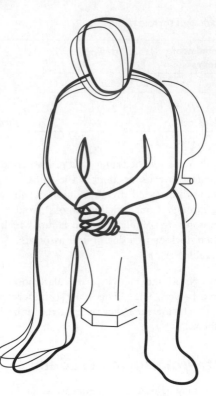

Figure 7.1 A representation of a person with thyroid deficiency (hypothyroidism). The hypothyroid person is slowed down, physically and mentally, and is likely to be constipated as implied in this drawing. Compare with the hyperthyroid person shown in Fig. 4.2.

The older person with thyroid deficiency may experience a tight constricting pain across the chest when walking fast or up an incline, which causes the person to rest for a while until the tightness wears off. This is called angina pectoris and is due to narrowing of the coronary arteries that carry blood to the heart. Similarly, if the arteries to the legs are narrowed, people may experience pain in one or other calf when they walk (intermittent claudication) and this will also cause the person to stop until the pain wears off.

In advanced cases of hypothyroidism the person feels unsteady on their feet and, once they have fallen, may be reluctant to venture out of the house alone. Words are less clearly articulated so that speech is slowed and slurred. People with mild hypothyroidism, and even more so those with severe hypothyroidism,

may become mentally disturbed, becoming depressed or anxious. These problems will improve gradually as the thyroid deficiency is corrected. In extreme cases when the metabolism is very slowed, some people may become unconscious, particularly during cold weather; this condition is known as myxoedema coma. This is most likely to happen in older women who live alone and are not visited by friends or relatives. Myxoedema coma is very rare nowadays but it is a serious condition which may end fatally unless treated promptly in hospital.

Mild hypothyroidism

If only a minor degree of thyroid deficiency is found, symptoms will be more vague. Tiredness for which there is no obvious physical or emotional reason, lack of energy, intolerance of cold, dryness of the skin, constipation, heavy periods in women, and a feeling of bloatedness may all occur.

What the doctor finds

Depending on the degree of thyroid deficiency and its duration, the changes in the person may or may not be obvious to a doctor. If the underactivity is marked and the doctor knows the person well but has not seen them for several months, he/she may immediately suspect the diagnosis. The doctor may find a puffy face (especially the eyelids) and hands, cool and dry palms, a yellow tinge to the skin although the cheeks may remain surprisingly pink, and swelling of the ankles. A comparison of a person's present appearance with an earlier photograph may be helpful in suggesting a diagnosis of hypothyroidism. Pictures taken before and after replacement treatment with thyroxine are often a witness to the striking therapeutic response (Fig. 7.2).

Movements, speech, and thought may be slowed. The heart rate may be slow and the blood pressure is occasionally elevated. The speed of the tendon reflexes, such as when the tendon just below the kneecap is tapped with a hammer, is influenced by the level of thyroid hormones. In practice the ankle reflex, and in particular the slow relaxation after contraction as judged by tapping on the Achilles tendon at the back of the heel, is the one tested. Rarely, fluid collects in the abdomen, the chest, or the membrane surrounding the heart (the pericardium) so that the person becomes short of breath. An electrical recording of the heart (an electrocardiogram or ECG) will show characteristic changes.

If the cause of hypothyroidism is Hashimoto's disease, the thyroid gland may be slightly enlarged, normal in size, or so destroyed that a doctor is unable to feel it. If the gland can be felt, it will be harder than normal. Sometimes nodules, which are usually small areas of normal tissue that have escaped the

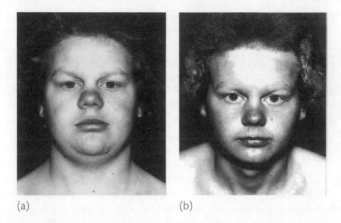

(a) (b)

Figure 7.2 A 17-year-old carpenter with myxoedema (severe hypothyroidism): (a) before treatment; (b) after treatment with thyroxine for 18 months.

autoimmune inflammatory attack, but are insufficient in amount to sustain normal thyroid function, or hard fibrous tissue, are found in a person with Hashimoto's disease.

Psychological problems in hypothyroidism

The association between hypothyroidism and clinical depression has been recognized for many years. Many people with thyroid deficiency feel 'low'. They find life unenjoyable, they worry and they are gloomy. At night they do not sleep well, waking up soon after they get to sleep. They feel exhausted in the morning and do not want to get up. They just feel tired and 'awful'. This clinical depression often remits when the hypothyroidism is corrected but may persist in some patients for several months, despite the correct replacement dosage of thyroxine.

The depression is due to a disturbance in the chemicals called neurotransmitters which regulate the cells in the brain. Persistent depression after correction of thyroid deficiency is quite common and is a cause for people being dissatisfied with their response to thyroxine treatment. It is of course essential that the correct replacement is being given and that TSH is within the reference range. If people continue to feel generally unwell despite having received the correct amount of thyroxine, it is possible that their ill health is due to a persistent degree of clinical depression, which merits treatment in its own right.

There is currently no evidence linking emotional or psychological stress to Hashimoto's thyroiditis, most probably because of the long natural history of the

disease requiring a large part of the gland to be damaged before thyroid function is compromised. Any major stress will have occurred many years before.

Diagnosis of adult hypothyroidism

The abnormalities in the thyroid function tests depend on the severity and the duration of the deficiency (see Table 7.1). In clinically obvious hypothyroidism, the T4 level is depressed below the normal range and the TSH level is very high. In mild early cases the T4 level may still be normal and the TSH is only marginally raised. The blood cholesterol and triglyceride (fat) levels may also be raised in thyroid deficiency and usually come down in response to adequate treatment. It is recommended that people found to have a raised cholesterol level have their thyroid function checked to see if there is any evidence of undiagnosed hypothyroidism before they are treated with cholesterol-lowering drugs. The electrocardiographic changes disappear with treatment.

The doctor may look for thyroid antibodies unless it is already known that a person has Hashimoto's disease or if the cause of the thyroid deficiency is obvious because the person has been treated with radio-iodine or had thyroid surgery. The finding of antibodies raises the possibility that the person may be subject to some other autoimmune disease sooner or later (Chapter 16).

Treatment

The best treatment for thyroid deficiency is replacement therapy with thyroxine. Although man-made, medicinal thyroxine is chemically identical to the natural hormone secreted by the thyroid gland. Since it is a pure substance, the amount in each tablet made by a reputable pharmaceutical company is precise and accurate. Three strengths of tablet are widely available throughout the world: 25 micrograms (also expressed as 0.025 milligrams), 50 micrograms (0.05 milligrams), and 100 micrograms (0.1 milligrams). In some countries, such as the USA, additional strengths are also available (75, 88, 112, 125, 137, 159, 175, 200, and 300 micrograms). Thyroxine is a stable substance and the tablets have a long shelf life.

The starting or initial dose of thyroxine that is given will depend upon the following:

1. Age: elderly people are usually started on a small dose, such as 25 micrograms, so as not to upset their heart. This will certainly be necessary if there is a history of heart disease such as angina or a heart attack in the past (see below).

2. The duration of time that a person has been thyroid deficient. If the underactivity has only just occurred, as a result of a thyroid operation for example, replacement with a larger initial dose, such as 100 micrograms, is safe. If the deficiency is of longer standing the initial dose may be 50 micrograms.

The dose of thyroxine will be adjusted by the doctor according to how the person feels and the results of the laboratory tests. Adjustment of the dosage by 25–50 micrograms is unlikely to be made more often than at intervals of a month. There is a good deal of debate about what the aim should be as regards the results of laboratory tests. The recommended approach is a target of a TSH within the reference range. This strategy will prevent over-replacement and decrease possible harmful effects (see below). Some people with thyroid deficiency feel at their best when the TSH level is towards the bottom of the normal range or even a little below it. There is no evidence that having a TSH at this level improves the quality of life of an individual. The T_4 level is often above the normal range but the T_3 should be normal in those treated with thyroxine achieving a normal TSH. The total daily dose in an adult with no functioning thyroid tissue is usually 100–150 micrograms. Occasionally, the dose may need to be as low as 25 micrograms or as high as 200 micrograms or more.

Thyroxine does not work fast. A tablet taken on a Monday, for example, will induce no biologically discernible effect on the body until the following Friday. Thus the tablets need only to be taken once daily. As thyroxine absorption may be variable, it is best taken half an hour before breakfast on an empty stomach with water. People treated for thyroid deficiency do not feel miraculously better overnight. The longer someone has had thyroid deficiency the longer it will take to feel well again, sometimes as long as 6–9 months. It takes this length of time for the changes in the tissues to be reversed.

Initial problems

Elderly people, even with a small starting dose of thyroxine, may develop heart problems, such as palpitations, irregularity of the pulse, ankle swelling, or angina. A small dose of a beta-blocker, such as propranolol 10–20 milligrams twice or three times daily, will usually quell these symptoms. Some people, particularly older people with longstanding deficiency, may experience muscular aches and pains, particularly in the thighs, arms, and back, during the early phases of replacement treatment. These symptoms can be treated with simple pain-killing medication until this problem has passed.

Adjustment of the maintenance dose

Once the maintenance dose has been established it is likely to remain stable for some time. However, many factors may induce the need for a change in the regular dosage and for this reason each person on thyroxine should have an annual check-up with their doctor. TSH is now used to monitor the correct dosage of thyroxine. The timing of the blood test is not important. In some areas computerized thyroid registers have been established and have been shown to be successful in ensuring excellent automatic follow-up for those people on thyroxine replacement.

The replacement dosage of thyroxine may need adjustment from time to time for a number of reasons. For example, if someone has Hashimoto's disease, the degree of thyroid deficiency may increase over the years and necessitate an increased dose of thyroxine. In general as people become older the replacement dosage may need to be decreased. However, a number of circumstances may necessitate an increased dose. If a woman becomes pregnant the dose will almost certainly need increasing (see Chapter 13). Certain diseases of the small intestine, such as coeliac disease or protracted diarrhoea, may impair the absorption of thyroxine and call for an increased dose. A number of different medicines which may be given could impede the absorption of thyroxine (Table 7.2). It is advised that people on thyroxine replacement take their thyroxine at least 4 hours apart from these medicines.

It is sensible for a person with hypothyroidism to ask a doctor for a signed document setting forth how the thyroid deficiency came to light, the results of the tests that confirm the diagnosis, and the current replacement dosage of thyroxine. This may be useful in years to come so that in the event of a person

Table 7.2 Medicines which may impede the absorption of T4 and invoke the need for an increase in thyroxine replacement therapy

Antacids
Aluminium hydroxide (AluCap, Aludrox, Maalox, Mucogel, Algicon, Gastrocote, Gaviscon, Topal, Asilone, Actal, Actonorm)
Sucralfate (Antepsin)
Cholesterol lowering agent
Colestyramine (Questran)
Iron preparations
Ferrous sulphate (Feospan, Ferrograd, Fefol)

moving or changing doctor, the new doctor is aware of the need for continued treatment with thyroxine.

Some people with thyroid deficiency like to take too much thyroxine in the mistaken hope that it will help them lose weight and because they claim to feel 'better'. Their blood tests will show an undetectable TSH level and a T_4 level raised far above the upper normal range in the blood. There is no doubt that some people become 'addicted' to thyroxine and take doses that make them hyperthyroid. This has an adverse effect on the heart and also induces thinning of the bones (osteoporosis), with an enhanced liability for the person to break their hip or wrist, or collapse the bones in their spine.

Other treatments in hypothyroidism

Other drugs have been used for the treatment of thyroid deficiency but have little to support their use. Thyroid extract can be prepared from the dried thyroid glands of animals. An example of this is Armour, which is a preparation that contains both T4 and T3 from desiccated pig thyroid. It is advertised and can be obtained via internet websites but is not listed in the British National Formulary and is not a licensed drug in the UK. The concentration of thyroid hormones in animal extracts may not be as consistent as that of pure thyroxine. There is no evidence for favouring the prescription of animal extracts in the treatment of hypothyroidism over the prescription of thyroxine. Concern has been expressed about the peaks and troughs in T3 levels in the blood of those treated with mixed T4 and T3 preparations and the potentially harmful effects on the heart and bones. There are also concerns about the difficulties of monitoring such treatment because of the fluctuating levels of T3 (which are not encountered with treatment by thyroxine alone).

T_3 is also sometimes used but has no advantage over thyroxine except in the treatment of people with thyroid cancer being prepared for isotope scans and treatment (see Chapter 12), and in the rare situation of myxoedema coma. T_3 has a rapid and short duration of action and the tablets need to be taken three times daily. If T_3 is used, the correct dosage can be judged by measurement of the TSH levels in the same way as is used for thyroxine replacement.

The following is the story of Alison who presents with a challenging problem for doctors looking after people on thyroxine therapy.

ⓘ Patient's perspective

I am now 47 and work as a medical secretary. My thyroid failed almost immediately after I received radio-iodine treatment for Graves' disease 5 years ago. I am taking thyroxine 150 micrograms daily, which

I remember to take every morning with water half an hour before break fast. I recently attended my annual visit to my family doctor. Over the past 12 months I have become tired very easily during the day with low energy levels and I feel as if I am walking through treacle. I have had increasing difficulty with losing weight and have actually gained 3 kilograms in the last year despite eating less fat and sweet things in my diet. My family doctor could find nothing wrong when he examined me. I was told that my recent thyroid function tests were normal with both my T4 and TSH levels nicely in the middle of the normal range. I am extremely reluctant to accept these results as normal, and have just never felt right since I was put on thyroxine. I read about T3 therapy in a lay article on an internet website. One of my friends in a similar situation started taking it and is feeling much better. What should I do?

The evidence for there being any benefit to people with hypothyroidism of adding T_3 tablets orally to thyroxine replacement is intriguing but unconvincing. Various studies have rigorously looked at this specific question and no benefit has been confirmed. Large doses of triiodothyronine have been employed in human studies but any beneficial clinical responses are likely to have been due to transient relative T_3 excess. The overall conclusion from recent studies is that there is no evidence of a beneficial effect of the combination therapy compared with thyroxine therapy alone. Indeed, a detrimental effect on psychological function in those given T_3 was noted in some of the studies. Imprecise dosing with currently available T_3 preparations is undesirable in view of the risks of over- and under-dosing, causing subclinical hyperthyroidism in the first case or subclinical hypothyroidism in the second. Availability of a more physiological slow-release T_3 preparation may be possible in the future but proof of true slow release over 24 hours to enable once-daily dosing will need to be demonstrated first. To be comparable with the physiological state, a T_3 and T_4 compound should mimic the amount of T_4 and T_3 secreted by the thyroid gland. Such a compound, which is proven safe, effective, and available to use, has not yet been developed. In the era of evidence-based medicine the available studies have not shown any advantage of a combination of thyroxine and T_3. Therefore in the UK the recommended management for thyroid hormone replacement continues to be thyroxine alone.

Subclinical hypothyroidism

Subclinical hypothyroidism or mild thyroid failure is defined as a raised serum thyroid stimulating hormone (TSH) (reference or normal range of

0.40–4.5 milliunits per litre in most laboratories) but a normal level of thyroid hormone (T4) in a person usually without symptoms. The causes of subclinical hypothyroidism are the same as for overt hypothyroidism. In worldwide terms the most common cause is iodine deficiency. However, in developed countries the most common cause is chronic autoimmune thyroiditis. It is more common in women (found in 8 per cent of women of all ages including 10 per cent of women aged over 55 years and only 3 per cent of men) and becomes increasingly common with age in both sexes. It is associated with the presence of thyroid antibodies.

If the blood T_4 is normal, treatment with thyroxine to move the TSH to within the reference range may only be indicated if the TSH is greater than 10 milliunits per litre. Many doctors recommend treatment if blood TSH levels are greater than 5 milliunits per litre, particularly in the presence of positive thyroid antibody tests even if symptoms are absent, in view of the high risk of progression to hypothyroidism over the next 20 years. In women at risk of hypothyroidism, just over half will become hypothyroid in 20 years if TSH is raised and thyroid antibodies are positive; only one-third will become hypothyroid in 20 years if only TSH is raised; and only one-quarter will become hypothyroid in 20 years if thyroid antibodies are present but the TSH level is normal. Most women who have either raised TSH alone or who are thyroid-antibody positive alone develop hypothyroidism only 10–15 years later. The risk of developing severe hypothyroidism is also greater the higher the blood TSH and the stronger the concentration of thyroid antibodies. Interestingly, although subclinical hypothyroidism is rarer in men than women, men are more likely to develop obvious hypothyroidism. However, a significant number of people with subclinical hypothyroidism will not progress to overt hypothyroidism.

What are the risks of thyroxine therapy?

There is considerable evidence that poor compliance with thyroxine therapy (i.e. people not always taking their tablets) or inadequately supervised treatment which does not correct subclinical hypothyroidism (to normalize the TSH) is common. Perhaps as many as half of treated people with hypothyroidism have serum TSH levels either above or below the reference range. Thus even when hypothyroidism is diagnosed, many people do not have their dose of thyroxine appropriately adjusted to normalize the TSH.

Up to a quarter of those on thyroxine therapy may have serum TSH concentrations pushed below the reference range, i.e. TSH less than 0.4 milliunits per litre; this is called subclinical hyperthyroidism or mild thyroid hormone excess. There has been some concern that thyroxine given in 'overdose' might

promote osteoporosis (thinning of the bones) although the clinical importance of this is controversial.

There is a concern that subclinical hyperthyroidism in older people could be a risk factor for an irregular heart rhythm (atrial fibrillation), which is an important risk factor for strokes. Studies have suggested that the risk of developing atrial fibrillation is increased threefold in those with low serum TSH concentration compared with those with normal TSH concentration. In a recent study, a low serum TSH (less than 0.05 milliunits per litre) but not a raised serum TSH was associated with an increased risk of premature death and cardiovascular disease (heart attacks and strokes).

What are the risks of not treating with thyroxine?

The symptoms of abnormal thyroid function in cases of mild thyroid failure are not clearly defined. Most evidence from studies of large numbers of healthy people in the community uses symptom scores and the results are inconsistent. Certain symptoms, such as dry skin, cold intolerance, and tiredness, appear more often in people with subclinical hypothyroidism than in those with normal thyroid function. Hypothyroidism may be the answer and it is interesting to note that a quarter of the healthy population complain of symptoms that could be attributed to hypothyroidism.

There have been several careful trials of the value of thyroxine therapy on symptoms in people with subclinical hypothyroidism. Three found improvement in symptoms, although one study documented that this improvement did not extend to people with a baseline serum TSH of less than 12 milliunits per litre and two studies have reported no benefit in symptom scores. A problem with these trials is that there is often what is termed a selection bias because people with poorer quality of life are more likely to present to their doctor and have thyroid function tests performed.

The possible effect of subclinical hypothyroidism raising cholesterol levels in the blood has long been associated with a theoretical increased risk of heart disease but the actual evidence to support this is inconsistent. There is a small rise in cholesterol but the improvement seen with thyroxine treatment is small and again probably limited to those with a TSH greater than 10 milliunits per litre. It is not known whether thyroxine therapy in subclinical hypothyroidism may reduce the risk of heart disease. The only studies available have either shown no effect, or even a protective effect, of subclinical hypothyroidism on death from heart disease in people followed for a long time in the community.

There is some recent evidence that subclinical hypothyroidism may be associated with an increased risk of miscarriage. Subclinical hypothyroidism present

during early pregnancy may be associated with a small reduction in intellectual performance demonstrated in children born to mothers with poorly treated hypothyroidism, although this is based on a relatively small number of cases (see Chapter 13).

Should subclinical hypothyroidism be treated?

If, after testing thyroid function, a high TSH and a low T4 is found, the person has overt hypothyroidism and should be treated with thyroxine. If the T4 is normal and the TSH is greater than 10 milliunits per litre, treatment with thyroxine is usually justified. If the TSH is mildly elevated (5–10 milliunits per litre), the thyroid antibody status should be established. If the person has thyroid antibodies, a yearly check of TSH is recommended, with commencement of thyroxine once the TSH rises above 10 milliunits per litre. If the person does not have thyroid antibodies, ensuring a check of TSH every 3–5 years may be all that is required. There is very limited evidence of benefit to support the treatment of subclinical hypothyroidism at TSH levels of 5–10 milliunits per litre in terms of symptoms, cholesterol levels, and risk of heart disease. Most people with borderline elevated TSH levels will not progress to clear thyroid failure in 20 years. Therefore adopting a 'wait and see' policy may avoid unnecessary treatment or the potential for harm. The alternative is a 'nipping in the bud' strategy and starting thyroxine in the expectation that the person has a high risk of developing more overt thyroid failure with time. In practice, if a person has symptoms that may be associated with those of thyroid underactivity, they are sometimes offered a 3-month trial of thyroxine therapy to see whether they perceive any benefit.

It is recommended that women in whom subclinical hypothyroidism is discovered preconception or during pregnancy are treated with thyroxine regardless of whether or not symptoms are present (see Chapter 13).

❓ Questions and answers

Q.1 I've taken the thyroxine tablets you prescribed for me 6 weeks ago. Why am I not feeling any better?

A. It is early days and you have only been on a small dose of thyroxine so far. It has taken many months, if not years, for you to develop thyroid underactivity and it may be a few months before you feel back to normal. In the meantime your dose of thyroxine will be increased stepwise until the tests show that your thyroid hormone

levels and TSH are normal, but it will take longer for your body tissues to recover completely.

Q.2 My period was very heavy again last month. Is this going to get better?

A. Almost certainly. It may take a few months for everything to return to normal. If your heavy periods persist 6 months after your hypothyroidism has been corrected, it may be wise to seek a gynae-cology opinion to make sure that you have no other problem such as a fibroid.

Q.3 Does it matter when I take my thyroxine tablets?

A. No, you can take them at any time of day provided that you always remember to take them, because their effect lasts over 24 hours. Most people are less likely to forget if they take them first thing in the morning when they brush their teeth.

Q.4 The tablets I got from the chemist this month are different from the previous ones that I had. The old ones were labelled 0.1 milligram but the new ones are 100 micrograms. I feel all right but has the chemist made a mistake?

A. No. 0.1 milligram is the same as 100 micrograms. Several different reputable manufacturers make thyroxine tablets and they are not all of the same size or strength. All thyroxine tablets are small, and it is not easy to distinguish 25 from 50 or even 100 micrograms by size alone. It is wise to check that you are taking the correct strength for you from the label on the bottle.

Q.5 If triiodothyronine (T_3) is the active ingredient of the thyroid hormones why am I not being given T_3 instead of thyroxine (T_4)?

A. The body converts thyroxine (T_4) to triiodothyronine (T_3) in appropriate amounts in different tissues so there is no advantage in taking T_3, which is short-acting and has to be taken three times a day, instead of once-daily thyroxine. If T_3 is taken, with or without T_4, the levels of T_3 rise and fall quickly over 3 or 4 hours and the T_4 level drops temporarily, but there is little change in T_4 levels 24 hours after taking one T_3 tablet in the morning.

Q.6 My friend has told me about a preparation of natural thyroid hormone extracted from pigs, called Armour, which she swears is much better than thyroxine for hypothyroidism. Can I change to Armour instead of thyroxine?

A. Over 100 years ago Dr. Murray in Newcastle upon Tyne discovered the treatment for hypothyroidism by straining a sheep's thyroid through a handkerchief and giving the extract to a patient with great benefit, so there is no question that animal extracts work. For the next 50 years or so extracts of animal thyroid were all that was available but they were crude and the concentration of thyroid hormones varied, unlike modern synthetic thyroxine which has exactly the same structure as human thyroxine and is supplied in precise concentrations. As your thyroid hormone levels and TSH are in the normal range I would not recommend any change to your present treatment.

Q.7 Have I got to take these thyroxine tablets for the rest of my life?

A. Yes, for the rest of your life as they are essential for your well-being. They won't cost you anything in the UK National Health Service because medicines for thyroxine deficiency are dispensed free of charge. You can obtain an exemption certificate signed by your family doctor to show the chemist. It also means that all your other prescriptions are free.

8

Hashimoto's thyroiditis

Hashimoto's thyroiditis (also known as chronic lymphocytic or autoimmune thyroiditis) is an important and common disease. It is named after the Japanese surgeon who first described it in 1912, but the condition was not properly understood until British doctors discovered thyroid auto-antibodies in 1956. This term is now commonly used to describe the presence of thyroid antibodies in the blood, with or without a goitre.

1. Hashimoto's thyroiditis affects about 1 in 10 women aged 30 years or over.

2. It is an important cause of goitre, especially in women, but may also affect young girls and adolescents.

3. It affects women 10 times more often than men.

4. It is an important cause of thyroid underactivity (hypothyroidism). In many parts of the developed world it is the most common cause of thyroid deficiency, although lack of iodine is the most common cause worldwide.

5. Over the years a goitre caused by Hashimoto's thyroiditis may disappear and the thyroid gland may be replaced by fibrous tissue (atrophic hypo-thyroidism).

Cause of Hashimoto's thyroiditis

As explained in Chapter 2, Hashimoto's thyroiditis is an autoimmune disorder caused by the presence of certain antibodies which react with the cells of the thyroid gland. Why these antibodies arise is not understood but they develop more commonly in people with a particular genetic make-up and there is

often a history of thyroid disease or other autoimmune disease in the person's immediate family or distant relatives (see Chapter 16). The thyroid peroxidase (TPO) (previously called microsomal) and thyroglobulin antibodies which appear in the blood and are formed by certain white blood cells called lymphocytes invade the thyroid gland and slowly destroy the thyroid cells.

Course of Hashimoto's thyroiditis

The course of the disease is protracted over many years and during this time may wax and wane in its destructive effect on the thyroid gland. At any stage the progression of the disease may appear to be arrested and to lie dormant. If a person develops Hashimoto's thyroiditis, they may become aware of it and seek medical advice at many different stages along the road. For example, the development of a small goitre, usually painless but sometimes associated with mild discomfort, may be the first manifestation of the disease. The goitre often feels rubbery and slightly knobbly. Alternatively, and perhaps more commonly, the person may only be aware that something is wrong much later in the course of the condition when they become thyroid hormone deficient.

A small proportion of people with Hashimoto's thyroiditis experience mild symptoms of thyroid overactivity for a few weeks or months, usually early in the course of the disease. This is called 'Hashitoxicosis'. People with this rare variant experience the symptoms and signs of Graves' disease including some of the eye changes of that condition (Chapter 4). Hashitoxicosis is due to thyroid-stimulating antibodies enhancing thyroid activity but the hyperthyroidism seldom lasts long because eventually the thyroid-destructive antibodies become more dominant.

What do people feel?

In the early stages of Hashimoto's thyroiditis people feel perfectly well but they or their family may notice the appearance of a small painless goitre. A slight discomfort or being conscious of a swelling in the neck is experienced, which might persist. Later in the course of the disease, as the thyroid gland functions less adequately, the symptoms of thyroid deficiency develop (Chapter 7) but these may be wrongly attributed to the menopause or simply growing older.

In the rare situation where people have a temporary period of Hashitoxicosis, they feel ill, lose weight, have pounding of the heart, feel overheated, and are intolerant of hot weather. There may be looseness of the bowels and their eyes may develop a staring appearance. Indeed, there may be any or all of the symptoms and signs of Graves' disease (see Chapters 4 and 5).

How is the diagnosis confirmed?

Essentially the diagnosis of Hashimoto's thyroiditis is based on finding thyroid peroxidase (TPO) antibodies in the blood. The level of these often increases as the disease progresses. In the later stages, if the thyroid gland is destroyed and becomes atrophic, no thyroid tissue will be left and the level of these autoantibodies may fall to low or undetectable levels. Thyroxine therapy to correct thyroid hormone deficiency may also reduce the level of autoantibodies with time.

The function of the thyroid gland has to be monitored at intervals throughout the long course of Hashimoto's thyroiditis despite the person experiencing few, if any, symptoms beyond having a small goitre. Although treatment with thyroxine may or may not prevent the goitre becoming larger or reduce its size, this therapy only becomes essential when TSH begins to rise and T_4 begins to fall, indicating failure of the thyroid gland.

There has been debate as to whether treatment with thyroxine should be started before obvious overt hypothyroidism has appeared, when only TSH is raised and T_4 is normal (see Table 7.1). Some doctors advocate starting treatment with thyroxine when there is evidence of impending thyroid failure (shown by a normal T_4 level together with an unquestionably raised TSH and the presence of thyroid autoantibodies) because about 5 per cent of such women develop a low T_4 each year. Others adopt a 'wait and see' policy rather than intervene to avoid unnecessary treatment (see section on subclinical hypothyroidism in Chapter 7). However, it is important to make a diagnosis so that a plan for appropriate follow-up is made and that doctors are aware of the potential to develop other autoimmune diseases.

Treatment

At present, there is no safe and reliable way of modifying the faulty immunological system which mistakenly believes that the person's own thyroid cells are 'foreign'. However, although the basic cause is untreatable, symptoms can be totally alleviated.

In general the treatment is replacement therapy for the thyroid failure. The essential step is the prevention of hypothyroidism when this is imminent or the correction of hypothyroidism when it has developed. The best treatment is replacement therapy with thyroxine (see Chapter 7).

Very rarely surgery is required, particularly if there is any possibility that the goitre is due to cancer and not to Hashimoto's disease. This difficulty may arise when the thyroid gland feels very hard or is enlarged unevenly, but usually a

fine-needle aspiration biopsy will resolve this diagnostic problem. Surgery is also advisable if people develop hoarseness of the voice, symptoms due to compression of the windpipe, or very rarely if the goitre remains cosmetically unsightly despite treatment with thyroxine.

If people have a temporary phase of Hashitoxicosis, a beta-blocker and/or anti-thyroid medication, such as carbimazole or methimazole, may be given for a short time (p. 40). If the gland becomes uncomfortably painful, a short course of corticosteroids may be used, as in subacute viral thyroiditis (see Chapter 9).

The following account describes the clinical course of a woman called Angela along the road of Hashimoto's disease.

ⓘ Patient's perspective

I'm now 60 and feel perfectly well. I take two thyroxine tablets every day, one of 100 micrograms strength and one of 50 micrograms strength. When I was aged about 17, my mother noticed that my thyroid gland was a bit big. She knew about the thyroid gland because my auntie, her sister, had Graves' disease. Over the next few years my goitre became more obvious. Our family doctor said my thyroid gland felt rubbery and fleshy, and I hadn't got Graves' disease. He sent me to the hospital where they found antibodies in my blood but told me that my thyroid was working normally. I felt perfectly well and the goitre didn't bother me.

At the age of 28 the goitre had become smaller but for the first time I had some discomfort in the front of my neck; it wasn't much although on a few occasions it hurt to swallow. Our doctor said that my thyroid felt firmer and was slightly tender when he pressed it.

At the age of 48 I began to feel tired. I thought it was the 'change' and having to look after my two teenage daughters. My periods were a bit heavier and I had to push myself to do the housework and the shopping. Eventually I went back to the doctor. He did some tests and said my thyroid was having difficulty making hormone because my TSH was up and the thyroid hormone was down. Our GP said that he couldn't feel my thyroid anymore and that I was hypothyroid. That's when he started me on thyroxine. My periods came back to normal and I didn't have the 'change' until I was 54.

Few people with Hashimoto's thyroiditis will be aware of all these different stages and not many doctors will be in the same practice long enough to follow an individual patient over the 30–40 years involved.

❓ Questions and answers

Q.1 What do you mean when you say I have an autoimmune disease?

A. Certain defensive cells in your body that 'fight' diseases, particularly infectious diseases, have mistakenly decided that your thyroid cells are not yours—they are 'foreign' enemy cells. Hence the defensive white blood cells are producing antibodies and these are quietly destroying your thyroid gland.

Q.2 I don't understand why I've got an underactive thyroid gland when my aunt says she had an overactive one.

A. Both you and your aunt have related autoimmune diseases. In her case her 'soldiers', which we call antibodies, stimulated her thyroid gland, whereas your antibodies are killing off your thyroid cells.

Q.3 Will the swelling in my neck get smaller with treatment?

A. Not necessarily, but it may if you take your tablets regularly and go on taking them.

Q.4 Ought I to have my children tested to see if they are going to get an autoimmune disease?

A. At the ages of 5 and 3 they are too young. They may possibly develop an autoimmune disease later in life, but it is too early to tell. In other words, the tests might be negative now, only to become positive later in life. It's unlikely that they will, but the best thing to do is to wait. If either of them develops a goitre then obviously tests must be done.

9

Subacute viral thyroiditis

This condition, also known as de Quervain's thyroiditis after the Swiss physician who first described it, is not uncommon. For every 10 people with Graves' disease, a thyroid specialist may see only one with viral thyroiditis. Because viral thyroiditis runs a self-limiting course, people with a mild illness may never seek medical advice and there can be no doubt that even in those with a more severe illness the correct diagnosis is often overlooked.

The condition occurs more commonly in women than in men. The inflammation of the thyroid is caused by one of several viruses. The most common is perhaps the Coxsackie virus (first isolated in a small township of that name in New York State) but the mumps virus and others may be the cause. Attempts are seldom made to identify the causative virus because this is difficult, it does not alter treatment, and there are no effective drugs against the viruses associated with this condition.

What is subacute viral thyroiditis like?

The disease varies from very mild to quite severe. Sir Richard Bayliss once had mild de Quervain's thyroiditis himself. Here he describes what happened.

🛈 Patient's perspective

One summer's day, when I was aged 45, I felt exceptionally and inexplicably tired. I just felt rotten. I went to bed immediately after supper and, feeling hot, I took my temperature. I had a slight fever of 37.7°C (99°F). I slept all right but next morning woke with a generalized headache and ached all over. My temperature was only marginally raised so I went to work. Again, I went to bed early and the headache was bad enough for me to take aspirin. I reckoned I'd got 'flu. The next few days were much the same. After a week of coming home early and going to bed, my wife reminded me that a professor of endocrinology from out of town was coming to dine with us. He was an

old friend so I came down to supper in my dressing gown, and told him I was getting over a brief attack of 'flu.

After dinner my professor friend asked, 'Are you sure you haven't got viral thyroiditis?'

'I shouldn't think so,' I said. 'Why do you ask?'

'Because you've been gently massaging your neck all evening as though it hurt and your thyroid is a bit enlarged.'

'Well, now you mention it, it does hurt.' I prodded my thyroid gland. 'Yes, it's quite tender and it hurts a bit when I swallow too. What's more I get stabs of pain that run up the side of my neck to just under my ears.'

The next day I was worse and asked our family doctor, who lives close by and was a good friend, to look in. He took my history and examined me from top to toe. (I did not mention thyroiditis because doctors who make a self-diagnosis can also make fools of themselves!) The GP looked puzzled. 'I'll drop in again early tomorrow', he said, 'and take some blood off you'.

Next morning he said, 'Would you think I'm mad if I said I thought you'd got subacute viral thyroiditis? I've read the chapter you wrote about de Quervain's disease in that textbook of medicine you contribute to. It seems to me you're a classic mild case. I want to see if your thyroxine level is up and whether your ESR is raised.' (The ESR, or erythrocyte sedimentation rate, is a non-specific test, which, if raised, usually indicates that you have some type of infection.)

He was right but there was more to come. I suddenly felt my heart pounding away at 92 beats per minute even when I was resting in bed. I was sweaty and irritable. I ate well enough but lost 4 pounds (1.8 kilograms) in the second week and rather less in the next. My hands became shaky when holding a teacup. It took me about a month to get over it, and all I took was some aspirin.

The illness usually starts with a generalized 'flu-like illness with tiredness, muscular aches and pains, a mild headache, and a slight fever. After a few days the thyroid gland becomes slightly but uniformly enlarged, painful, and tender to the touch. Swallowing hurts, and characteristically stabs of pain run up the front of the neck to the ear on one or both sides.

Because the gland is inflamed by the virus, the preformed thyroid hormones leach out into the bloodstream and the levels of thyroid hormones rise. This induces symptoms of hyperthyroidism and people may become mildly thyrotoxic as clearly described by Sir Richard.

People may go to the doctor complaining of a sore throat. Unless it is clear that the soreness is in the front of the neck, the doctor may mistakenly focus attention on the pharynx at the back of the mouth and find that the tonsillar area is normal or slightly pinker than normal. Unless it is recognized that it is the thyroid gland that is sore, the diagnosis may well be missed.

Most people with subacute viral thyroiditis recover in 3–6 weeks and a stoical patient may ignore the symptoms altogether. If the attack is more severe people can be ill for much longer, with symptoms that wax and wane, and feel generally ill for some time. A sufferer may also go through an underactive (hypothyroid) phase before the gland recovers spontaneously.

How is the diagnosis confirmed?

Provided that the diagnosis is suspected from the history and what the doctor finds, it can easily be confirmed. During the acute inflammatory phase the blood levels of T_4 and T_3 are raised and because of the feedback mechanism the TSH is suppressed. Usually the ESR or another marker of inflammation, the C-reactive protein (CRP), is quite considerably raised. The sure way of distinguishing this from other causes of thyrotoxicosis is to do a radio-isotope scan.

Sometimes it is necessary to distinguish subacute viral thyroiditis from the early stages of Hashimoto's thyroiditis or Graves' disease. In Hashimoto's disease there are high levels of thyroid auto-antibodies. In Graves' disease the gland is rarely tender and the uptake of radio-isotope is increased, not reduced as in viral thyroiditis. The other main cause of a suddenly painful thyroid gland is a bleed into a cyst or nodule, which can usually be identified on an ultrasound scan (see Chapter 11).

Treatment

In mild episodes of de Quervain's thyroiditis treatment with aspirin, paracetamol, or a non-steroidal anti-inflammatory drug, such as ibuprofen, is all that may be required to relieve the neck discomfort. If the symptoms of thyrotoxicosis are troublesome, treatment with a beta-blocker is usually adequate to control them. If the discomfort in the neck is not controlled by simple analgesics, steroids such as prednisolone (cortisone-like drugs) reduce the inflammation in the thyroid gland. A fairly large dose (30–40 milligrams daily) will be used at least for the first week and this is gradually reduced over the next 3–6 weeks. Some people experience a relapse and the course of steroids has to be repeated.

It is unusual for the thyroid gland to be damaged permanently, although after the acute phase temporary thyroid deficiency may result. This rarely requires treatment because the gland usually recovers quickly but if it persists thyroxine replacement may be commenced. Thyroxine can be stopped a few months later to see if the thyroid function has recovered, in which case the thyroid tests will remain normal.

❓ Questions and answers

Q.1 The two lots of tablets you gave me last week have helped, doctor. I'm in much less of a state and my heart is not banging around, but my neck still hurts a lot. In fact it's more painful than it was and swallowing hurts. Is there anything you can do?

A. The propranolol (a beta-blocker) that I gave you is obviously helping. That is why your heart is quieter and you're not so het up. But I'm afraid the paracetamol (acetaminophen) is not strong enough to relieve your pain. I'll have to give you some prednisolone (a steroid) for a month or 6 weeks.

Q.2 Is this form of thyroiditis going to cause permanent damage?

A. Almost certainly not. Most people get over subacute thyroiditis without permanent damage. You may temporarily go through an underactive (hypothyroid) phase after all the stored thyroid hormones have been discharged during the acutely active toxic phase. This can be corrected with thyroxine, which can be stopped after a few months to see if your thyroid has regained its normal function in which case the thyroid function tests will remain normal off treatment.

Q.3 Can you tell me why I have got this disease?

A. Not really. It is caused by one of a number of viruses, but we do not know which one and there is no point in trying to find out because there is no effective treatment against the viruses that cause subacute viral thyroiditis.

Q.4 My husband or the children won't catch this disease from me, will they?

A. We have never heard of a member of the family catching it from another, but Sir Richard Bayliss knew of a family where one of the children got mumps and a month later the mother got subacute viral thyroiditis.

10

Simple non-toxic goitre

'Simple non-toxic goitre' is a time-honoured clinical description of a particular type of goitre. However, the term is not ideal. It does not indicate the cause of the condition nor, at its face value, is 'simple' appropriate.

Simple

In this context the word 'simple' implies several things: that the gland is not nodular but diffusely and uniformly enlarged, that it is not hard, that it is not cancerous, and that there are seldom complications.

Non-toxic

This means that a person with a simple non-toxic goitre has no evidence, either clinically or on laboratory testing, of hyperthyroidism. This distinguishes a simple non-toxic goitre from a diffuse goitre caused by Graves' disease (see Chapter 4). Nor is there underactivity of the thyroid gland caused by an autoimmune process such as occurs in Hashimoto's thyroiditis (see Chapter 7).

Goitre

'Goitre' simply means enlargement of the thyroid gland. A goitre can be discovered when people are looking at their neck in the mirror, for example while buttoning the collar of their blouse or shirt, or noticed by friends or relatives, or following an examination by a doctor.

The size of the normal thyroid gland varies in different parts of the world, being larger in areas where there is iodine deficiency. In the developed world, the thyroid gland may be just visible in a young woman with a long thin neck if she holds her chin up, but in most people the gland is invisible. An

obvious goitre will be visible and the gland feels larger than normal. The most accurate way of defining the size of a goitre is by an ultrasound scan. The two lobes of a thyroid gland may vary in their dimensions but, using ultrasound, a normal gland can be shown to have a total volume no greater than 20 cubic centimetres.

Some enlargement of the thyroid gland, whether due to a simple non-toxic goitre or other causes, is quite common. In a survey done in the northeast of England over 30 years ago nearly 15 per cent of the population had a small or obvious goitre, with a female to male ratio of 4 to 1, which emphasizes how much more common thyroid enlargement is in women, particularly those aged 15–25 years. When the participants of this survey were examined 20 years later, the goitre had disappeared in over half of those who had a goitre at the first examination. The presence of a goitre in either survey was not associated with the development of any evidence of hypothyroidism or hyperthyroidism.

Thyroid cancer is a very rare disease and is by far the least common cause of generalized enlargement of the thyroid.

What does someone with a simple goitre feel?

Many people with a small non-toxic goitre are unaware of its presence and have no symptoms. Understandably people may become apprehensive if they see in the mirror that their thyroid gland is enlarged or if it is pointed out by a friend or relative. Once aware of a goitre, people sometimes describe a feeling like 'a lump in the throat', difficulty in swallowing, or a choking feeling. Because quite large goitres seldom cause any symptoms at all, it is usual that any symptoms in those with a small goitre are more the consequences of apprehension than related to the actual enlargement of the thyroid gland. Thus the assessment of someone with a simple non-toxic goitre is as important in allaying their fears as it is in determining the cause of the thyroid enlargement and deciding how best to treat it. Over the years the gland may fluctuate in size a little but with the passage of time it tends to grow smaller.

What the doctor finds

Initially a simple non-toxic goitre is seldom large, although it may be obvious. It is symmetrical, and feels smooth and soft. It is painless. Often it gradually becomes smaller and may disappear altogether in time so that it can safely be left alone. However, if whatever is causing the goitre persists, it may become larger and, as the years pass, more irregular so that eventually it contains several nodules and becomes a multinodular goitre (see Chapter 11).

Complications

Any complications from a simple non-toxic goitre are very unusual unless over the years the goitre increases very much in size. A simple goitre may become nodular and rarely grow to sufficient size to cause pressure symptoms by virtue of its bulk.

Over the years a simple non-toxic goitre may fail to produce sufficient thyroid hormones, either because the underlying cause continues, for example iodine deficiency, or because the gland becomes involved, as a separate illness, by Hashimoto's thyroiditis. Only when a simple non-toxic goitre has progressed to a multinodular goitre will thyroid overactivity sometimes develop (see Chapter 11).

Causes of simple non-toxic goitre

'Normal' or physiological causes

Slight enlargement of the thyroid gland is common in girls at or soon after the onset of puberty. Quite a number of women notice that their thyroid gland becomes slightly larger around the time of their menstrual period. Enlargement of the gland may also occur in pregnancy too (see Chapter 13). Hormonal changes are largely responsible for the thyroid becoming larger under these circumstances but a minor degree of iodine deficiency may sometimes be a factor. This is especially true in pregnancy, because the baby growing inside the womb needs iodine, and women may lose more iodine in the urine and reduce their own body stores.

Iodine deficiency and endemic goitre

In worldwide terms iodine deficiency is the most common cause of a simple non-toxic goitre but it only occurs in areas where there is a lack of iodine in the diet or the diet contains anti-thyroid or goitre-producing substances (goitrogens). These substances interfere with the use of the small amount of iodine available and so interfere with the synthesis of thyroid hormones. In 1999, according to the World Health Organization and the International Council for Control of Iodine Deficiency Disorders, iodine deficiency was recognized to represent a significant public health problem for over two billion people (approximately one-third of the world population) in 130 countries, with 740 million having a goitre. In 1994, 43 million were believed to be mentally handicapped as a result of iodine deficiency, mostly in underdeveloped counties. Although the disorders that result from iodine deficiency are preventable

by appropriate adequate iodine supplementation to the diet, they continue to occur because of various socio-economic, cultural, and political limitations.

Iodine is essential for the manufacture of the thyroid hormones, and if it is in short supply the thyroid gland may enlarge under the influence of the thyroid-stimulating hormone (TSH) secreted by the pituitary in an often successful attempt to maintain normal levels of the thyroid hormones in the bloodstream. The iodine content of food, mainly in milk, eggs, and vegetables, largely depends upon the amount of iodine in the soil, and this in turn depends upon rainfall derived from seawater. Thus iodine deficiency is found in areas far removed from the sea. This was the case in alpine countries such as Switzerland, around the Great Lakes in the USA, and even in the Pennines in England ('Derbyshire neck') until corrective measures were taken to fortify salt and bread with iodine. Iodine deficiency is still common in large land-locked areas such as the Himalayas, parts of China, Iran, the Congo basin, the Andes, and New Guinea, where preventive measures are still imperfect. In these parts of the world goitre is so common that it affects 20 per cent or more of the population and is therefore called endemic.

In iodine-deficient regions there is a direct relationship between the degree of iodine deficiency and the prevalence of goitre. If the deficiency is marked, and this can be assessed by finding very small amounts of iodine in a 24-hour urine collection, a large proportion of the population will have a goitre. In such areas the incidence of goitre and the risk of an iodine-deficient goitrous mother giving birth to a baby with thyroid deficiency have been reduced by fortifying cooking salt with iodine and also by giving the mother an injection of iodized poppy seed oil every 5 years.

Food and drugs

Certain foods and drugs interfere with the synthesis of thyroid hormones. Cabbage, certain vegetables of the kale family, cassava (which is consumed as a staple diet in Africa), or milk from cows that have been fed on kale may produce a goitre. Similarly, certain commonly used over-the-counter medicines, notably cough and asthma cures which may contain a large amount of iodine, can cause thyroid enlargement when taken over a long period of time. Many drugs, ranging from those used for the treatment of irregularities of the heartbeat, such as amiodarone, to those used to treat certain psychiatric illnesses, such as lithium, may cause the thyroid to enlarge. Therefore if a person develops a goitre, it is important that they tell the doctor about all the drugs, medicines, or herbal remedies that they are taking or have taken during previous months.

Disturbed manufacture of thyroid hormones

The making of the thyroid hormones thyroxine (T_4) and triiodothyronine (T_3) involves many orderly chemical steps. Normally each is precisely regulated, in the same way as the assembly of a motorcar involves many distinct stages. In some people the synthesis of thyroid hormones may be slowed down at a particular stage. This is called dyshormonogenesis, a word that literally means 'disordered genesis (formation) of hormones'. The severity of the disorder may vary from a mild hiccup in the synthetic process to a more major hold-up.

Goitres caused by dyshormonogenesis are very rare and tend to run in families. Usually the condition declares itself soon after birth because the baby has a goitre. In others the abnormality does not become noticeable until some years later, because as the child grows and the need for thyroid hormone increases the gland enlarges in an attempt to meet the demand. In rare instances disordered thyroid hormone synthesis is associated with other congenital problems, such as deafness, a condition known as Pendred's syndrome after the doctor who originally recognized the association.

In most of these patients treatment with thyroxine prevents the goitre from becoming any larger and often makes it smaller. Furthermore, such treatment avoids the risk of the patient becoming thyroid hormone deficient.

Diagnosis of simple non-toxic goitre

Although a careful history will be taken and tests may be done, it is often impossible to discover the precise cause of a simple non-toxic goitre. Thyroid function tests (blood levels of T_4, T_3, and TSH) are normal. There is usually nothing from a dietary history to suggest iodine deficiency, no evidence of autoimmune thyroid disease (that is no thyroid autoantibodies), and no good evidence of abnormal thyroid hormone synthesis. The diagnosis of simple non-toxic goitre is based on excluding other known causes of goitre. Usually there is no history of eating particular foods or taking drugs that may induce a goitre. In the early stages an isotope scan will show a normal pattern of uptake.

Treatment

The logical treatment of a simple non-toxic goitre is to correct or remove the cause but as this is unknown in most people, it is not always possible. Most small goitres can be left alone because they are benign and likely to become smaller. An adequate intake of iodine may be all that is required for people

who live in relatively iodine-deficient areas. It is sensible to use iodized salt or sea-salt in cooking and at the table, both of which are widely available in supermarkets and clearly labelled as 'iodized'. Sea-fish is also a good source of iodine. On the other hand, excessive amounts of iodine may cause a goitre and large amounts of kelp, seaweed, and iodine-containing medications should be avoided.

If a thyroid gland increases in size where there is adequate iodine intake or the thyroid gland is enlarged when medical advice is first sought, a trial of treatment with thyroxine is occasionally used for 6 months or so to see if it is effective. In most people the gland remains unchanged but occasional shrinkage has been reported. If the gland develops into a large multinodular goitre then further treatment, such as radio-iodine or surgery, can be offered (discussed in Chapter 11).

❓ Questions and answers

Q.1 What do you mean exactly when you say I've got a goitre?

A. The word goitre simply means that you have an enlargement of your thyroid gland.

Q.2 Does it mean that I've got cancer?

A. No, most goitres are not malignant and the thyroid is functioning normally. To reassure you we can undertake a fine-needle aspiration of the gland (see Chapter 3) to examine the cells but I would expect these to show normal thyroid tissue.

Q.3 Why have I got a goitre?

A. I don't know yet. There are many different causes and we will try to find out but sometimes there is no obvious answer.

Q.4 Will it get any bigger? It is ugly enough as it is.

A. You are more aware of the presence of your goitre than anyone else. It is not that noticeable and other people, including many doctors, would not notice it. The gland may fluctuate in size depending on the cause. It will probably become smaller but if it were to get much bigger radio-iodine or surgery may be appropriate.

Q.5 Does eating kelp have any effect on my thyroid?

A. Kelp contains a lot of iodine and if taken in large quantities can cause a goitre and even cause thyroid overactivity or underactivity.

11

Multinodular goitre and the solitary nodule

A multinodular goitre is likely to occur in a person who has had a problem with their thyroid gland for many years. However, a solitary nodule or lump in the thyroid gland may appear suddenly. A very small swelling or a lump in the neck may have been noticed and ignored previously, but then concern may rise if it suddenly increases in size or becomes painful.

Multinodular goitre

Lumps and nodules can develop within the thyroid gland and this may happen in a thyroid gland that has been enlarged for some years. The condition is more common in women than men. The enlargement may have evolved from a simple non-toxic goitre (see Chapter 10) or be associated with Hashimoto's thyroiditis (see Chapter 7). A multinodular goitre is usually the result of some low-grade, probably intermittent, stimulus to the thyroid gland, as may result from iodine deficiency, goitrogens in the diet, dyshormonogenesis (Chapter 10), or an autoimmune disease which causes small groups of thyroid cells to multiply and increase in size. Multinodular goitre is quite common, and in the developed world is found in about 5 per cent of women and 1 per cent of men, particularly those aged 45 or over. It is even more common in those parts of the world where there is iodine deficiency.

Usually a nodule has to be at least 1 centimetre in diameter to be felt by a doctor. Often, however, additional nodules are present which are too small to be felt and are only revealed when an ultrasound scan of the thyroid, which can detect nodules only a few millimetres in diameter, is done. The great majority of multinodular goitres are not malignant but it may be difficult to exclude cancer with certainty unless a fine-needle aspiration of the largest nodule is done. Fine-needle aspiration is now increasingly being performed, particularly if the largest nodule (termed the dominant nodule) is greater than 1 centimetre in diameter.

Symptoms associated with a multinodular goitre

Pressure symptoms

The enlargement of the thyroid gland is usually obvious. The swelling is irregular and knobbly, and one or more painless nodules may be felt. Some people, particularly if they are older, ignore the condition and only seek help once the goitre is really large and causing pressure symptoms. The most common problem then is compression of the windpipe, which may cause obvious shortness of breath. In extreme cases, breathing is partially obstructed and when asleep people may make a curious crowing noise, known as stridor. Other pressure symptoms are difficulty in swallowing, hoarseness or weakness of the voice due to pressure on the nerves to the vocal cords, and engorgement of the veins in the neck with a feeling of congestion in the face. The magnitude of the problem is best defined by a CT scan, which will show clearly whether the goitre is also extending downwards behind the breast-bone (retrosternal).

Hyperthyroidism

A radio-isotope scan, usually done with technetium, will show gross irregularity of uptake. Sometimes most of the uptake is concentrated in a few of the nodules, which are therefore described as 'hot', and the rest of the gland is 'resting' or suppressed, taking up little of the isotope. Usually the blood levels of T_4 and TSH are normal, but if the nodules are 'hot' and secrete increased amounts of the thyroid hormones, the person may be thyrotoxic.

In older people thyrotoxicosis due to 'hot' nodules in a multinodular goitre is common and of insidious onset. The condition is sometimes called Plummer's disease after the American surgeon who distinguished it from Graves' disease. Many of these people fail to exhibit the classic symptoms and signs seen in the younger person with thyrotoxicosis. They may not lose a lot of weight. They may not be particularly anxious and may not have a tremor. However, insidious congestive cardiac failure may develop instead, with an irregular pulse due to atrial fibrillation, swelling of the feet and ankles, and shortness of breath so that at night they cannot lie flat and have to sleep propped up with pillows.

Hypothyroidism

Over the years a multinodular goitre may fail to produce sufficient thyroid hormones, either because the initial cause (e.g. iodine deficiency) persists or the gland is destroyed by an ongoing condition such as Hashimoto's thyroiditis (see Chapter 8).

Treatment

Once any question of cancer or hyperthyroidism has been excluded, there may be no need for any special treatment if the multinodular goitre is small. Most people will remain under medical surveillance by their family doctor with an annual blood test of thyroid function to ensure that they do not become thyrotoxic in the future. There is no evidence that thyroxine is effective in making the multinodular goitre smaller or will prevent it becoming larger. If treatment is considered necessary, the options are either radioiodine or surgery. In most instances radio-iodine is the treatment of choice. A diagnostic radio-isotope scan is performed to assess whether there are many 'hot' areas and to provide a guide as to the likely impact of radio-iodine. To be successful a relatively large dose has to be given. This will reduce the size of a multinodular goitre by about 50 per cent after 1 year so that the appearance is cosmetically more acceptable. Radio-iodine will also cure any hyperthyroidism, but the overactivity of the gland may first have to be controlled with an anti-thyroid drug especially if the blood levels of T_4 are high and there is any concern regarding heart failure. Thyroid failure may occur as a result of radio-iodine treatment. Alternatively, the goitre can be removed surgically. This is more difficult in the older person, although it may be indicated if malignant change is a possibility or there is involvement of the laryngeal nerves to the vocal cords or development of enlarged lymph nodes in the neck. The possible complications of surgery are the same as for a thyroidectomy for Graves' disease (p. 46).

A solitary nodule

A single nodule can develop which is unattached to the overlying skin and not associated with any enlargement of the lymph glands in the neck. What appears to be a single nodule may on ultrasound scanning may prove to be one of several nodules which are too small to feel on examination. Hence what appears to be a solitary nodule is often the first visible expression of a multinodular goitre (see above).

A solitary nodule usually appears as a smooth rounded lump that is not painful. It may contain fluid and therefore is a cyst, but this can only be established with certainty from an ultrasound scan or by doing a fine-needle aspiration when fluid will be withdrawn. Cysts are thought to originate when solid nodules outgrow their blood supply and the cells breakdown leaving fluid, which collects as a cyst. Thyroid cysts are very rarely malignant.

Sudden painful enlargement of a nodule will occur if there is bleeding into it. The reason for this happening is not known. The smooth round swelling

increases in size quite suddenly, becomes hard because of the increased pressure inside it, and may be very painful, particularly if pressed. If a fine-needle aspiration is done (p. 24), bloodstained fluid will be withdrawn; the lump then becomes less tense and the pain is relieved.

A single nodule is usually a benign (not cancerous) cluster of cells which does not produce an excess of thyroid hormones. However, over the years a benign non-toxic nodule may begin to produce excess thyroid hormones and people can become thyrotoxic (see above and Chapter 6).

Unless it causes obvious symptoms of thyrotoxicosis, confirmed by thyroid function tests, a nodule must always be shown to be non-malignant. The distinction between benign and malignant is not easy. Imaging using either ultrasound or isotope scans is unreliable in distinguishing between benign and malignant nodules. An experienced radiologist may be able to offer clues as to whether a nodule is suspicious, for example the presence of lymph nodes not felt on neck examination or tiny amounts of calcium within the nodule. An ultrasound scan also enables evaluation of the possibility of coexisting nodules and an unsuspected multinodular goitre. Isotope studies to establish whether a nodule is 'hot', 'warm', or 'cold' are now recognized to be of little value in assessing a thyroid nodule. Historically, a 'cold' nodule, which does not take up isotope, was associated with a greater risk of malignancy but it was recognized that as many benign lumps and cysts were 'cold' on isotope scanning.

Therefore the most valuable investigation is a fine-needle aspiration to obtain cells for accurate assessment, occasionally guided by ultrasound. A suitable sample for assessment under the microscope is usually obtained in eight out of ten aspirations. Occasionally the appearance of the cells (called follicular cells) may be questionable and not allow total exclusion of cancer. If this happens, another fine-needle aspiration biopsy must be done.

As the tests for distinguishing between a benign isolated nodule and a cancerous one are not always conclusive, specialists may advise surgical removal of the lobe containing the lump (a hemithyroidectomy). Not only will this establish the precise diagnosis with certainty but, hopefully, the surgery will also get rid of the problem permanently.

❓ Questions and answers

Q.1 Is this little lump that has developed in my neck likely to be cancer?

A. The lump is in your thyroid and is not an enlarged lymph gland. It is unlikely to be malignant but I cannot be sure until certain tests have been done. These will include a fine-needle aspiration of the thyroid lump (see Chapter 3).

Q.2 Are the tests you are going to do always conclusive?

A. Not always, but in the majority of cases we get a clear answer. If not we may have to advise you to have an operation, but even then most lumps turn out not to be malignant.

Q.3 This lump in my neck has suddenly blown up and it really hurts. What is it?

A. You have a nodule in your thyroid and bleeding into it has occurred, which explains why it has suddenly enlarged and become painful. Removing the fluid from the nodule will relieve the pain and it will become smaller. Later other tests will be needed to find out why the nodule developed and to see if there are other smaller nodules that cannot be felt.

Q.4 My lump has almost disappeared since you removed the fluid from it. You say it was a thyroid cyst. Will it come back again?

A. It may and I cannot promise that it won't. If it does come back there is a good chance that removing the fluid again will fix it, or we could consider injecting a substance that will cause the cyst to collapse and become fibrotic.

Q.5 I have had this goitre for years and years and I don't really want anything done. Why are you so concerned about it?

A. The tests show that although it is still functioning normally, the goitre is pressing on your windpipe (the trachea). You have told me that you have difficulty in breathing and this is at least in part due to the narrowing of your trachea. It might be wiser to have treatment for it sooner, with either radio-iodine or surgery, than to have to deal with it later as an emergency which would be necessary if you were to develop a major obstruction due to further swelling or inflammation.

12

Cancer of the thyroid gland

The thyroid gland is an uncommon site for cancer to occur, accounting for only about 1 per cent of all cases of cancer. When compared with the incidence of malignant disease elsewhere in the body, thyroid cancer is responsible for less than 0.5 per cent of all deaths from cancer. Each year approximately 900 new cases and 250 deaths due to thyroid cancer are recorded in England and Wales. In the UK, the number of new cases reported is 1–2 per 100 000 people per year. Since 1980, the incidence of thyroid cancer in the USA has been increasing rapidly due in part to more sensitive diagnostic methods which find very small tumours with little or no tendency to progress. Although it may occur at any age, it is most common between the ages of 30 and 60 and, as with other thyroid disorders, it is more common in women than men. The long-term outcome for the majority of people treated effectively is usually favourable. Most thyroid cancers are very treatable and curable; however, there is the possibility of recurrence that can occur at any stage. Recurrences can also be treated successfully so lifelong follow-up is very important. Less than 10 per cent of people with a diagnosis of thyroid cancer die of their disease.

What is the cause of thyroid cancer?

Although the precise genetic causes of thyroid cancer are unknown, previous external X-ray treatment to the head, neck, or chest is a definite predisposing factor, particularly in children. Japanese survivors of the atomic bombs in 1945 have shown an increase in malignant thyroid nodules since the late 1950s. Nuclear fall-out remains a well-recognized cause of an increase in the risk of thyroid cancer in children. Following the Chernobyl atomic power-station explosion in 1986 the incidence of thyroid cancer rose considerably in children in the region but is now declining.

The likelihood of developing thyroid cancer after exposure to radio-iodine is very much dose related. There is no risk from isotopes, such as ^{131}I, used for diagnostic or therapeutic purposes. After careful scrutiny of their use for over

60 years there is no evidence that they increase the incidence of subsequent thyroid cancer. A pre-existing goitre, irrespective of cause, does not seem to increase the risk of malignant change because most thyroid cancers develop in a previously normal gland.

Types of thyroid cancer

Several different types of cancers affect the thyroid gland and they can be separated into two main groups:

1. Those in which the cells are well differentiated and look and behave in rather the same way as normal thyroid cells.

2. Those in which the cells are not differentiated (anaplastic) and behave in an unruly aggressive manner.

Differentiated cancers

There are two distinctive types of differentiated thyroid cancers which are responsible for over 90 per cent of all thyroid cancers. The most common is the papillary type, which tends to affect children and young women and spreads to the neighbouring lymph glands in the neck. It is liable to occur in several sites in the thyroid gland at the same time. The other type is follicular cell cancer, which tends to occur in slightly older people and spreads to the lungs or bones.

In both types the cells that have become malignant continue to look very much like normal thyroid cells and also behave like them. They continue to respond to the thyroid-stimulating hormone (TSH) from the pituitary gland and they usually continue to take up iodine (and radio-iodine) from the bloodstream. These tumours are not usually aggressive; they grow slowly and spread to distant parts of the body (metastasize) late. The fact that they continue to take up radio-iodine makes the detection of secondary deposits (metastases) in other parts of the body easier and allows effective treatment to be given by irradiating the metastases with radio-iodine. Also, if the secretion of TSH is reduced to low or negligible amounts by giving thyroxine by mouth in suppressive doses, the stimulus for any residual cancer cells to grow is diminished.

Hürthle cell variant of follicular carcinoma

This is a very rare tumour composed of a certain type of thyroid cell, called Hürthle cells, and is a recognized variant of follicular cancer of the thyroid.

These tumours are twice as likely to spread (metastasize) to the lungs and have a slightly higher mortality than thyroid follicular cancers. This is thought to be because these tumours are less likely to respond to radio-iodine therapy than other differentiated tumours (see below).

Medullary cell cancer

An unusual form of differentiated thyroid cancer may develop from cells which, strictly speaking, are not thyroid cells at all but 'lodgers' living in the thyroid gland. These so-called medullary cells, also known as C cells or parafollicular cells, do not make or secrete thyroid hormones. They manufacture a hormone called calcitonin (hence 'C cells') which regulates the amount of calcium in bones as well as other hormones that act on the intestines and blood vessels. People with medullary cell tumours may produce excess hormones from the C cells, causing diarrhoea and flushing. The diagnosis is usually made following fine-needle aspiration of a thyroid nodule or lymph node in the absence of previous clinical suspicion. Unsuspected medullary thyroid cancer can also be found at thyroid surgery.

These rare tumours tend to run in families and a relevant family history is found in 25 per cent of patients. In addition, there is a rare association with high calcium levels produced by excess parathyroid hormone from benign tumours of the parathyroid glands in the neck as well as with small non-malignant tumours of the adrenal glands in the abdomen (phaeochromo-cytomas) which secrete excess adrenaline and noradrenaline (catecholamines). These 'fight or flight' hormones can cause fluttering of the heart (palpitations) and high blood pressure if produced in excess.

Undifferentiated cancers

Less commonly, the cells of a thyroid cancer are undifferentiated. These anaplastic tumours behave very aggressively and are uncontrollable. The anaplastic cells multiply rapidly and invade surrounding structures in the neck which may make surgical removal difficult or impossible.

Lymphomas

Sometimes the thyroid is the site of a malignant lymphoma, which is a tumour that arises from white blood cells or lymphocytes residing in the thyroid gland. Lymphomas are often fast growing so that the thyroid rapidly increases in size and may compress the windpipe to cause shortness of breath or a crowing noise (stridor) when breathing. This is an uncommon disorder constituting less than 3 per cent of all lymphomas. There is an association with a history of Hashimoto's thyroiditis in approximately half of cases, with the lymphoma

typically occurring in women in the sixth decade of life, 20–30 years after the onset of the thyroiditis.

Metastatic cancer

Sometimes the thyroid becomes the site of a single or multiple secondary deposits from a primary cancer in the lung, breast, or kidney, but at this stage the underlying cancer will usually have declared itself.

What are the symptoms of thyroid cancer?

The first thing that will probably be noticed in a person who develops one of the most common differentiated types of thyroid cancer (the papillary or follicular varieties) is a small lump in the thyroid gland. The lump is usually round and nodular, often hard to the touch, usually but not always painless, and may initially be little bigger than a grape. In papillary thyroid cancer more than one nodule may appear simultaneously. The malignant cells may spread to a nearby lymph gland in the neck. This enlarged lymph gland may be the presenting symptom which takes a person to their doctor and a primary growth of the thyroid may be found on close examination.

The main warning symptoms or signs that alert a doctor to the possibility of thyroid cancer are as follows.

1. A previous history of X-ray therapy to the head and neck.

2. A family history of thyroid cancer.

3. The sudden development of a lump, which is usually painless, in the thyroid gland which gradually increases in size.

4. A lump in, or asymmetrical enlargement of, the thyroid, particularly in a child or a man (because thyroid disease is relatively uncommon in men).

5. Difficulty in swallowing (dysphagia) because of the close anatomical position of the thyroid gland and the oesophagus (gullet).

6. Difficulty in breathing (dyspnoea) and stridor because of the close anatomical position of the thyroid gland and the trachea (windpipe).

7. Hoarseness of the voice.

8. The finding of enlarged lymph glands in the neck in association with a goitre or a thyroid nodule.

9. Excessive hardness of the thyroid or the nodule.

10. Fixation of the nodule or the thyroid gland to the skin or the muscles of the neck so that it does not move freely on swallowing.

Often there are no symptoms and the cancer is found by chance. Both thyroid overactivity and underactivity are very rare, as thyroid cancer cells do not generally affect hormone production from the thyroid. Left untreated, a differentiated thyroid cancer will eventually spread (metastasize) to other parts of the body, with the malignant cells being carried in the bloodstream or the lymphatic system to the lungs, liver, or bones. Not until there has been considerable destruction of a bone by a metastasis will there be any bone pain. Sometimes the pain comes on suddenly if the involved bone breaks without a preceding fall or application of unusual force (a 'pathological fracture'). Hoarseness of the voice may also occur if the malignant cells encroach on the nerves that activate the vocal cords.

The undifferentiated anaplastic type of thyroid cancer tends to occur in older people. The thyroid gland enlarges quite quickly and becomes generally tender. The highly malignant cells may invade the overlying skin, making it red as though it were inflamed. Deeper structures in the neck may be invaded so that on swallowing the thyroid gland does not move up and down in the neck as freely as it should. Huskiness of the voice is common.

How is cancer of the thyroid diagnosed?

The diagnosis is made on the basis of clinical suspicion and confirmed by fine-needle aspiration. If this is inconclusive, the diagnosis may be confirmed only by surgery. Sometimes additional tests, such as ultrasound and CT and MRI scans, are done but they are usually less informative. Radio-isotope scans were often performed in the past but the finding of a 'cold' nodule is now known to be a poor indicator of a malignant thyroid tumour. Tests of thyroid function will be done but these are usually normal and of little help in establishing a diagnosis (see Chapter 11). If associated gastrointestinal symptoms, such as diarrhoea, or facial flushing are found in the presence of a thyroid nodule or goitre, the diagnosis of the rare medullary thyroid tumour can be made before surgery by finding a high level of calcitonin in the blood.

There are many relatively trivial and also some serious causes for the development of an enlarged lymph node in the neck. Less serious causes, including a simple sore throat or glandular fever, are much more common than the more serious causes such as tuberculosis, other infective or inflammatory diseases, and cancer of various kinds. Examination and simple investigations will usually establish the cause but sometimes complicated tests and imaging are required, including the removal of the lymph gland for microscopic examination.

Determining the outcome in differentiated thyroid cancer

The long-term outcome of people treated effectively for differentiated thyroid cancer is usually favourable. The overall 10-year survival rate for middle-aged adults with differentiated thyroid cancer is 80–90 per cent. However, 5–20 per cent develop recurrence of their tumour in the neck and approximately 10 per cent develop more distant metastases. People who are at the highest risk of recurrence or death can be identified at the time of diagnosis by considering certain prognostic factors: extremes of age, male gender, the size and characteristics of the tumour under the microscope, and the presence of metastases.

How is cancer of the thyroid treated?

Differentiated cancer

The mainstay of treatment of differentiated thyroid cancer is surgery. An adequate fine-needle aspiration sample is required for planning surgery. If the cells are clearly malignant and the tumour size is greater than 1 centimetre, urgent treatment by removal of the whole thyroid gland is required. Sometimes there is some doubt when only follicular cells and little colloid protein are seen (see p. 108). A hemithyroidectomy to remove one lobe of the thyroid is required to provide a firm diagnosis and will include excision of the lump in question. If thyroid cancer is subsequently confirmed on microscopic examination, removal of the other lobe will be necessary in those considered at high risk of cancer being present in both lobes. A further operation, a complete thyroidectomy, will usually be performed within a few weeks. In some centres, the tissue under suspicion is removed at operation and is looked at under a microscope while the person is anaesthetized. This may allow the distinction to be made between whether the tissue is benign or malignant, which in turn may allow the surgeon to proceed to the more extensive operation (a total rather than a hemithyroidectomy). However, these distinctions are not easy and require considerable pathological expertise. It is often advised to wait

until the full microscopic examination is available and then perform a second operation if thought necessary.

In skilled hands a total or near-total thyroidectomy can usually be accomplished without damage to the vocal cords and without loss of the parathyroid glands (see Chapter 4). The surgeon will also remove any neighbouring lymph glands in the neck, which may be the site of local spread. The extent of the operation depends on various factors such as the age and gender of the person and the results of the microscopic examination. These decisions are now usually made following discussions by a multidisciplinary team of doctors, which will include specialists in endocrinology, thyroid surgery, cancer, and medical physics. The plan will usually be discussed with the patient in a combined clinic where two or more of these specialists will be present.

Several weeks after the operation, most people, especially those with a tumour of size greater than 1 centimetre, will be given a large therapeutic dose of radioactive iodine. The aim of this further treatment is to kill off any residual normal or malignant thyroid cells left behind after surgery. Following the thyroidectomy, triiodothyronine (T_3) is the preferred thyroid hormone replacement, usually at a dose of 20 micrograms three times daily. This form of thyroid hormone is chosen in this situation as it has a very short half-life within the body. People are required to be hypothyroid for radio-iodine treatment to be effectively taken up by the body, which means having no thyroid hormone replacement (T_3) for at least 2 weeks. If they are being treated with conventional thyroid hormone replacement in the form of thyroxine (T_4), this must be stopped 4 weeks prior to the radio-iodine. In this 4-week period specialists may change to T_3 for the first 2 weeks and then stop replacement altogether for the last 2 weeks before the radio-iodine. Symptoms of underactivity, with weakness and tiredness, are likely in this period but this will resolve once hormone replacement is taken again, usually a few days after the radio-iodine.

There may be special circumstances when allowing the person to become hypothyroid is not considered possible or safe. These circumstances may include those with known pituitary gland failure, severe ischaemic heart disease, the frail and elderly, and those who have previously poorly tolerated thyroid underactivity. The alternative is to receive two injections of thyroid-stimulating hormone (TSH) just prior to the radio-iodine and to continue the thyroid hormone replacement therapy. Stimulation of the thyroid gland by this new injectable and well-tolerated form of TSH (called recombinant TSH) may not be as effective as thyroid hormone withdrawal so its use is usually reserved for exceptional circumstances.

People are admitted to hospital for the relatively large doses of radio-iodine used for treating cancers and are nursed in a special room. After being given the therapeutic dose of radio-iodine, the radioactivity in the body is carefully monitored and discharge occurs once the radiation has fallen to an acceptable level, usually within 2–4 days. People should not feel sick, lose any hair or have any other side effects with the usual dose required. They are then advised when they can resume non-essential contact with children and other adults and when they can return to work. All of these procedures are to keep everybody's exposure to radiation to a minimum.

Thereafter people are treated with thyroxine (T_4) not only as replacement therapy for the inevitable thyroid deficiency but also to suppress the level of TSH in the bloodstream and so reduce the stimulus for any remaining cancer cells to grow. The dosage of thyroxine will be adjusted until the level of the TSH is below normal but will not be sufficient to make the person hyperthyroid. Keeping the TSH level suppressed ensures that any remaining malignant thyroid cells are not exposed to its stimulating action and thus remain dormant.

After 3–6 months a review is carried out by one or more members of the thyroid cancer multidisciplinary team to check that all is well. A reassessment with a diagnostic radio-iodine scan (after stopping thyroxine for 4 weeks) is indicated after the first therapeutic radio-iodine treatment in some circumstances, particularly in those considered at highest risk of persistent malignant cells. If evidence of thyroid tissue is still detectable on this scan, a further dose of radio-iodine is given. A further scan following this second treatment is performed to ensure that there are no thyroid cells remaining. If there is any suspicion of residual disease, a further scan will usually be carried out 6 months later.

Most people will be reviewed at intervals of 6–12 months thereafter to monitor for any evidence of recurrence of the cancer by measuring the level of thyroglobulin in the blood. This is a substance normally present in small amounts in healthy people and is manufactured by normal and malignant thyroid cells. The amount of thyroglobulin found in the blood of those with a differentiated thyroid cancer, either papillary or follicular, who have been treated as described above should be negligible because all the normal and malignant thyroid cells will have been eradicated. Increased amounts of thyroglobulin will appear if there is a recurrence of the cancer. Thus thyroglobulin can be used as a marker of the tumour and simply be monitored in the blood while thyroxine treatment to prevent thyroid deficiency and to suppress the TSH is continued. There is now increasing evidence of benefit of using recombinant TSH to stimulate thyroglobulin production at 1 year to ensure that there is no recurrence. Periodic ultrasound examinations of the neck by a specialist radiologist are also recommended.

If the thyroglobulin level rises, the replacement thyroid hormone treatment with T_4 will be stopped for 4 weeks; T_3 will be used for the first 2 weeks and then replacement stopped altogether for the last 2 weeks to allow the TSH to rise above the upper normal range. A further dose of radio-iodine is given followed by an isotope scan of the neck. If a significant number of thyroid cells, normal or malignant, remain in the neck they will show up, as will any differentiated cancerous cells that have formed secondary deposits elsewhere in the body. If the scans show evidence of residual thyroid tissue, another therapeutic dose of radio-iodine is given and the replacement with thyroid hormone resumed.

Several other imaging tests can be done for those with thyroid cancer who have evidence of recurrence, which is usually shown by a raised blood thyroglobulin level but who may have a negative whole-body diagnostic radio-iodine isotope scan even after administration of a high dose of radio-iodine. Ultrasound of the neck is essential as many recurrences are found in the neck. The next step is normally a CT or MRI of the neck and chest. Recently, new imaging techniques, such as positive-emission tomography (PET) and somatostatin-receptor isotope scans, have become available. The choice of which scan is best is not yet clear and there is some debate about the value of finding recurrent or metastatic thyroid cancer which does not take up radio-iodine. Cancer in the neck found on the ultrasound scan and localized cancer elsewhere, can be removed surgically but finding evidence of metastatic disease using these new imaging techniques does not necessarily alter therapy. Scans that rarely modify treatment should be done only after consultation with the person about possible benefits.

It is essential for planned lifelong follow-up as thyroid cancer has a long natural history. Late recurrences can occur but can be successfully treated. Cure and prolonged survival are common, even after tumour recurrence. Regular follow-up is also necessary for monitoring lifelong TSH suppression by thyroxine, which remains one of the mainstays of successful treatment.

An account by a woman who had a differentiated thyroid cancer is given below. Initially this was not treated in an ideal way, but happily all is well now.

🛈 Patient's perspective

When I was aged 35 a small painless lump appeared in my thyroid gland, but I took no notice of it. Two years later I had my last (third) child and during the pregnancy the lump increased in size. Not until I was 40 did the lump seem sufficiently large for me to draw my doctor's attention to it. At that time we were living abroad. The lump was removed surgically and I was told that it was a cancer. I was given thyroxine tablets.

Four years later—we were still living in Africa—I noticed another lump in my thyroid gland on the other side. This time the surgeon removed all my thyroid gland and I was once more given thyroxine to take by mouth.

When I was 46 we came back to England and I noticed a painless lump in the right side of my neck under the angle of my jaw. A radio-iodine scan showed that it was thyroid tissue—almost certainly malignant they said—in a lymph gland. I was operated on and several lymph glands containing cancer were removed. I was then given what my doctor said was a curative dose of radio-iodine.

I am now 56. My thyroglobulin is measured every 6 months and I have had no recurrence since and certainly feel fine taking 250 micrograms of thyroxine daily.

Medullary thyroid cancer

The treatment for medullary thyroid cancer is extensive surgery of the neck including total thyroidectomy and often removal of many of the sites of lymph nodes in the neck. Subsequent treatment may be used but neither external beam radiotherapy nor chemotherapy has been demonstrated to be very effective if there is residual tumour. There is no need to use high-dose thyroxine replacement to suppress TSH in people requiring thyroxine after thyroidectomy in this form of thyroid tumour. Most people survive for many years even if there is still tumour present after surgery. Occasionally they may have significant gastrointestinal symptoms because of the high calcitonin level and in these circumstances there is an effective treatment that can block the effect of this excess hormone (somatostatin analogues). Subsequently the calcitonin level in the blood can be used as a tumour marker to assess whether there is any recurrence or worsening of the disease.

It is important to recognize the inherited forms of medullary thyroid cancer because of the risk of other tumours within the individual and in the family. Early detection and prophylactic surgery are very effective in reducing both mortality and morbidity. The lack of a family history does not exclude inherited disease as the tumour may not have been apparent in relatives or an isolated case may be the start in that family. Because of this possibility, every person with medullary thyroid cancer should be offered genetic testing and counselling.

Undifferentiated thyroid cancer

This type of tumour occurs predominantly in people aged 50 or more. In the early stages of an undifferentiated (anaplastic) thyroid cancer, it may be

possible to remove the growth or at least alleviate the symptoms surgically or with deep X-ray therapy. The prognosis is very poor whether treated or not.

Lymphomas

Lymphomas of the thyroid are usually sensitive to X-ray treatment and chemo-therapy, and a thyroidectomy is not indicated.

? Questions and answers

Q.1 I have had many tests for the lump in my neck and been told that the results are encouraging but I have still been advised to have an operation. I don't understand why.

A. The tests indicate that your thyroid is functioning normally but the result of the fine-needle aspiration is uncertain. The cells seen on the fine-needle aspiration biopsy are called follicular cells and they do look benign. However, with these particular cells we cannot be certain that the lump in your thyroid is not malignant so the only way to be sure is to remove it. Even if it is a cancer the outlook is good.

Q.2 Will I have to go through all these investigations, particularly the radio-isotope scan, again next year to show that I've not got any cancer left?

A. Once you have had a second scan following your thyroidectomy which shows no evidence of any persistent thyroid tissue, your freedom from disease can be monitored by measuring thyroglobulin in a simple blood test even while you are taking thyroxine. Only if this test comes back positive or any new lumps were to appear in your neck or else-where will you need to have another radio-iodine scan.

Q.3 I feel fine so why has my dose of thyroxine been increased?

A. Your dose of thyroxine has been raised a little because the blood level of TSH, which stimulates any remaining thyroid cells, is not sufficiently suppressed.

Q.4 But won't my thyroxine dose make me nervous and jumpy?

A. The aim is to increase the blood levels of your thyroid hormones to the upper limit of normal but not to a level that will upset you, while suppressing the TSH.

Q.5 How can you be certain that this lump in my thyroid is not a cancer?

A. The fine needle aspiration of the lump and surrounding areas will show benign tissue in about 75 per cent and definite malignancy needing surgery in probably less than 5 per cent depending on other factors. In the remaining 20 per cent, if even a second fine-needle aspiration is still uncertain, it is best to have the lump out.

13

Thyroid problems during and after pregnancy

Changes in the thyroid gland and in thyroid hormone secretion occur during pregnancy in parallel with the other major hormone adjustments that occur at this time. In a normal thyroid gland these changes are of no clinical importance, although family doctors and obstetricians will be aware that the levels of thyroid hormones and of the thyroid-stimulating hormone (TSH) change during pregnancy.

Thyroid changes that occur in pregnancy

As soon as conception occurs a hormone is secreted from the placenta. This is called human chorionic gonadotrophin (hCG) because it is secreted by cells in the chorion or placenta and it stimulates the secretion of hormones, such as oestrogens, from the gonad (ovary). The oestrogens increase the blood level of thyroxine-binding thyroglobulin (TBG) by increasing the synthesis of this protein from the liver. TBG is an important protein to which thyroxine (T_4) and triiodothyronine (T_3) are bound and carried around in the bloodstream (see p. 16). In pregnancy the amount of TBG nearly doubles so that more thyroxine has to be secreted by the thyroid gland to occupy the binding sites on this transport protein. Otherwise the level of *free* T_4 in the bloodstream, which is the hormone that is metabolically active, might become too low.

Thus in pregnancy the thyroid gland has to produce more thyroid hormones and there is a tendency for it to enlarge. The degree of this enlargement tends to vary according to the amount of iodine, an essential component of the thyroxine molecule, available in the body. Iodine is also necessary to supply the growing baby with this essential element, and during pregnancy more iodine is lost in the urine than usual. In countries such as the USA and UK, where there is sufficient iodine in the diet, little or no enlargement of the thyroid gland occurs. However, in many parts of the world, where the amount of dietary iodine is marginally or very deficient, the thyroid gland enlarges and the extent of this is related to the degree

of iodine insufficiency. For example, in ancient Egypt, where dietary iodine was insufficient, a fine thread used to be tied around the neck of a young bride. When the thread broke it was taken as evidence that she had become pregnant.

Another factor that tends to make the thyroid gland larger during pregnancy is that the hCG stimulates the thyroid in much the same way as TSH normally does. This may increase the level of thyroid hormones in the blood and cause some temporary lowering of the TSH level during the first 3 months but it seldom falls below the normal range for non-pregnant women. Occasionally, when the blood level of hCG is very high for a prolonged period of time, pregnant women may develop temporary hyperthyroidism (see below).

Any slight enlargement of the thyroid gland during pregnancy is unlikely to be of any consequence but women are advised to ensure that they have an adequate supply of iodine in their diet, particularly if they live in an area of known iodine deficiency.

Thyroid function tests during normal pregnancy

The results of thyroid function tests change during pregnancy. Because of the marked rise in the thyroxine-binding globulin, the levels of total T_4 and total T_3 rise. However, nearly all laboratories now measure the unbound biologically active hormones free T_4 and free T_3. During the first 3 months of pregnancy the level of free T_4 is usually slightly higher than in non-pregnant women, especially toward the end of this period. As explained above, the TSH level may be transiently depressed during the first 3–4 months of pregnancy when the hCG level reaches its peak and in about 20 per cent of normal pregnant women the TSH value falls below the lower limit of normal at this time. Thereafter the TSH level tends to rise slightly but progressively until term; this is particularly common where iodine intake is restricted. Such changes are not relevant if the thyroid is normal but they become important if a woman has suffered from over- or underactivity of the thyroid gland before becoming pregnant or if either condition is diagnosed during the pregnancy. In the later stages of pregnancy there is normally a modest decrease in the levels of free T_4 and free T_3, which may fall below the reference range derived from non-pregnant women.

Overactivity of the thyroid gland during pregnancy

Graves' disease

By far the most common cause of overactivity of the thyroid gland, of sufficient degree to induce symptoms during pregnancy, is Graves' disease. If

hyperthyroidism is untreated, women are less likely to become pregnant. However, once the overactive thyroid is controlled by an anti-thyroid drug or cured and made euthyroid on thyroxine replacement following either surgery or radio-iodine, fertility is restored to normal.

Sometimes Graves' disease develops for the first time during pregnancy. The diagnosis is not always easy because some of the symptoms of thyroid over-activity, such as increased heart rate, feeling hot, increased perspiration, and tiredness, also occur in pregnant women with a normally functioning thyroid gland. An important clue to the diagnosis may be the failure to gain weight to the expected degree or even weight loss in pregnancy.

Diagnosis of Graves' disease during pregnancy

The diagnosis is confirmed by finding high levels of free thyroid hormones in the blood and a very suppressed level of TSH which is well below the lower limit of the normal range and usually undetectable. It is now possible to measure the thyroid-stimulating antibody (TSH-RAb), which is the autoimmune cause of Graves' disease (see p. 19 and p. 37). A radio-iodine uptake scan (see p. 19) should not be done because the isotope would also be taken up by the thyroid gland of the fetus.

Treatment of Graves' disease during pregnancy

If a woman becomes pregnant while taking an anti-thyroid drug for Graves' disease (see p. 40), the treatment will be continued at the smallest effective dose during the pregnancy with the aim of maintaining thyroid hormone levels in the upper end of the reference range. Generally propylthiouracil is preferred to carbimazole or methimazole for treating Graves' disease in preg-nancy because less propythiouracil than carbimazole crosses the placenta and thus is less likely to suppress thyroid function in the baby. There is also some evidence that carbimazole and methimazole may be associated with birth defects that develop in the fetus while it is growing in the first 12 weeks of pregnancy so propylthiouracil is recommended as a first-line treatment for this reason as well. However, both carbimazole and methimazole may still be used if propylthiouracil is not tolerated or is unavailable. Except in those women with severe Graves' disease, the anti-thyroid drug can usually be stopped in the last 2 months of the pregnancy. In most cases this is possible because the auto-immune disorder that causes Graves' disease tends to lessen during this time and the severity of the thyrotoxicosis becomes milder. If an anti-thyroid drug is given during pregnancy to control Graves' disease, in theory the baby could be born with a suppressed thyroid gland but this is unlikely. All babies are tested to exclude thyroid deficiency around the fifth day after birth (see

Chapter 14) because the most common cause of hypothyroidism, lack of thyroid tissue, can affect any baby and occurs in approximately 1 in 3500 births.

Alternatively, a thyroidectomy can be performed safely during the fourth, fifth, or sixth month of pregnancy without harming the baby or the risk of inducing a miscarriage. Indications include a severe adverse reaction to anti-thyroid drug therapy, the requirement of persistently high doses of anti-thyroid drug therapy, or uncontrolled hyperthyroidism.

Radio-iodine should not be given to a woman who is, or may be, pregnant. If radio-iodine is given inadvertently there may be a risk of thyroid destruction in the fetus if given after week 12 of pregnancy. Before week 13 of pregnancy the thyroid of the growing fetus has not yet fully developed; therefore it does not take up radio-iodine and there is no risk of thyroid problems in later life. Although there is a small increased risk of some other cancers in children (increase in risk of solid tumours to 1 in 800 from 1 in 1800), there is no need or indication for a termination of the pregnancy.

After delivery

A recurrence of Graves' disease often occurs within 3–6 months after delivery, and anti-thyroid drugs are likely to have to be restarted. Propylthiouracil is preferred to carbimazole or methimazole because less of it is secreted in breast-milk. The amount of anti-thyroid drug in breast-milk is usually very little and there is no absolute contraindication to breast-feeding. However, it may be necessary to check the thyroid function of the baby, especially if high doses of anti-thyroid drugs are required (more than 300 milligrams per day of PTU and 20 milligrams per day of carbimazole or methimazole). No side-effects of anti-thyroid drugs have been reported in infants breast-fed by mothers on anti-thyroid drug therapy.

Neonatal hyperthyroidism

In women successfully treated for Graves' disease in the past or who have had Graves' disease during a recent pregnancy, there is a very small risk of thyroid overactivity in the baby either *in utero* or following delivery (see Chapter 14). The cause of the hyperthyroidism is the thyroid-stimulating antibody present in the blood of the mother which can cross the placenta and stimulate the baby's thyroid. These stimulating antibodies may persist in the blood even though the Graves' disease was treated and cured long ago. They may be present even if a woman is on thyroxine therapy for an underactive thyroid following radio-iodine treatment or a thyroidectomy.

In fact very few babies (less than 1 in 100) of previously thyrotoxic mothers are affected but they are more likely to be so if there have been severe eye complications (see Chapter 5) or pretibial myxoedema (see p. 34). Both of these findings are usually associated with high levels of thyroid-stimulating antibodies in the blood.

If women are treated with an anti-thyroid drug during pregnancy it is unlikely that the baby will be born hyperthyroid because the propylthiouracil, carbimazole, or methimazole will cross the placenta and tend to suppress the baby's thyroid gland.

Predicting neonatal hyperthyroidism

In women with a past or present history of Graves' disease, a careful watch will be kept on the baby before it is born. Fetal hyperthyroidism may be suspected if the baby's heart rate *in utero* is unduly fast (more than 160 beats per minute), the baby's growth is slow, or the baby develops a goitre as measured by ultrasound scans. The doctor may be alerted to the possibility of the baby being thyrotoxic by finding a high level of thyroid-stimulating antibodies in the mother's blood. Increasingly these antibodies are now being measured before pregnancy or by week 28 of pregnancy in women with current Graves' disease, with a history of Graves' disease and treatment with radio-iodine or thyroidectomy, or with a previous baby with neonatal hyperthyroidism. Women who are negative for these antibodies or who do not require anti-thyroid drug therapy during pregnancy have a very low risk of their fetus or newborn baby having any thyroid problems. If there is evidence of intrauterine thyrotoxicosis, the overactive thyroid of the baby can be treated by giving the mother an anti-thyroid drug, which will cross the placenta. During this treatment the mother is prevented from becoming hypothyroid by being given thyroxine, which barely crosses the placenta in the later stages of pregnancy and thus will not affect the baby.

Gestational hyperthyroidism

This is a transient episode of mild thyrotoxicosis which occurs early in pregnancy and is caused by an excessively high level of hCG, which stimulates the thyroid gland. This is a rare condition, often not diagnosed because it is mild and occurs in only about 2 per cent of women. Treatment is seldom necessary but if the symptoms are troublesome and very high levels of thyroid hormones are present, short-term administration of carbimazole may be given and can be effective.

Hyperthyroidism in hyperemesis gravidarum

Many pregnant women suffer from morning sickness. Sometimes vomiting becomes so severe that the woman becomes dehydrated and has to be admitted to hospital for replacement of the lost fluid via an intravenous drip. If the vomiting is severe enough to result in more than 5 per cent weight loss, the condition is known as hyperemesis gravidarum (excess vomiting in the pregnant woman). It is more common in twin pregnancies. It is probable that the vomiting is induced by the high levels of hCG secreted by the placenta and the high levels of oestrogens induced by the hCG. The hCG stimulates the thyroid gland, as explained above, and approximately half of women with hyperemesis gravidarum have a degree of hyperthyroidism with raised levels of free T_4 and free T_3 and a suppressed TSH level. In addition to correction of the dehydration in hyperemesis gravidarum, treatment of the temporary hyperthyroidism with carbimazole may be necessary. The condition is usually self-limiting by weeks 15–20 of the pregnancy, and the free T_4 and free T_3 levels return to normal within a few weeks of cessation of the vomiting. If the thyroid hormone abnormalities persist after week 20 of the pregnancy, it is possible that the mother has undiagnosed Graves' disease.

Pregnancy and the underactive thyroid

Subfertility can occur in women who have overt hypothyroidism, and thyroid function tests are usually performed in women who present with a history of being unable to conceive for more than 12 months. However, once the thyroid deficiency has been corrected, normal fertility is restored if the severity of hypothyroidism was the explanation for the subfertility. It is recommended that the dose of thyroxine be adjusted to ensure that the TSH is no higher than 2.5 milliunits per litre prior to conception. Evidence of early mild thyroid failure (subclinical hypothyroidism) with a raised TSH and normal T_4 levels is a relatively common finding when women with subfertility are tested. Although rarely an explanation for being unable to conceive, it is recommended that thyroxine is given to such women to ensure that the TSH is normal prior to conception. Although there may be a link between the presence of thyroid antibodies (found in up to 10 per cent of women of childbearing age) and miscarriage, screening for thyroid antibodies is not routinely performed. However, it has recently been shown that thyroxine does decrease the miscarriage rate in women who have circulating thyroid antibodies with mildly abnormal thyroid function tests.

Both maternal and fetal thyroid hormone deficiency may have serious adverse effects on the fetus so maternal hypothyroidism should be avoided. Subtle

detrimental effects on intellectual function have been suggested in the offspring of women with evidence of mild thyroid failure during pregnancy. Severe maternal hypothyroidism due to iodine deficiency is often associated with an irreversible impairment in fetal brain development. Thus it is very important that women given long-term thyroxine replacement therapy continue this during pregnancy and afterwards. In hypothyroid women on thyroxine, the TSH may rise during pregnancy and the expectation is that they will require an extra 25–50 micrograms of thyroxine daily during the earliest 4–8 weeks of pregnancy. For this reason, following discussion with their doctor, women may be told to increase their dose of thyroxine by 25 micrograms as soon as their pregnancy is confirmed and have a blood test to recheck thyroid function within a couple of weeks. The free T_4 should be maintained at the upper end of the reference range and the TSH at the lower end of the reference range during the pregnancy. It is recommended that thyroid function tests be checked every 6–8 weeks during pregnancy. Iron supplements, iron-containing vitamin preparations, and calcium supplements may interfere with thyroxine absorption so they should be taken at least 4 hours from the daily thyroxine dose. Following delivery most women need to decrease the thyroxine dosage they received during the pregnancy, usually to their pre-pregnancy dose, within a matter of days or weeks.

Neonatal hypothyroidism

If women are given anti-thyroid drugs in large doses during pregnancy to control Graves' disease, in theory their baby could be born with a suppressed thyroid gland. In practice this is unlikely because the smallest dose of PTU necessary to maintain maternal euthyroidism is chosen.

If a woman develops hypothyroidism during the pregnancy and is being treated with thyroxine there is no cause for concern as the fetal thyroid starts producing its own thyroid hormone from around week 10 of pregnancy. Every newborn baby should be screened either at birth or more usually on the fifth day after birth for neonatal hypothyroidism, whether or not its mother has been treated for thyroid disease (see Chapter 14).

Pregnancy and thyroid nodules and cancer

A thyroid nodule more than 1 centimetre in size presenting during pregnancy should be investigated by fine-needle aspiration cytology. In the rare situation that thyroid cancer is suspected or confirmed, management requires careful consideration of risks to the mother and the fetus. Counselling of the couple by specialists working within a multidisciplinary team is essential. In nearly all

cases the tumour is not aggressive and it is reasonable to allow the pregnancy to continue. Women of childbearing age with thyroid cancer generally have a good outcome, similar to that of non-pregnant women. Thyroidectomy in the first trimester of pregnancy carries an increased risk of miscarriage but can be considered and safely performed in the latter half of the pregnancy if necessary. It is possible to commence suppressive thyroxine therapy during the pregnancy and then defer surgery and radio-iodine therapy until after the delivery of the baby. In cases of advanced or aggressive disease, delays in treatment would be undesirable and termination of the pregnancy will be discussed with the couple. Radio-iodine scans and therapy should be avoided during pregnancy and while breast-feeding. Furthermore, pregnancy should be avoided for 6 months to a year in women with thyroid cancer who receive therapeutic doses of radio-iodine to ensure stability of thyroid function and confirm remission of the cancer.

Maternal thyroid problems after delivery

Abnormalities of thyroid function are common after delivery and usually occur within 6 months. Mild hyperthyroidism, hypothyroidism, or thyroid overactivity followed by underactivity may occur during this post-partum period.

Post-partum thyroiditis

It is estimated that at least 5 per cent of women, nearly always those who have certain thyroid antibodies (thyroid peroxidase, see p. 18) present in the blood prior to conception, develop some disorder of thyroid function within the first 6 months after delivery. It is three times more common in women with type 1 insulin-dependent diabetes, which is a related autoimmune disease. Short-lived thyrotoxicosis alone or thyrotoxicosis followed by short-lived underactivity are less common than hypothyroidism alone.

The symptoms produced by these abnormalities are not always recognized because many women accept them as the consequences of having to look after a new baby and having to return to work or run their home. Often the thyroid over- or underactivity is so short-lived that no treatment is necessary.

Maternal thyrotoxicosis after delivery due to silent thyroiditis

Post-partum thyroiditis causing thyrotoxicosis is usually so short-lived that no treatment is required, although if necessary a beta-blocker (see p. 39) will help relieve any symptoms. It usually occurs 1–6 months after delivery. Post-partum hyperthyroidism is also known as 'silent thyroiditis' (see Chapter 15).

It is 'silent' not because there are no symptoms but because the gland is not painful or tender, although it may enlarge. This thyroid activity is due to a type of autoimmune thyroiditis quite distinct from Graves' disease and only partially related to Hashimoto's thyroiditis. Although symptoms during the thyrotoxic phase tend to be milder than during thyrotoxicosis due to Graves' disease, it is important to differentiate the two conditions as the treatment options are different. A diagnostic radio-isotope thyroid scan shows reduced uptake of the isotope in post-partum thyroiditis. This test only involves a very small exposure of a short-lived radio-isotope so it can be done if women stop breast-feeding for the day of the scan only.

Maternal hypothyroidism after delivery

About 10 per cent of apparently normal healthy women are found to have thyroid autoantibodies in the blood when they first attend an antenatal clinic. Although, as previously discussed, there may be a slightly increased risk of miscarriage if these antibodies are present, they seldom cause any problems during pregnancy. Women known to be thyroid peroxidase antibody positive should have a measurement of TSH performed at 3 and 6 months after delivery.

After delivery, the symptoms of underactivity of the thyroid gland characterized by fatigue, weakness, depression, failure to lose weight, impairment of memory, and lack of ability to concentrate may occur and may be incorrectly attributed to having post-partum 'blues'. If the TSH is raised, treatment with thyroxine will be helpful. In some women thyroxine replacement is only required temporarily as in the majority the thyroid gland recovers normal function within a year of delivery

It is usually suggested that thyroxine is stopped 12 months after delivery and the thyroid function is tested a month later to see if thyroxine is required in the long term. If an asymptomatic woman who is not planning a subsequent pregnancy has a TSH above the reference range but below 10 milliunits per litre, thyroxine is not necessarily required (see p. 83) and the test can be repeated in 2–3 months. If a woman is attempting a further pregnancy, thyroxine treatment is required whether she is symptomatic or not.

Even if thyroid function does return to normal, there is an increased risk of developing permanent hypothyroidism in the 5–10 year period following the episode of post-partum thyroiditis, with an estimated quarter of women requiring thyroxine replacement within 3 years. Therefore an annual follow-up measurement of TSH is recommended for all women who have had an episode of post-partum thyroiditis. There is also a high risk of developing another episode of post-partum thyroiditis following any future pregnancies.

It is advisable to check thyroid function at 3 and 6 months post-partum in women with this history and indeed in all those women known to be thyroid antibody positive before the pregnancy.

Post-partum pituitary failure

Rarely, thyroid underactivity may also occur because of failure of the pituitary gland to secrete enough TSH. Pituitary failure may complicate a delivery that is associated with catastrophic haemorrhage in the post-partum period (see p. 146). This pituitary failure, called Sheehan's syndrome after a Liverpool doctor, is now a very rare event with modern obstetric care. It is nearly always associated with failure to secrete other hormones from the pituitary, most importantly the adrenocorticotrophic hormone (ACTH), which stimulates the adrenal gland to produce cortisone.

Another rare cause of pituitary failure usually associated with pregnancy is called lymphocytic hypophysitis. This is an autoimmune condition affecting the pituitary which becomes swollen, causing increasing headaches, visual disturbances, and pituitary failure. Most cases occur in women towards the end of a pregnancy or just after delivery, although it is also rarely described in men and in women not related to a pregnancy. Treatment may involve surgery to decompress the pituitary swelling, high doses of corticosteroids, and replacement of the missing hormones, again most importantly the adrenal hormones as well as thyroxine. In both these situations the resulting adrenal failure must be treated before thyroxine replacement is started (see p. 146).

❓ Questions and answers

Q.1 After my first baby was born, I had thyroid deficiency for about 4 months. Is this likely to happen again if I have another child?

A. Yes it is, particularly as we know that you have thyroid autoantibodies in your blood.

Q.2 Would it be better to have an operation for my Graves' disease when I am 4 or 5 months pregnant or to go on taking an anti-thyroid drug all the way through my pregnancy?

A. The choice must be yours, but I think it unlikely that you will need to take an anti-thyroid drug all through your pregnancy. We shall probably stop it 6–8 weeks before you've delivered. You are likely to have to restart it again within 3 months of delivery.

Q.3　My obstetrician asked me to tell you that my thyroxine level is too high. He wondered whether I should reduce my dose of thyroxine to the amount I was having before I became pregnant.

A.　The level of your total thyroxine is high, but that always happens in pregnancy. I'll measure your free thyroxine and your TSH. If they're normal, you should go on with the present dose. I'll let you know the results.

Q.4　Will there be problems in breast-feeding my baby if I am on an anti-thyroid drug?

A.　Not really. A tiny amount of the anti-thyroid drug may be present in your milk. This is unlikely to affect your baby but we shall check the baby's own thyroid function.

Q.5　You've told me I have Graves' disease. I feel fine on the treatment, but will my baby be all right?

A.　You are having the smallest dose of the anti-thyroid drug, propylthiouracil, to control your hyperthyroidism and this can usually be stopped altogether a few weeks before your baby is born. It is unlikely to harm your baby.

Q.6　I had such severe vomiting quite early on during my last pregnancy that I had to be admitted to hospital for intravenous fluid treatment. The doctors said that my thyroid was overactive at the time. Will this happen again in my next pregnancy?

A.　This condition is called hyperemesis gravidarum (severe vomiting of pregnancy) and it might recur. If it does, you should go to the hospital so that intravenous fluids can be started quickly. Thyroid function is often temporarily disturbed during such episodes but usually recovers spontaneously once you are over the vomiting. Sometimes short-term treatment with an anti-thyroid drug is necessary (when you are able to keep down the tablets) if high levels of thyroxine persist.

14

Thyroid problems in infants, children, and adolescents

Thyroid overactivity in children

Thyroid overactivity in children and adolescents is less common than in adults and is rare in neonates. In all three groups, the cause is nearly always Graves' disease, as in adults. Most aspects of thyrotoxicosis (and Graves' disease) in the newborn, children of any age, and adolescents are similar to those in adults, but a few are age specific. For example, in neonates (the first month of life) the thyrotoxicosis is transient and has effects on the growth and development of the nervous system. In children, thyrotoxicosis has effects on growth, pubertal development and the skeleton that do not occur in adults. Graves' ophthalmopathy is seldom as severe as in adults and pretibial myxoedema is extremely rare. With respect to treatment of Graves' disease there has historically been more reluctance to undertake destructive therapy with radio-iodine or surgery, although radio-iodine is increasingly gaining acceptance in adolescents.

Neonatal hyperthyroidism

Thyroid overactivity in a newborn baby is very rare. It occurs only when the baby's mother has been successfully treated for Graves' disease in the past or has had Graves' disease during her recent pregnancy. The cause of the baby's hyperthyroidism is the thyroid-stimulating antibody present in the mother's blood which is passed to the baby during pregnancy via the placenta (see Chapter 13).

The onset, severity, and duration of symptoms in newborn babies with Graves' thyrotoxicosis is variable. It occurs equally in boys and girls. There is a risk of premature delivery and the birth weight is often low. The baby will have an unduly fast heart rate and be restless. Minimal eye signs may be present but the main features are failure to thrive and gain weight (despite an

enormous appetite), irritability with difficulty to console, and occasionally heart failure. The baby's thyroid gland is likely to be enlarged but this is not easy to detect at this age. The diagnosis can be confirmed quickly by measuring the baby's thyroid hormone levels but it must be remembered that a mildly raised thyroxine (T_4) and triiodothyronine (T_3) level is normal within the first week of birth. If the mother was receiving an anti-thyroid drug at the time of delivery, the baby may not become thyrotoxic for several days until the drug is metabolized.

Treatment is given with small doses of iodine or an anti-thyroid drug. Fortunately, neonatal thyrotoxicosis is self-limiting because the thyroid-stimulating anti-bodies from the mother persist in the baby for only a few weeks or months. Thus active treatment is only required during this time. There is a possibility that following an episode of neonatal hyperthyroidism, even if treated promptly and adequately, the baby may suffer impairment of growth and intellectual function as it gets older. Therefore long-term follow-up by a paediatrician is advised.

Thyroid overactivity in children and adolescents

The vast majority of cases of thyrotoxicosis in children and adolescents are caused by Graves' disease. It may begin in infancy but it is rare in children less than 5 years old and the peak incidence is in children aged 11–15 years. Girls are more commonly affected than boys. Most children with Graves' disease will have a relative with autoimmune thyroid disease (either Graves' disease or Hashimoto's disease) or some other autoimmune disease such as insulin-dependent (type 1) diabetes (see Chapter 16). It is also more common in children with Down syndrome (see Chapter 16).

The main clinical features of thyrotoxicosis in children and adolescents are similar to those in adults (see Chapter 4). Often the onset is gradual and many children have what they and their parents recall as a few symptoms for several months or even years before the child is diagnosed. Nervousness, emotional lability, behavioural changes, and deteriorating school performance are the symptoms most likely to bring the child to medical attention. Tiredness, weakness, and shortness of breath may lead to a child reducing or stopping athletic activities. A smooth goitre is present in nearly all children with Graves' disease. Some degree of eye involvement with staring eyes is common but severe eye disease is rare. Acceleration of growth is common in children with thyrotoxicosis and many have a growth spurt, although their final adult height is not increased above that expected from their parents. The diagnosis is confirmed by finding raised thyroid hormone levels and suppressed TSH in the blood. Other tests including anti-thyroid antibodies and radio-iodine scans are rarely necessary.

Treatment of thyroid overactivity in children and adolescents

Children and adolescents with Graves' thyrotoxicosis, like adults, can be treated effectively with anti-thyroid drugs, radio-iodine, and thyroidectomy (see Chapter 4). There are some differences among the three treatments in the time needed to reduce raised thyroid hormone levels to normal, the required degree of child and family compliance with the treatment, the number of follow-up visits, and the short- and long-term likelihood of recurrent thyrotoxicosis and hypothyroidism.

In contrast with adults, in whom radio-iodine therapy alone or a relatively short course of an anti-thyroid drug followed by radio-iodine therapy if remission does not occur is probably the most common treatment approach, most children with Graves' thyrotoxicosis need treatment with an anti-thyroid drug for a long time. However, the chances of a long-term cure of hyperthyroidism following a prolonged course of anti-thyroid drug therapy are lower than in adults and relapse is common.

There have been concerns from doctors, children, and parents that radio-iodine therapy may prove to have some long-term side-effects despite current evidence to the contrary. In fact it is very effective treatment and there is no evidence of an increase in thyroid tumours or other non-thyroid problems in more than 1000 children treated with radio-iodine. However, because there is a theoretical risk of increased sensitivity of the thyroid gland in young children, most paediatric endocrinologists prefer not to treat children until they are aged 10, or older if possible. Hypothyroidism is a likely outcome as in adults.

In skilled and experienced hands, thyroidectomy is the most rapidly effective treatment for thyrotoxicosis but it is usually reserved for those children with markedly enlarged thyroid glands. A near-total thyroidectomy is now usually performed so hypothyroidism is almost an inevitable outcome. The risks of other complications are very low.

Thyroid underactivity in children

The onset of thyroid underfunction in younger children is usually due to imperfect development or maldescent (p. 2) of the thyroid gland earlier in life or to Hashimoto's thyroiditis. Less often the cause is some congenital defect whereby the manufacture of T_4 and T_3 by the thyroid cells is impaired (dyshormonogenesis).

Thyroid underactivity in the newborn (neonatal hypothyroidism)

Thyroid failure in the newborn, if unrecognized, can be disastrous because delay in treatment results in permanent mental deficiency (cretinism). In the developed world the most common cause of congenital hypothyroidism is poor development or incomplete descent of the thyroid gland from its original site at the base of the tongue. The prevalence is 1 in 3500 births and approximately 15 per cent of cases are hereditary. Thus in developed countries every newborn baby is screened to exclude thyroid deficiency. In the UK, nationwide screening is based on using filter paper bloodspot TSH measurements, while in parts of the USA screening is based on bloodspot T_4 measurement. The value of screening is that prompt treatment and maintenance of normal thyroid function in babies with congenital hypothyroidism is associated with a normal intelligence quotient (IQ), which does not differ significantly from the IQ of their unaffected siblings.

In areas of the world where iodine deficiency is common (p. 101) the prevalence of neonatal hypothyroidism is high and the degree of mental defect and damage to the nervous system is great. In these cases the baby's mother usually has a goitre caused by lack of iodine and possibly by other anti-thyroid factors in the diet or drinking water. This type of endemic neonatal hypothyroidism can be prevented by giving the mother injections of iodized oil before and during her pregnancies or fortifying salt or bread with iodides.

Transient congenital hypothyroidism may occur in infants born to mothers treated with an anti-thyroid drug. These drugs are cleared rapidly from the infant's circulation and the hypothyroidism is short-lived. Maternal antibodies which block the action of TSH can cross the placenta to the fetus and can be another rare cause of transient congenital hypothyroidism. The antibodies are cleared relatively slowly so hypothyroidism may take some weeks to resolve.

What does a baby with thyroid deficiency look like?

In many cases the baby can look perfectly normal, even to a trained experienced eye, so a screening test is essential and routine on every newborn baby in developed countries. Babies with thyroid deficiency fail to thrive. The baby does not kick vigorously, sleeps excessively, and is constipated. The baby's cry may be croaky. The scalp hair may be short and coarse. Often the tummy is unduly protuberant, the navel may bulge outwards and be the site of a rupture. The tongue is unusually large and to the experienced eye the face may have a characteristic flat bloated look. Where there are abnormal features, these depend upon the degree of thyroid deficiency and become more obvious as the baby grows older but by then permanent damage to the brain may have occurred. Left untreated, these changes may include poor co-ordination, shakiness, and unsteadiness.

Diagnosis of neonatal hypothyroidism

Prior to the development of a screening test, babies with neonatal thyroid deficiency were seldom diagnosed until they were 6 months old and by then the brain damage (cretinism) was irreversible. Although the physical changes disappeared with thyroxine treatment, the mental state was likely to remain permanently damaged.

Nowadays every newborn baby should be screened for thyroid deficiency by the fifth day after birth. A needle prick will be made on the baby's heel and four spots of blood placed on a special piece of paper. Two of these spots are analysed for TSH and the other two are used to screen for another congenital disease (phenylketonuria). The normal range of TSH can be as high as 20 milliunits per litre in the first few days after delivery. In babies with thyroid deficiency the TSH is substantially raised. When the level is not all that high, the test has to be repeated. Sometimes congenital thyroid deficiency is transient and without treatment the baby will recover normal thyroid function. This may happen in premature births and in babies of mothers who have been taking thyroid hormone, anti-thyroid drugs, or iodine-containing drugs during the pregnancy. It is safer to treat all infants showing a positive test and when the baby is about 2 years old to stop the replacement treatment for a few weeks and carefully observe the T_4 and TSH levels. If the T_4 falls and the TSH rises, thyroxine can be restarted and the infant will not suffer any brain damage from being temporarily deprived of the replacement treatment.

Thyroid underactivity in infants, children, and adolescents

Occasionally, when the thyroid gland has not developed properly, the amount of thyroid tissue may have been adequate initially to sustain normal levels of the thyroid hormones but as the child grows the poorly developed gland cannot keep pace and thyroid deficiency gradually develops. However, the most common causes of hypothyroidism in children, other than congenital hypothyroidism, are the same as in adults. Worldwide, iodine deficiency is the most common cause; in developed countries, it is chronic autoimmune thyroiditis. As in children with Graves' disease, it is common for a relative to have autoimmune thyroid disease or some other autoimmune disease (see Chapter 16). It is also more common in children with Down syndrome and Turner's syndrome (see Chapter 16). Goitrous Hashimoto's thyroiditis is more common in adolescents, whereas the atrophic form occurs at any age and is the most common cause of acquired hypothyroidism in infants. Destruction of the thyroid gland as a result of X ray treatment to a tumour in the neck is probably the second most common cause in older children and adolescents. A lymphoma is the most likely tumour because the neck receives X-rays directly.

Hypothyroidism can also occur in children with rare brain tumours where the neck is included within the field of the X-ray treatment.

The symptoms of acquired hypothyroidism in infants, children, and adolescents vary considerably depending on the age of onset and the rapidity of its progression. Unlike in infants aged less than 2 years old, hypothyroidism in older infants and children does not cause permanent impairment of mental function but it can have detrimental effects on growth and development until puberty is complete. The most obvious consequence of thyroid underactivity is that the child stops growing. There are seldom other symptoms and the child's performance at school is usually maintained until the disease is severe and of prolonged duration. Although failure to grow is the presenting feature, the child is often plump and may have pads of fat above the collar-bones. Otherwise thyroid underactivity causes many of the same symptoms and signs as in adults, especially in older children and adolescents (see Chapter 7).

In children with hypothyroidism of several years duration and severe growth retardation at the time of diagnosis, the adult height attained may be less than that predicted based on the height of the parents, even if correctly treated. Hypothyroidism during adolescence is usually mild and most have a goitre. When hypothyroidism occurs just after puberty has started, pubertal development slows or stops. A girl's periods may be delayed, and growth of axillary, pubic, and facial hair in boys slows, although the body hair growth may increase.

The diagnosis is based on the same tests as are used for confirming thyroid underactivity in the adult. In addition, X-rays will show that the development of the bones is delayed in relation to the child's chronological age. An isotope scan of the neck may show the gland is abnormally small (maldevelopment), and in maldescent (p. 20) the uptake may be near the root of the tongue instead of in the normal position.

Treatment of thyroid deficiency in infants, children, and adolescents

The treatment of choice for hypothyroidism is thyroxine given once daily. Infants are treated with a full replacement dose of 50–75 micrograms daily (4–8 micrograms per kilogram per day). Such a dose will raise the T_4 level to normal quickly without causing thyrotoxicosis. The dosage has to be increased as the baby grows older and is best judged by the free T_4 and TSH levels in the blood. Additional assessment of the response is made from the child's growth in height and the maturing of the bones as judged by simple X-rays of the hand and wrist.

Children and adolescents can be treated less aggressively. The appropriate dose is that which ameliorates the clinical symptoms and signs of hypothyroidism, restores the growth rate to normal for age, and maintains the child's blood TSH level within the normal range. An appropriate initial dose of thyroxine is 25–50 micrograms daily for 2–4 weeks, after which the dose should be increased by increments of 25 micrograms daily at intervals of 4–8 weeks until the child's TSH has returned to normal. When treated, some children may initially have a short attention span, restlessness, insomnia, and poor school performance, particularly when full replacement doses are prescribed. Excessive thyroxine therapy should be avoided at any age. A child given too much thyroxine is likely to become overactive and unduly excitable, and will grow faster than normal. Importantly, the neuropsychological development of children who develop hypothyroidism after age 2–3 years and are treated adequately thereafter is normal.

Goitre in children

As in adults, children may have goitres that are diffuse or nodular and the goitres may be associated with normal, decreased, or increased thyroid function. The causes of goitre in infants, children, and adults are similar, but nodular goitres are rare. Once the goitre is detected, the appropriate diagnostic evaluation and treatment depend on the age of the child, whether thyroid function is abnormal, and the characteristics of the goitre. Some enlargement of the thyroid gland is common in girls at puberty and is not associated with any malfunction of the thyroid gland. Such goitres normally become smaller with age.

Congenital goitre

Although the causes of goitre may be congenital, and sometimes hereditary, the goitre and the thyroid problems that accompany it may not be evident at birth. Goitres caused by dyshormonogenesis, for example Pendred's syndrome associated with deafness, have already been described. Neonatal hyperthyroidism due to Graves' disease can also result in a goitre (see above) (see p. 126).

Acquired goitre in childhood

In worldwide terms, iodine deficiency is the most common cause of a thyroid swelling. If moderate to severe deficiency is present, thyroid failure may be present and require treatment. Chronic autoimmune (Hashimoto's) thyroiditis affects up to 2 per cent of school-aged children in the USA. This goitre is usually diffuse but may be irregular and nodular. It is usually discovered incidentally during a routine examination. Although most children have normal thyroid

function, some have evidence of mild or even overt thyroid failure. Treatment with thyroxine is usually indicated if the TSH is raised and this may result in a decrease in goitre size. Treatment with thyroxine to reduce goitre size if the TSH is normal is usually disappointing. Graves' disease with goitre and hyperthyroidism is much less common and usually occurs in adolescent girls.

Thyroid nodules and cancer in children

Thyroid cancer is rare in children but the children particularly at risk are those previously exposed to radiotherapy to the head or neck. There was an increased incidence of thyroid cancer in children living in the affected areas after exposure to the high doses of radiation that followed the Chernobyl nuclear accident. Twenty years after the accident, the frequency of such childhood cancers is now declining. Thyroid nodules are more likely to be malignant in children than in adults so surgical removal may be appropriate even if findings from fine-needle aspiration cytology suggest benign disease. Thyroid cancer in children aged 10 years or less is more aggressive than in adults and the risk of recurrence is slightly higher. The general principles of management are similar to those in adults (see Chapter 12). Total thyroidectomy followed by TSH suppression is recommended for all patients. Radio-iodine treatment is also usually recommended, especially in children aged less than 10 years and those with evidence of the tumour having spread to the lymph nodes in the neck. Follow-up for life is essential, with regular measurements of thyroglobulin in the blood which is a marker for recurrence of thyroid cancer. The survival rate in children with thyroid cancer appears to be better than that in adults.

❓ Questions and answers

Q.1 I had surgery for Graves' disease many years ago and have been on thyroxine ever since. I am now pregnant. Is there any risk that my baby could have Graves' disease?

A. It is possible for the antibodies that caused your Graves' disease to persist (even though you now need thyroxine) and to transfer to the fetus, causing the baby's thyroid to become overactive. However, this is very uncommon, especially if you do not have any of the extra-thyroidal features such as persistent eye problems or pretibial myxoedema. If it does occur, the baby's heart rate can be controlled by giving you an anti-thyroid drug which will cross the placenta and treat the baby in the uterus. After the baby is born, the overactive thyroid can be treated temporarily. It is a self-limiting condition as your antibodies will clear from the baby over a few weeks.

Q.2 My new baby had a blood test on a sample from a heel prick 5 days after birth. The doctors say that the baby's TSH is high and he should be given thyroxine. Will this be permanent?

A. It is important that your baby is started on thyroxine straightaway so that his mental and physical development will not be impaired. It is likely that he will need thyroxine for life but this can be rechecked when he is a year older by stopping the thyroxine temporarily and rechecking the TSH. If the TSH rises again it will confirm the need for permanent treatment and his development should be normal.

Q.3 My 13-year old daughter has been diagnosed as having Graves' disease and has responded to treatment. She is very self-conscious about her goitre and would like to have it removed. Is this advisable?

A. It is likely that her goitre will shrink with time as she responds to medical treatment so there is no need to rush to surgery which might leave her just as self-conscious about a scar and would also be likely to leave her needing thyroxine replacement for life. Once the condition has settled down, we would be pleased to discuss this with her again and if the goitre remains large we would also consider the alternative of radio-iodine therapy.

Q.4 I am 13 and I do not like having a goitre even though you say my thyroid is working normally. Can I have it removed surgically?

A. It is common for the thyroid to enlarge during puberty and it is likely to become smaller with time. Surgery carries a likelihood that you would develop hypothyroidism and need thyroxine for life, even if there were no other complications, so I would not recommend surgery for a simple goitre at your age. We can reconsider this if your goitre were to get much larger or become overactive, which I think is unlikely.

Q.5 Why should I have an operation if you say the results of the biopsy of my thyroid lump are equivocal?

A. The word 'equivocal' means that we cannot be certain, even after repeating the biopsy, whether the nodule is benign or malignant. We recommend that you have the lump removed in case it is a cancer. If it turns out to be benign, then at least you will not have to worry about it anymore.

15

Miscellaneous disorders of the thyroid gland

A number of miscellaneous disorders of the thyroid gland, not adequately dealt with elsewhere in this book or in need of further consideration, are discussed in this chapter.

Pituitary diseases and the thyroid

Although the relationship between the pituitary gland, its secretion of thyroid-stimulating hormone (TSH), and the thyroid gland has been discussed in Chapter 1, little mention has been made of the thyroid disorders that may develop as a consequence of pituitary disease.

Excessive secretion of thyroid-stimulating hormone (TSH) from the pituitary

Overactivity of the pituitary gland with increased secretion of TSH is a rare cause of thyroid overactivity (p. 69). The clue that leads a doctor to diagnose this is that a person is thyrotoxic with a raised level of thyroid hormones in the blood but surprisingly the TSH level is normal or raised. It is not suppressed as is usually the case because of the operation of the feedback mechanism (p. 3). When increased thyroxine (T_4) or triiodothyronine (T_3) production is caused by a disorder that is primarily in the thyroid gland, the raised level of thyroid hormones switches off the pituitary secretion of TSH.

Although anti-thyroid drugs will reduce the excessive production of thyroid hormones caused by excess TSH secretion from the pituitary and will render the person euthyroid, this treatment will not cure the underlying condition. Attention has to be given to why the pituitary gland is secreting too much TSH. The cause is usually a benign pituitary tumour called a TSHoma. This tumour is usually diagnosed following an MRI scan of the pituitary. The best treatment is by an operation that is done through the back of the nose (the 'trans-sphenoidal' route). Sometimes the whole tumour cannot be removed

surgically and radiotherapy to the pituitary gland is also required to shrink the tumour. If symptoms persist and thyroid hormones remain elevated, medical treatment can be given in the form of drugs called somatostatin analogues which are administered by monthly injections. These drugs are effective in switching off TSH production from the residual tumour and as a consequence reduce the production of thyroid hormones back to normal.

Reduced secretion of thyroid-stimulating hormone (TSH) by the pituitary gland

Failure of the pituitary gland to secrete enough TSH is more common and is the cause of secondary, as opposed to primary, thyroid failure. Lack of enough TSH reduces the secretion of thyroid hormones from the thyroid gland and causes a clinical picture very similar to that which follows primary failure of the thyroid gland (see Chapter 7). However, this picture is often modified by additional features resulting from the diminished secretion of other pituitary hormones which influence growth and sexual development and function, and regulate the adrenal glands.

Reduced secretion of TSH is usually due to either a tumour or to some other damage to the pituitary gland. Thus in addition to failure of the thyroid, there is failure of the other endocrine glands which are regulated by the pituitary. If a tumour of the pituitary is the cause, it may induce local pressure symptoms, such as headache and visual disturbances, because the nerves that carry the signals from the eyes to the brain pass close to the pituitary gland.

If a tumour is present, treatment must be directed at this and replacement therapy must also be given to make good not only the thyroid deficiency but also the deficiencies of the other endocrine glands that are controlled by the pituitary, all or some of which may also be underactive.

An account of the illness of a woman who suffered destruction of her pituitary gland as a result of an unhappy obstetric event is given below. In pregnancy the pituitary gland enlarges and is very dependent on a good blood supply. As described, the blood supply to the pituitary was jeopardized when she had her baby.

ⓘ Patient's perspective

I'm now 39 years old. I got married at the age of 26 after training to be a nurse. My husband is a lawyer and we moved abroad, where I had Benjamin when I was 28. Immediately after he was born I had an enormous haemorrhage. The head nurse told me that my haemoglobin fell to 7 grams per

100 millilitres, whereas my normal level is 14 grams per 100 millilitres. There were no facilities to give me a blood transfusion, which I'm sure they would have done at home. I couldn't feed Benjie because I had no milk.

My periods never came back properly; I just had the odd one, very light, every now and then. Although we take no precautions, I've never become pregnant again. I put on a certain amount of weight and I lost my libido; I just wasn't interested in sex any more. I began to feel tired all the time and lost my sparkle. Also I became constipated, which I'd never been before, and when we returned to England, when Benjie was 4, I couldn't stand the cold.

I went to my doctor in England and she pointed out that the hair under my arms had disappeared and my pubic hair was very sparse, something I hadn't noticed because it happened so slowly. She quickly confirmed that I was hypothyroid, but was surprised that my TSH level was not raised at all. I think it was that which made her realize that my pituitary had packed up. She sent me to a specialist who did a lot of tests one morning. He found that my ovaries and my adrenal glands, as well as my thyroid, were not working properly because most of my pituitary had been destroyed when I had that ghastly post-partum haemorrhage. As a result my pituitary no longer produces enough TSH or the other hormones that should activate my ovaries and adrenals.

I'm feeling fine now—better than I have for years. Of course I have to take a lot of pills, but I'm used to that and never forget. I take my thyroxine for my thyroid, and a steroid called hydrocortisone twice a day for my adrenals, and oestrogens—hormone replacement therapy really—for my inactive ovaries.

This is a very clear account of a woman suffering from Sheehan's syndrome (hypopituitarism following post-partum haemorrhage, see p. 132).

Silent thyroiditis

This is an uncommon cause of hyperthyroidism. It is called 'silent' because the thyroid gland is not tender as in subacute viral thyroiditis (see Chapter 9) nor is it much enlarged. The exact cause is not known. There is no good evidence of a virus infection and it appears to be due to a short-lived autoimmune disorder, similar but not identical to Hashimoto's thyroiditis. It occurs more often in women than men and is particularly common in the post-partum period

(p. 130). Perhaps because of greater awareness, silent thyroiditis seems to be more common in certain states in the USA than it is in Europe. Although it varies from state to state, silent thyroiditis is the cause of hyperthyroidism in about 10 per cent of patients with thyrotoxicosis in the USA.

Silent thyroiditis is a complication of interferon therapy which acts as a strong stimulant of the immune system and is an effective treatment against certain viruses. It is most commonly used in viral infections of the liver (hepatitis B and hepatitis C) and thyroid autoimmune diseases may be unmasked during the course of treatment.

What happens in silent thyroiditis?

If a person develops silent thyroiditis they will become thyrotoxic but the degree of this is seldom severe and it will not cause eye complications. The level of thyroid hormones in the blood will be raised and the TSH depressed. However, the most important finding is that a technetium or radio-iodine scan will show a reduced uptake of the isotope by the thyroid gland because the thyrotoxicosis is due to the release of preformed thyroid hormones stored in the gland. This important difference in radio-isotope uptake distinguishes silent thyroiditis from Graves' disease. In addition, the lack of neck tenderness and blood tests which do not indicate any infection or inflammation make subacute viral thyroiditis less likely (see p. 97).

How is it treated?

Silent thyroiditis is a relatively short-lived condition which resolves spontaneously in 2–6 months. If symptoms are mild, no treatment may be necessary. If they are troublesome, a beta-blocker will prove helpful; if severe, prednisolone is used as in the treatment of viral thyroiditis (see p. 97). The treatments used for Graves' disease (see Chapter 4), such as radio-iodine or thyroidectomy, are not indicated because the thyroiditis resolves within a few months.

Are there any after effects?

In about half of those people who have silent thyroiditis, after the hyperthyroidism has remitted and they have become euthyroid, there follows a phase of hypothyroidism. This is most often seen in post-partum women (see Chapter 13). The phase of thyroid deficiency is usually also short-lived, lasting 2–4 months, but in about a quarter of those affected it is permanent and this will necessitate lifelong thyroxine replacement.

'Non-thyroidal illness'

The non-thyroidal illness pattern of thyroid function tests (formerly called the 'sick euthyroid syndrome') is not really a true thyroid disorder (see p. 17). If a person becomes seriously ill from almost any cause, physical or psychological, the level of T_3 in the blood may drop below normal and in severe cases the T_4 may also become rather low. This may suggest that a person is thyroid deficient but they are not because the level of TSH in the blood is not raised. It is also important to consider and exclude pituitary failure, as the same biochemical pattern can be seen in this condition (see p. 146). As a person recovers from whatever non-thyroidal illness they have, the level of the thyroid hormones returns to normal.

Infiltrative disorders of the thyroid

Riedel's thyroiditis

This is an extremely rare condition in which an enlarging thyroid gland becomes replaced by scarring fibrous tissue. The thyroid may be tender and feels as hard as wood. It is also known as invasive fibrous thyroiditis.

The gland becomes attached to the overlying skin and to deeper structures in the neck so that the windpipe may be constricted and involvement of the nerves to the vocal cords makes the voice weak or husky. Swallowing may be difficult. Without a biopsy it may be difficult to distinguish this condition from an undifferentiated anaplastic cancer (p. 113), and an operation may be required to relieve the constriction of the windpipe. Riedel's thyroiditis is usually slowly progressive but it may also regress spontaneously. Treatment is surgical relief of any obstruction if necessary and prednisolone has been used successfully in some cases. In about half of cases there is enough destruction to cause hypothyroidism requiring thyroxine replacement therapy.

Riedel's thyroiditis may be associated with similar fibrotic changes that involve the covering of the intestines (peritoneal fibrosis), structures in the back of the abdomen (retroperitoneal fibrosis), the duct that carries bile from the liver to the intestines (sclerosing cholangitis), or structures in the centre of the chest (mediastinal fibrosis). The cause of this very rare condition is unknown.

Sarcoidosis

Sarcoidosis is a rare disorder of unknown cause which can affect many organs within the body. It is characterized by the presence of clusters of large cells known as granulomata, which are due to an inflammatory reaction and are

formed by various cells from the immune system. It typically affects young adults and results in enlarged lymph glands, commonly within the neck or chest, and eye and skin problems. Sarcoidosis can cause a diffuse goitre or rarely a solitary thyroid nodule. Occasionally hypothyroidism can result from infiltration of the thyroid tissue.

Haemochromatosis

This hereditary condition causes excess iron deposition in the thyroid gland as well as in other tissues such as the liver and pancreas. The risk for hypothyroidism in men with haemochromatosis is much more common than for men in the general population. Excess iron deposition is also found in children and adults who require multiple blood transfusions throughout life for rare conditions such as beta-thalassaemia major and they are also at risk of developing thyroid failure.

Suppurative (or acute) thyroiditis

In suppurative thyroiditis the thyroid gland becomes infected with pus-forming bacteria such as staphylococci or streptococci, which are the cause of boils, or some other micro-organism. The thyroid gland becomes acutely inflamed and very painful. A high fever will be present and these people are very ill. The infection may spread to other parts of the body. The response to drainage of a pus-filled abscess and an appropriate antibiotic is usually rapid.

Thyroid hormone resistance

This rare congenital and genetic disorder has been described in over 1000 people in the world. It occurs with equal frequency in both sexes and there is evidence of a familial occurrence in approximately 75 per cent. There are mutations in the gene responsible for the thyroid receptors on the cells in the body which fail to respond properly to the thyroid hormones. This results in the body trying to compensate by the thyroid secreting increased amounts of T_4 and T_3. Thus the blood levels of these hormones are high although the TSH level is not suppressed. Because the abnormality in the thyroxine receptors may vary from one tissue or organ to another, the responsiveness of the cells to the excess thyroid hormones also varies. There may be retardation of growth and a delay in the way that the bones mature. Some of the cells in the brain may be relatively unresponsive so that the person has learning difficulties and an attention deficit when concentrating, although the intelligence quotient (IQ) is usually normal. Other tissues continue to respond to the increased amounts of thyroid hormones and this may be manifest by hyperactivity and a rapid heart beat. A goitre is nearly always present.

Most people with thyroid hormone resistance have few symptoms and treatment is not usually required. The diagnosis is important as it allows appropriate family counselling. Symptoms of thyrotoxicosis, particularly a rapid heart beat, can be treated with a beta-blocker. The person may be given high doses of triiodothyronine (T_3) which increases the blood level of this hormone even more above the normal level and this may help to surmount the resistance of the tissues and reduce the size of the goitre.

In the past some people with thyroid hormone resistance have been mistakenly diagnosed as having hyperthyroidism and been subjected to subtotal thyroidectomy or radio-iodine treatment. This was an understandable mistake when the thyroid hormones were greatly increased and there was an increased pulse rate. However, a warning note should have been sounded by finding that the TSH was not suppressed. Those who were operated upon, and made worse, needed higher than normal doses of replacement therapy to provide higher levels of T_4 and T_3 to surmount the tissue's resistance to the thyroid hormones.

The presence of elevated thyroid hormone levels and a normal or raised TSH also raises the possibility of a pituitary tumour producing TSH (a TSHoma) and this needs to be considered and excluded (p. 145). Another more common reason for a raised thyroid hormone and a normal TSH level is interference with the laboratory tests for either T_4 or T_3 by thyroid antibodies (so-called heterophile antibodies).

❓ Questions and answers

Q.1 You say I've got hypopituitarism but my GP says I've got Sheehan's syndrome. Who is right?

A. They're one and the same thing when the pituitary has been damaged as a result of a haemorrhage associated with childbirth. The late Professor Sheehan of Liverpool first clearly described the association.

Q.2 You say my pituitary gland was damaged when I had my post-partum haemorrhage. Will it ever recover?

A. Sometimes it does if the damage is slight but your haemorrhage was severe and occurred many years ago. Judging by the present tests, the damage to your pituitary was severe and I'm afraid there is no chance of any recovery now.

Q.3 I have been told that I have thyroid hormone resistance. Should my children be tested for the same condition?

A. The condition can be familial so it would seem reasonable to screen your parents and your brothers and sisters, if they are agreeable, with a simple blood test. It might help to avoid future misinterpretations of any thyroid function tests that might be undertaken if any of them have the same condition. There is no urgency to test your children while they are very young but it would be appropriate to do so if they were to have any other medical investigation for some reason or when they are old enough to understand.

16

Other diseases associated with thyroid disorders

Autoimmune diseases

Certain people and certain families are more prone to autoimmune diseases than others, hence other autoimmune diseases are associated with thyroid autoimmune disorders. For example, if a person develops Hashimoto's thyroiditis, they may find that their grandmother had Graves' hyperthyroidism. In other words, two different types of autoimmune thyroid disease are occurring in the same family but skipping a generation, as often happens. Autoimmune thyroid diseases certainly run in families, as do other autoimmune diseases, although not all members of a family are so affected. There are several other autoimmune diseases that may rarely occur in the person or a relative of a person with autoimmune thyroid disease.

The following are autoimmune disorders that may sometimes be associated with autoimmune thyroid disease.

Pernicious anaemia

This is a particular type of anaemia in which the body makes antibodies against certain cells in the wall of the stomach. These cells secrete a substance, intrinsic factor, which promotes the absorption of vitamin B_{12} from the intestinal tract which is essential for making red blood cells. It is found in about 10 per cent of people with hypothyroidism due to Hashimoto's thyroiditis and is particularly common in elderly women. Pernicious anaemia is easily corrected by giving injections of vitamin B_{12} every 6 weeks or so.

Type 1 diabetes mellitus

Type 1 diabetes (formerly called insulin-dependent or juvenile-onset diabetes) is the diabetes which usually occurs in young people and requires insulin injections for its control. It is caused by antibodies attacking the islet cells

in the pancreas that secrete the hormone insulin. The presenting symptoms, which may come on quite suddenly, are the passage of large volumes of urine, increased thirst, tiredness, blurred vision, and weight loss. Treatment is by diet and injections of insulin. It occurs with increased incidence in the families of people who have autoimmune thyroid diseases. There is evidence of thyroid autoimmunity in up to one-third of women with type 1 diabetes and post-partum thyroiditis is three times more likely (see p. 130). There is no evidence that type 2 diabetes (non-insulin-dependent or maturity-onset diabetes), which usually occurs in middle-aged and elderly people and is treated by diet, exercise, and tablets, is associated with an increased incidence of thyroid disease.

Addison's disease of the adrenal glands

The adrenal glands are two small endocrine glands which lie just above the kidneys and secrete steroid hormones such as cortisone. These hormones are essential to life and regulate the blood pressure and the response to infections, stress, physical accidents, and surgery. Failure of the adrenal glands was described by Dr Thomas Addison, who was a physician at Guy's Hospital, London, in the mid-nineteenth century, and who was also the first physician to describe pernicious anaemia. In the time of Addison tuberculosis was the most common cause of destruction of the adrenal glands but nowadays the most common cause is autoimmune destruction of the adrenal cells. Adrenal failure is characterized by extreme weakness, dizziness and fatigue, a low blood pressure, which drops further on standing, and darkening of the skin, particularly over the knuckles and the mucous membrane inside the mouth on the gums. It responds well to replacement therapy with hydrocortisone and related steroids taken by mouth. When a person with Hashimoto's thyroiditis also develops Addison's adrenal failure, the condition is known as Schmidt's syndrome. It is important that the adrenal insufficiency component is treated with steroids before thyroxine is started, because if thyroxine is given first, adrenal insufficiency will be made worse, sometimes dangerously so. Adrenal failure itself can also sometimes result in mild thyroid failure or subclinical hypothyroidism (see p. 83). In this situation the thyroid failure will resolve once the person is adequately replaced with hydrocortisone. If the adrenal failure is not recognized and thyroxine is started, it can provide an explanation for the rare occurrence that people's symptoms worsen after commencing thyroxine.

Vitiligo

This is a skin disorder in which patches of white skin devoid of normal pigment develop. It is thought to be due to an autoimmune process directed

against the pigment-producing cells within the skin called melanocytes. Vitiligo is a common associate of all autoimmune diseases and may be looked upon as a 'marker' or an indicator for some autoimmune disorder that may develop in the distant future. As an example, vitiligo is a component of an autoimmune syndrome affecting many hormone-producing glands which is characterized by the presence of autoimmune thyroid disease (usually Hashimoto's thyroiditis or Graves' disease), type 1 diabetes mellitus, Addison's adrenal failure, and pituitary failure, among other disorders.

Alopecia and hair loss

Alopecia is an autoimmune disease which causes patchy loss of hair, usually on the scalp but sometimes in the beard area. The areas of hair loss may be small and few, or they may be quite large.

Generalized hair loss, particularly from the scalp, also occurs in people with hyper- and hypothyroidism. Recovery of the lost hair is always slow after the underlying condition is treated and it may take up to 2 years to return to its previous condition.

Chronic urticaria

Chronic urticaria is defined by the presence of skin eruptions which come and go for a period of at least 6 weeks. The chronic form accounts for approximately 30 per cent of cases of urticaria. External triggers, such as a food or medication, may occasionally be identified. However, in most people with chronic urticaria no external cause can be found. Thyroid antibodies, such as thyroid peroxidase antibodies or antimicrosomal antibodies, are found in up to a quarter of people with chronic autoimmune urticaria. These antibodies may be a reflection of an underlying tendency to develop antibodies against any part of the body. Thyroid status does not necessarily correlate with the presence of urticaria; people who are euthyroid, hypothyroid, or hyperthyroid may have urticaria. People with evidence of thyroid autoimmunity and urticaria are often poorly responsive to standard therapies for urticaria and may have more persistent disease.

Myasthenia gravis

This rare muscle disorder caused by an autoimmune disturbance is said to be more common in people with Graves' disease than in the general population. Often it first affects the muscles of the eyes and leads to double vision. Later, other muscles in the limbs or trunk may become involved. As the day progresses the person experiences increasing weakness and the more they try

to do, the weaker and more tired they become. There may be difficulty in swallowing, the voice becomes nasal, and breathing may become a struggle. The response to medical treatment is usually satisfactory.

Coeliac disease

Coeliac disease (also called gluten-sensitive enteropathy or coeliac sprue) is a condition in which the lining of the small intestine is abnormal because of an abnormal immune reaction to gluten. It improves once gluten (a protein contained in wheat, rye, barley, and a multitude of prepared foods) is eliminated from the diet. Coeliac disease can occur in people of any age and affects both men and women equally. It occurs more commonly in people with autoimmune thyroid disease and in hypothyroidism more often than hyperthyroidism. It can present with weight loss and gastrointestinal symptoms including bloating and diarrhoea. The observation that an increased dose of thyroxine is required in a person who has previously been shown to be on a stable dose for some time may raise the suspicion of coeliac disease. The diagnosis is confirmed by detecting certain antibodies produced by people with coeliac disease and a biopsy of the small intestine performed by an endoscopy.

Because of these associations, doctors may do tests unrelated to the thyroid condition to make sure that people do not develop some other incipient autoimmune disorder, such as pernicious anaemia, which may declare itself later in life (see Chapter 17). The following is an account from a woman who started with Graves' disease and then developed diabetes, only later to have pernicious anaemia associated with vitiligo and ending up with hypothyroidism due to Hashimoto's disease:

🛈 Patient's perspective

I'm now aged 55. I trained as a lawyer but all my working life I've been in local government. At the age of 12, I developed Graves' disease. I remember eating like a horse, but despite this I lost a lot of weight. My eyes became slightly starey. I was very clumsy and was always dropping things. My overactive thyroid was brought under control with anti-thyroid tablets, and everything was all right until, at the age of 17, I began to lose weight again. I was very thirsty and used to take a jug of water to bed with me. My sleep was disturbed by having to get up several times at night to pass urine. Our doctor found that I'd developed diabetes, and this was treated with diet and twice-daily insulin injections, which I soon got used to. When I was 30 I was made deputy head of the department. Normally I'm pretty lively,

but I became tired and my aunt commented on how pale I'd become. I'd also developed some funny white patches on my forearms. The doctor at the hospital where I go for my diabetes found that I'd developed pernicious anaemia. This quickly responded to injections of vitamin B_{12}, which I was given by our family doctor, but I could have given them myself as I'm used to injecting myself with insulin. I remained very well until I was aged about 45 when I began to feel the cold terribly and used to complain to the engineer at the Town Hall where I worked about the temperature in my office. He took no notice of me and I wore thicker clothes in a vain attempt to keep warm. Not until the next winter did I mention this to my family doctor and he spotted that I'd become thyroid deficient. Apparently I'd developed another sort of thyroid trouble called Hashimoto's thyroiditis, but there was no swelling in my neck like there was when I had Graves' disease. The hypothyroidism was put right by giving me thyroxine. I feel fine now. I take my thyroxine tablets every day, have my vitamin injection every month, and give my insulin injections twice daily.

Connective tissue diseases

Connective tissue disease is the name given to a group of disorders of skin, joints, and bones. The frequency of thyroid disease, particularly Hashimoto's thyroiditis, may be increased in people with connective tissue diseases. Many connective tissue diseases are caused by an autoimmune process. Both thyroid hormone deficiency and connective tissue diseases often cause muscle and joint aches, pain, and stiffness. Common treatments for connective tissue diseases and the illnesses themselves may affect thyroid function or thyroid function tests. Even if thyroid disease and connective tissue disease are associated, there is no evidence that their concurrence alters the symptoms or natural history of either disorder.

Antinuclear antibodies in people with thyroid disease

The antinuclear antibodies (ANA) test is a blood test that is commonly used when evaluating those who are suspected of having an autoimmune or connective tissue disorder. The ANA test identifies autoantibodies that target substances contained in the nucleus of cells. Symptoms of autoimmune and connective tissue disorders vary from person to person and may be difficult to diagnose. Doctors often use the ANA test when an autoimmune disease is suspected. A positive ANA test, by itself, does not establish a diagnosis but in combination with a particular person's symptoms, a thorough physical

examination, and other laboratory testing, a positive test may help to establish a diagnosis. Antinuclear antibodies have been detected in the blood of some people with both Graves' disease and Hashimoto's thyroiditis.

Systemic lupus erythematosus

When doctors suspect that a person has systemic lupus erythematosus (SLE), the ANA test plays an important role in the diagnosis. SLE is a chronic inflammatory disease that can affect many parts of the body, including the skin, joints, kidneys, lungs, nervous system, blood vessels, and immune system. Because the severity and symptoms of SLE differ from person to person, laboratory tests (including testing for antinuclear antibodies) provide information that can be valuable in helping physicians make a diagnosis of SLE. The ANA test is considered the best diagnostic test for SLE and it is typically performed whenever a doctor suspects a person has SLE.

Approximately 15–20 per cent of people with SLE have thyroid antibodies. Subclinical or overt hypothyroidism is more common than hyperthyroidism in most studies. Part of the association between SLE and thyroid disease may be due to genetic factors and a shared chromosome abnormality has been demonstrated between these two related autoimmune conditions.

Polymyalgia rheumatica and giant cell arteritis

These two diseases are related. The first is characterized by pains in the muscles and joints. Giant cell arteritis, or cranial arteritis as it is also called, gives rise to headaches, fever, and general malaise. Treatment for both conditions is with corticosteroids in carefully controlled doses. Either may occasionally be associated with hypothyroidism caused by Hashimoto's thyroiditis and may occur before or after the thyroid deficiency declares itself.

Fibromyalgia

Fibromyalgia is a chronic pain disorder of unknown cause. Many physical and emotional stressors may trigger or aggravate symptoms, including certain infections, such as a viral illness, or physical trauma. The diagnosis is currently based upon the presence of widespread musculoskeletal pain and excess tenderness at certain sites of the body. There have been suggestions that reduced thyroid hormone activity may be associated but the importance of this finding is unclear. The effects on thyroid hormone may be due to an increase in cortisol secretion from the adrenal gland, due either to the fibromyalgia itself or to the depression that often accompanies it.

Sjögren's syndrome

Sjögren's syndrome is a chronic inflammatory disorder characterized primarily by diminished lacrimal and salivary gland secretions resulting in symptoms of dry eyes and dry mouth. Estimates of the prevalence of thyroid disease in people with Sjögren's syndrome vary widely, ranging from 10 to 70 per cent.

Rheumatoid arthritis

Rheumatoid arthritis is a chronic inflammatory disorder that primarily involves joints. The arthritis is usually symmetrical and may be remitting but if uncontrolled may lead to destruction of joints due to erosion of cartilage and bone which leads to deformity. Approximately one-third of people with rheumatoid arthritis have been found to have some evidence of thyroid disease. This compares with approximately 10 per cent of people with osteoarthritis or fibromyalgia. The frequency of thyroid antibodies may also be increased in those with rheumatoid arthritis.

Scleroderma

The term scleroderma is used to describe the presence of thickened hardened skin. Scleroderma may be a clinical feature of a limited area of the skin and adjacent tissues or it may be associated with generalized body involvement; the latter is referred to as systemic sclerosis. The most common manifestation is an abnormality of the blood vessels of the hands and feet called Raynaud's phenomenon. Other organs that can be involved include the kidney, lungs, heart, and gut. In this disorder, fibrosis of the thyroid gland can occur which can directly cause hypothyroidism. This occurs independently of chronic autoimmune thyroiditis.

Chromosomal disorders in children

Children with some chromosomal disorders are at increased risk for chronic autoimmune thyroiditis, and to a lesser extent hypothyroidism. These include Down syndrome (trisomy 21) and Turner's syndrome. For this reason regular blood tests for thyroid function are performed (see Chapter 17).

Down syndrome

Down syndrome is the most common chromosomal abnormality in newborns, occurring in about 1 in 700 live births. The syndrome is due to an extra copy of chromosome 21 (three instead of two copies). For this reason, Down syndrome is also called trisomy 21. Chromosomes are the structures in cells that

contain the genetic information passed from parents to their children. Each parent contributes one chromosome, but children with Down syndrome have three copies of chromosome 21. The extra chromosome may come from either parent.

Individuals with Down syndrome typically have several of the following characteristics: moderate to severe learning disability, short stature, distinct facial features, abnormalities of the heart and gastrointestinal system, and vision and hearing problems. Children with Down syndrome often have high blood thyroid antibody concentrations and evidence of subclinical and overt hypothyroidism. Hyperthyroidism also occurs but is less common. One-third of children are hypothyroid by the age of 25 years, therefore regular checks of thyroid function are performed in all children with Down syndrome.

Turner's syndrome

Turner's syndrome, which is usually caused by loss of part or all of an X chromosome, is an important cause of short stature in girls and the absence of periods in young women. The reported incidence of hypothyroidism in adults with Turner's syndrome is 25–30 per cent; up to 50 per cent have thyroid antibodies. Hyperthyroidism is not reported as being more common.

❓ Questions and answers

Q.1 Are these other autoimmune disorders common in people like me with thyroid disease? How likely am I to get one?

A. They are more common than in the general population but it is difficult to give you precise figures. All of us have had experience of the occasional patient with autoimmune thyroid disease of one sort or another who, for example, has developed pernicious anaemia later in life.

Q.2 My grandmother says that she had myxoedema 20 years ago; she's on thyroxine. Now you tell me I've got an overactive thyroid gland. Is there any connection?

A. Yes, there is. You and your grandmother both have autoimmune thyroid diseases of different kinds and this does tend to run in families.

Q.3 I've had Hashimoto's thyroiditis for years and now you tell me I've got pernicious anaemia. What is going to happen to me next?

A. Nothing more I hope, but we should keep a regular eye on you in the remote possibility of yet another autoimmune disease developing.

Q.4 My GP has found me to be anaemic and put me on iron but it hasn't improved. I've been on thyroxine tablets for years and my thyroid function tests have been stable for years, but recently they have changed. Are these two problems related?

A. Taking iron might alter the absorption of your thyroxine and therefore might explain why your thyroid function test has changed. We should look for the cause of your anaemia, which might be due to some other condition such as coeliac disease which can affect the absorption of thyroxine. We can do some further tests.

17

Who should be tested for thyroid problems?

Testing the healthy adult population

It is desirable to detect any disease in its early stages, particularly when treatment is available which will benefit the affected person and forestall or improve the natural history of the condition. Screening is the identification of unrecognized disease by an investigation which can be rapidly performed to disitinguish apparently well persons who probably have a disease from those who probably do not. In general, screening is justified under the following conditions.

1. A disease is common and associated with significant ill-health and mortality.

2. When screening tests are sufficiently accurate in detecting disease at an early stage and are acceptable and feasible to the population.

3. When treatment after detection by screening has been shown to improve prognosis relative to treatment after the usual diagnosis.

4. When evidence exists that the potential benefits outweigh the potential harms and costs of screening.

Controversy exists concerning whether or not healthy adults in communities with adequate iodine intake would benefit from screening for autoimmune thyroid disease. Although the prevalence of unsuspected overt hypothyroidism or hyperthyroidism is low, a significant proportion of subjects will have evidence of mild thyroid failure or excess when tested. The evidence currently available suggests that detection and treatment of subclinical thyroid disease found on screening a healthy person without symptoms is not warranted. The reason is that there have been no clinical trials to determine whether identification and treatment of subjects with thyroid dysfunction, which would mostly be

subclinical hypothyroidism, results in any long-term benefit. The potential benefits in treating subclinical hypothyroidism in terms of decreased symptoms or other systemic effects are generally small and may not enhance quality of life (see p. 83). Any potential benefits of therapy in subclinical hyperthyroidism must be weighed against the possible ill-health associated with the treatment of thyrotoxicosis (see p. 67). However, case-finding in women at or after the menopause or if visiting a doctor in primary care with symptoms such as lethargy and general malaise is justified in view of the high prevalence of mild thyroid failure.

Measurement of TSH alone as the only initial blood test may be cost effective for a wide range of clinical purposes, including screening and case finding, but it may be inappropriate in some specific clinical settings. Measurement of both TSH and T_4 is essential in the following situations.

1. When optimizing thyroxine therapy in newly diagnosed patients with hypothyroidism if TSH is not normalized.

2. Diagnosing and monitoring thyroid disorders in pregnancy.

3. Monitoring patients with hyperthyroidism in the early months after treatment.

4. Diagnosis of pituitary failure and its subsequent monitoring and treatment.

5. Diagnosing thyroid hormone resistance (see p. 150).

6. Diagnosis and treatment of TSH-secreting pituitary adenomas (see p. 145).

Measurement of TSH alone is appropriate after the initial investigation in the future follow-up of individuals who have not been treated for thyroid disorders and who may be at risk of developing future thyroid dysfunction, for example subclinical hypothyroidism.

If screening is performed and a high TSH concentration is found with a normal T_4, the measurement should be repeated 3–6 months later after excluding non-thyroidal illness and drug interference. If the TSH is greater than 10 milliunits per litre and the T_4 level is low, the subject has overt hypothyroidism and should be treated with thyroxine. If the T_4 concentration is normal but the serum TSH is greater than 10 milliunits per litre, treatment with thyroxine is recommended. If the serum TSH concentration is above the reference range but less

than 10 milliunits per litre, thyroid peroxidase antibodies should be measured. If this antibody concentration is high, TSH should be measured annually or earlier if symptoms develop; thyroxine therapy should be started if the TSH concentration rises above 10 milliunits per litre. If the antibody concentration is not raised, repeat measurement of TSH approximately every 3 years is all that is required. Although there is no evidence to support the benefit of routine early treatment with thyroxine in non-pregnant people with a TSH above the reference range but less than 10 milliunits per litre, doctors will consider the suitability of a therapeutic trial of thyroxine on an individual person basis.

If a TSH concentration below the reference range but greater than 0.1 milliunits per litre is found, the measurement should be repeated 1–2 months later together with free T_4 and free T_3, after excluding non-thyroidal illness and drug interferences. If the TSH is less than 0.1 milliunits per litre, T_4 and T_3 must be measured to exclude overt hyperthyroidism. If treatment is not undertaken, TSH should be measured every 6–12 months with follow-up measurements of T_4 and T_3 if the TSH result is low.

Congenital hypothyroidism

Congenital hypothyroidism affects about 1 in 3500 newborns and is the most treatable cause of mental retardation (see p. 138). Iodine deficiency, particularly in preterm infants, still accounts for many cases of congenital hypothyroidism in Europe, Asia, and Africa. The clinical diagnosis is made at birth in less than 5 per cent of newborns with hypothyroidism because the symptoms and signs are often minimal. The value of screening for congenital hypothyroidism in heel-prick blood specimens is unquestioned and it is now done routinely in many countries.

Which conditions require at least one test of thyroid function?

There are certain conditions or diagnoses within the adult population that should trigger an assessment of thyroid function at least once to detect or exclude possible thyroid abnormalities which may not be clinically obvious to the doctor. They include the following.

1. Atrial fibrillation as this can be caused by thyrotoxicosis (see p. 36).

2. High blood cholesterol which can result from hypothyroidism and resolve once the thyroid failure is treated (see p. 79).

3. A suspected goitre (diffuse, multinodular, or single nodule) to evaluate for hypothyroidism or hyperthyroidism (see p. 7).

4. Osteoporosis which can result from hyperthyroidism (see p. 68).

5. Subfertility, abnormal menstrual cycles and recurrent miscarriages can be caused by either hyperthyroidism (see p. 125) or hypothyroidism (see p. 128).

6. Women with type 1 diabetes should have a test of thyroid function before any possible pregnancy, including their thyroid peroxidase antibody status, as they are three times more likely to develop post-partum thyroid dysfunction (see p. 130). There is currently no recommendation for the routine testing of other women for thyroid dysfunction before or during a pregnancy.

The occurrence of thyroid disease in people hospitalized for acute illness is no more common than in the general population. Therefore testing should be limited but with a high index of clinical suspicion, particularly in elderly women, and with an awareness of the difficulties in interpreting thyroid function tests in the presence of acute or chronic non-thyroidal illness. Unless clinically indicated, caution is also required in the investigation of thyroid function in acute psychiatric disturbances and clinical depression since non-thyroidal illness and medication which affect thyroid function are both common and may prompt inappropriate intervention (see p. 149).

Surveillance of thyroid function tests

The following situations require long-term regular checks of thyroid function.

Following destructive treatment for thyrotoxicosis by either radio-iodine or surgery

After destructive treatment of thyrotoxicosis with radio-iodine or thyroidectomy the incidence of overt hypothyroidism is greatest in the first year (see Chapter 5). Hypothyroidism is more likely to occur in people who receive higher doses of radio-iodine (above 10 millicuries or 370 megabecquerel) or who have a near-total thyroidectomy. Hypothyroidism post radio-iodine is also more common in people with Graves' thyrotoxicosis than with nodular goitre. Of people who have subclinical hypothyroidism a year or more after

radio-iodine treatment, 1 in 20 will progress to overt hypothyroidism per year (see p. 45).

Recurrence of hyperthyroidism after radio-iodine is rare so surveillance is largely targeted at detecting hypothyroidism. In contrast, recurrent hyperthyroidism occurs more frequently after partial thyroidectomy and follow-up should test for both hypothyroidism and recurrent hyperthyroidism. Thyroid function should be assessed about 4–8 weeks post-treatment, then every 3 months up to 1 year and annually thereafter.

Treatment of thyrotoxicosis with anti-thyroid drugs

Anti-thyroid drugs (carbimazole, methimazole, and propylthiouracil) decrease thyroid hormone secretion and are used in the management of thyrotoxicosis (see Chapter 5). It is recommended that thyroid function is tested every 1–3 months when initiating therapy until stable and annually if used as a long-term treatment option.

Thyroxine replacement therapy

Once hypothyroidism has been diagnosed and the appropriate dose of thyroxine has been established, the dose remains constant in most people. In pregnancy there may be a need to increase the dose by at least 50 micrograms daily to maintain a normal serum TSH which should be measured early in the pregnancy and then at 16 and 28 weeks in the pregnancy.

People with hypothyroidism who are taking thyroxine may become hypothyroid if given drugs which decrease thyroxine absorption, such as colestyramine and iron salts, or increase its clearance, such as the anti-epileptic drugs phenytoin and carbamazepine. Oestrogen therapy may increase the need for thyroxine because of an oestrogen-induced increase in the serum concentration of thyroxine-binding globulin. Poor compliance with thyroxine therapy or suboptimal treatment may also result in hypothyroidism. There is evidence from community studies that as many as half of all people undergoing treatment for hypothyroidism have TSH levels outside the reference range. Once thyroxine replacement is initiated, for whatever indication, long-term follow-up with at least an annual measurement of TSH is required to check compliance and dosage and take account of variations in dosage requirement caused by concomitant drug treatment.

People who have hypothyroidism due to treatment with thyroidectomy and radio-iodine for papillary and follicular thyroid cancer should undergo annual monitoring to ensure that the TSH remains adequately suppressed.

Post-partum thyroiditis

Women who have had an episode of post-partum thyroiditis have a risk of developing post-partum thyroiditis following future pregnancies and a risk of subsequent permanent hypothyroidism. All such women should be offered a check of thyroid function annually and should also be tested prior to and at 6–8 weeks after any future pregnancies.

Diabetes mellitus

There is a high frequency of thyroid abnormalities in people with type 1 diabetes and an annual test of thyroid function should be performed (see p. 153). People newly diagnosed with type 2 diabetes should have their thyroid function checked but if it is normal subsequent routine monitoring of thyroid function is not usually required.

Down's syndrome and Turner's syndrome

In view of the high incidence of hypothyroidism in Down's syndrome and Turner's syndrome, all adults and children should have an annual check of thyroid function (see pp. 159 and 160).

Amiodarone therapy

Amiodarone is a drug used for heart rhythm abnormalities which contains high amounts of iodine. It is frequently associated with iodide-induced thyroid dysfunction. Amiodarone-induced hyperthyroidism is particularly prevalent (10 per cent) in areas of iodine deficiency and in people with underlying thyroid disease. Amiodarone-induced hypothyroidism is more common in iodine-replete communities (up to 20 per cent) and related to the presence of thyroid autoimmunity. All people on amiodarone therapy should have their thyroid function tested before commencing treatment and should then be routinely monitored every 6 months thereafter while on treatment and up to 12 months after cessation of therapy (see pp. 68 and 74).

Lithium therapy

Lithium, which is used in the treatment of bipolar depression, is associated with mild and overt hypothyroidism in up to 34 per cent and 15 per cent of people, respectively, and can appear abruptly even after many years of treatment. Lithium-associated thyrotoxicosis is rare and occurs mainly after long-term use. All patients on lithium therapy should have their thyroid function tested

before commencing treatment and should then be routinely monitored every 6–12 months while on treatment (see p. 74).

After neck surgery or irradiation

The incidence of hypothyroidism after neck surgery, external radiation therapy of the neck or both in people with head and neck cancer (including lymphoma) is as high as 50 per cent within the first year after treatment. The risk is highest in those who have undergone surgery and received high doses of radiation. The effect is dose dependent, the onset is gradual, and subclinical hypothyroidism can be present for many years prior to the development of overt disease. Thyroid function should be tested every 12 months.

18

Who should be referred to a thyroid specialist?

The pattern of referral to a specialist will depend on the following:

1. The presenting symptoms and signs.

2. The expertise of the doctor making the referral.

3. Access to a specialist.

4. Local circumstances.

5. Patient preference.

The clinical team managing a person with thyroid disease should have the following expertise or facilities:

1. A specialist trained in endocrinology and thyroid disorders.

2. Access to the latest thyroid function tests.

3. Access to nuclear medicine facilities.

4. Access to a specialist ophthalmology opinion.

5. Access to an experienced thyroid surgeon.

6. A clear treatment and monitoring plan with an understanding of the risks, benefits, and individual appropriateness of different treatment modalities.

7. Awareness of the psychological needs of people with thyroid disease and access to a specialist nurse or patient self-help groups for support as necessary.

8. Availability of informed staff to discuss any queries after the initial consultation (e.g. a specialist nurse).

Hyperthyroidism

Any person with hyperthyroidism can reasonably expect to be referred to an endocrinologist for a specialist opinion at diagnosis. If the person has no features of hyperthyroidism, treatment does not need to be initiated by a family doctor in primary care. If the person has features of hyperthyroidism, treatment may be initiated in primary care while waiting for the specialist assessment. Beta-blockers are the first choice unless contraindicated. Anti-thyroid drugs may be initiated in primary care after confirmatory thyroid function tests if beta-blockers are contraindicated or in addition to beta-blockers if features of hyperthyroidism are marked. Specialist advice should be sought for treating hyperthyroidism in pregnancy or in breast-feeding women.

Hypothyroidism

Most people with hypothyroidism will be managed by their family doctor within primary care. However, a person with hypothyroidism can expect to be referred for a specialist opinion under the following circumstances.

1. Aged less than 16.

2. Pregnant or post-partum.

3. Any evidence of pituitary disease.

4. Particular management problems, for example ischaemic heart disease or treatment with amiodarone or lithium.

5. People whose TSH level fails to return to within the reference range despite a dose of 200 micrograms or more of thyroxine after compliance has been checked.

6. People who continue to be symptomatic despite apparently adequate thyroxine replacement.

Investigation of goitre and thyroid nodules

Thyroid cancer usually presents with a lump in the neck which may be solitary or multinodular. There are often no other symptoms or signs. As benign thyroid nodules are very common, the presence of associated symptoms may indicate that the tumour is more aggressive or has spread to a distant site.

The presence of any of the following symptoms or signs may be indications for urgent referral to a specialist and such people should preferably be seen within 2 weeks.

- ◆ Thyroid lump newly presenting or increasing in size.

- ◆ Thyroid lump in a person with a family history of thyroid cancer.

- ◆ Thyroid lump in a person with a history of previous neck irradiation.

- ◆ Thyroid lump or swelling in the very young (less than 10 years) or older (more than 65 years) people, especially men.

- ◆ Unexplained hoarseness or voice changes associated with a goitre.

- ◆ Lymph nodes palpable in the neck.

- ◆ The presence of pressure symptoms in the neck such as difficulty in breathing (stridor) or swallowing (see p. 114).

Appropriate investigations pending specialist appointment include thyroid function tests. People with a thyroid nodule who have normal thyroid function may have thyroid cancer and should be referred to a member of the multidisciplinary thyroid cancer team. People with hypothyroidism or hyperthyroidism and a nodular goitre should be referred routinely to an endocrinologist. Other investigations (e.g. thyroid ultrasound) are not required and are likely to result in unnecessary delay in diagnosis.

People with suspected thyroid cancer should be referred to a surgeon or endocrinologist with a specialist interest in the condition who is a member of the thyroid cancer multidisciplinary team (MDT). A clinical oncologist or nuclear medicine physician may also be an appropriate member of the MDT. All members of the MDT will be working according to guidelines. The treatment plan and care of each newly diagnosed person with thyroid cancer should be discussed and supervised by the core team (physician, surgeon, and oncologist) in consultation with other members of the MDT. Close communication between all the team members is essential to delivering optimal care.

Glossary of terms

Addison's disease This disease is the consequence of failure of the adrenal glands, usually caused by an autoimmune disorder. It may be associated with autoimmune thyroid disease.

Adrenal glands Two small endocrine glands which lie on top of the kidneys and secrete cortisone-like steroid hormones. Normal function is essential for life.

Agranulocytosis A disappearance of the neutrophils from the blood which may occur as a rare side effect of treatment with anti-thyroid drugs. The loss of this type of white blood cell renders a person liable to any intercurrent infection.

Alopecia An autoimmune disease causing patchy loss of scalp hair.

Amiodarone A drug used to correct abnormal heart rhythms which contains a high amount of iodine and may affect thyroid function.

Anaplastic A word used to describe very undifferentiated cancer cells which are aggressively malignant.

Antibodies Proteins present in the blood that are formed by lymphocytes (a particular type of white blood cell) in response to invasion by any foreign protein (antigen). Such proteins constitute a defence against any viruses and bacteria that may be encountered. Auto-antibodies are antibodies that react against certain of the body's own tissues, such as thyroid cells, which are important in the causation of autoimmune thyroid disorders, such as Graves' disease and Hashimoto's disease.

Antinuclear antibodies The antinuclear antibodies (ANA) test is a blood test used when evaluating those who are suspected of having a connective tissue disorder. The ANA test identifies auto-antibodies that target substances contained in the nucleus of cells. ANA have been detected in the blood of some people with autoimmune thyroid disease.

Anti-thyroid drugs The group of drugs called the thionamides, which include carbimazole, propylthiouracil, and methimazole, which suppress hormone manufacture by the cells in the thyroid gland.

Apathetic hyperthyroidism A rare presentation of hyperthyroidism usually seen in older people.

Atrial fibrillation An irregular, and often fast, beating of the heart, which is common in elderly people with hyperthyroidism and associated with a risk of stroke.

Atrophic Destruction of a tissue or an organ which becomes wasted and fibrosed as seen in atrophic hypothyroidism.

Autoimmune disease A disease which results from the body making antibodies that attack its own normal cells and tissues. Examples include Graves' disease, Hashimoto's thyroiditis, and Addison's disease.

Benign Not malignant or cancerous.

Beta-adrenergic blocking drugs These slow the heart rate, reduce palpitations and sweating, and improve some of the other features of thyroid overactivity, but do not cure the underlying disease.

Beta-blockers A colloquial name for beta-adrenergic blocking drugs, such as propranolol or atenolol.

Biopsy A term used to describe the removal of a small piece of tissue in order to examine it under the microscope. A biopsy of the thyroid gland may be made with little discomfort by a fine-needle aspiration or during a surgical operation.

Calcitonin A hormone secreted by the medullary, C-, or parafollicular cells which reside in the thyroid gland but are not of thyroid origin. Calcitonin influences the calcium level in the blood and the amount of calcium in the bones. Measurement of the calcitonin level can be used as a marker to assess the effectiveness of treatment of a medullary cell carcinoma.

Carbimazole A commonly used anti-thyroid drug which works by blocking the amount of iodine that can enter the thyroid gland from the bloodstream thus reducing its ability to manufacture thyroid hormones.

Carcinoma Cancer. A differentiated carcinoma of the thyroid gland is one of the malignant diseases that is most amenable to treatment. An undifferentiated (anaplastic) carcinoma is more invasive.

Carrier proteins Substances to which the thyroid hormones are loosely attached as they are transported round the body in the bloodstream (see thyroxine-binding globulin).

CAT or CT scan Computer-assisted tomography is a special type of X-ray examination, used in thyroid disorders to examine particularly the eye changes in Graves' disease and sometimes a retrosternal goitre and compression or displacement of the windpipe.

Cholesterol A particular type of fat found in the bloodstream. The level may be raised in hypothyroidism and decreased in hyperthyroidism, but it is also affected by many other factors such as inherited disorders of cholesterol or diabetes mellitus.

Chronic lymphocytic goitre Another name for Hashimoto's thyroiditis.

Coeliac disease A condition (also called gluten-sensitive enteropathy or coeliac sprue) in which the lining of the small intestine is abnormal because of an immune system reaction against gluten, resulting in poor absorption of nutrients. The diagnosis is confirmed by detecting certain antibodies and a biopsy of the small intestine performed by an endoscopy. It is treated with a gluten-free diet (e.g. avoiding wheat and its products).

'Cold' nodule A nodule in the thyroid gland which does not take up a radio-isotope such as technetium or radio-iodine.

Colloid The protein substance which contains stored thyroid hormones within the thyroid gland.

Congenital Existing at birth. A baby may be born with congenital hypothyroidism.

Connective tissue diseases A group of disorders of skin, joints, and bones, often due to an autoimmune process, some of which are associated with auto-immune thyroid disorders.

Corticosteroids Also called 'steroids'; cortisone-like hormones secreted by the adrenal (suprarenal) glands and as drugs used to suppress an autoimmune response.

Cortisone A steroid hormone secreted by the adrenal glands which is essential for life and regulates the blood pressure and the response to infections, stress, physical accidents, and surgery.

Cretinism Thyroid deficiency occurring in an infant or child and associated with impaired mental development.

CRP C-reactive protein; a protein produced by the liver which is a marker of inflammation in the blood.

CT scan See CAT scan.

Cyst A hollow tumour, usually benign, which may contain fluid.

Decompression Surgical decompression of the bony orbits, in which the eyes lie, may be necessary to reduce the intra-orbital pressure in severe ophthalmopathy.

Deiodinases Enzymes which remove iodine molecules from thyroxine (T_4) and triiodothyronine (T_3).

de Quervain's thyroiditis The same as subacute viral thyroiditis.

Diabetes mellitus Type 1 diabetes (formerly called juvenile-onset or insulin-dependent diabetes) usually occurs in young people and requires insulin injections. It is caused by antibodies attacking the islet cells in the pancreas that secrete the insulin. Type 2 diabetes (maturity-onset or non-insulin–dependent diabetes) usually occurs in middle-aged and elderly people and is treated by diet, exercise, tablets, and sometimes also requires the addition of insulin.

Diffuse (toxic) goitre Another name for Graves' or von Basedow's disease. 'Diffuse' because the whole gland is generally enlarged, and 'toxic' because excess secretion of the thyroid hormones induces thyrotoxicosis.

Diplopia Double vision as may occur in Graves' ophthalmopathy.

Down syndrome This is the most common chromosomal abnormality in newborns and is due to three copies of chromosome 21 (also called trisomy 21). Individuals with Down syndrome typically have learning disability, short stature, distinct facial features, abnormalities of the heart and gastrointestinal system, and vision and hearing problems. Adults and children with this disorder have an increased risk of thyroid disorders.

Dyshormonogenesis A defect in one or more of the several chemical steps that take place in the manufacture of thyroid hormones. The defect varies in severity and may be a rare cause of thyroid underactivity and goitre in infancy or childhood.

Dysphagia Difficulty swallowing.

Dyspnoea Shortness of breath.

Endemic goitre When more than 20 per cent of a population surveyed is found to have a goitre, the goitre is said to be endemic.

Endocrine gland A gland that forms a hormone which it secretes into the bloodstream. These chemical messengers affect cells and tissues far removed from where they are produced.

Erythrocyte sedimentation rate (ESR) A non-specific test to see if a person is ill, commonly as the result of some infection. It measures the rate at which the red blood cells settle in a glass tube in 1 hour. It is now often replaced by the CRP.

Euthyroid This means that a person has normal levels of thyroid hormones in the blood and that there is no under- or overactivity of the thyroid gland.

Evidence-based medicine Advice a doctor gives or what medication is prescribed should be justified from scientifically controlled studies and trials. Based on such evidence a number of best-practice protocols have been published for specific thyroid diseases by authoritative bodies from the UK, Europe, and the USA. Increased adherence to these protocols by doctors has improved standards of care and standardized treatment for patients as much as possible.

Exophthalmometer An instrument for measuring the degree of protrusion of the eyeballs.

Exophthalmos Also known as proptosis.

Fibrosis The deposition of fibrous connective tissue (scarring) in an organ that has been subjected to injury, usually inflammation, as may occur in the thyroid gland late in the course of Hashimoto's thyroiditis.

Fibromyalgia A chronic pain disorder of unknown cause with the presence of widespread musculoskeletal pain and excess tenderness at certain sites of the body.

Fine-needle aspiration biopsy A virtually painless procedure carried out on an outpatient basis in which thyroid tissue or fluid containing some cells is sucked through a fine needle into a syringe for examination under a microscope. A careful study of the cells can usually indicate if a thyroid nodule is benign or malignant.

Follicle An organization of normal thyroid cells surrounding a reservoir of colloid which stores thyroid hormones.

Follicular thyroid cancer Malignant change of the cells of the follicle.

Free thyroxine (T_4) level This test measures the tiny amount of thyroxine that is present in the water of the blood, which is a fraction of the very much larger amount that is loosely bound to the thyroxine-binding carrier proteins. The advantage of measuring the unbound 'free' thyroxine is that the level is less influenced by changes in the amount of transport protein. It is this free thyroxine which determines the thyroid status of a person. For this reason in many centres measurement of the free thyroxine is now used as a first-line test of thyroid function in preference to total thyroxine. The normal reference range for free T_4 will depend on the exact technique used but, in round numbers, it is usually about 9–25 picomoles per litre (pmol/L). Levels greater than 26 picomoles per litre occur in most cases of hyperthyroidism, and below eight picomoles per litre in thyroid deficiency. The more severe the thyrotoxicosis, the higher will be the free T_4 level, and the more severe the hypothyroidism, the lower will be the free T_4. Occasionally the free T_4 test gives misleading results if certain interfering antibodies or an unusual albumin carrier protein are present in the blood. Low levels may sometimes occur in a variety of non-thyroidal illnesses (see 'Non-thyroidal illness').

Free triiodothyronine (T_3) level This test measures the level of unbound 'free' T_3 in the blood. In normal people the reference range is of the order of about 3–9 picomoles per litre but varies according to the technique used. Free T_3 is particularly useful in the diagnosis of hyperthyroidism because it may rise some weeks or months before the free thyroxine (free T_4) level does. Indeed, there are some patients with thyrotoxicosis who never develop a raised free T_4 level (so-called T_3-toxicosis). The free T_3 level is of little use in diagnosing hypothyroidism compared with the free T_4. The failing thyroid gland finds it easier to produce triiodothyronine and the level of free T_3 falls much later than that of free T_4 and is often normal even in severe hypothyroidism. Low free T_3 levels are common in people suffering from any non-thyroidal physical or psychiatric disease (see 'Non-thyroidal illness').

Gestational hyperthyroidism This is a transient episode of mild hyperthyroidism associated with severe vomiting which occurs early in pregnancy (hyperemesis gravidarum) and is caused by an excessively high level of hCG.

Goitre Any enlargement of the thyroid gland is called a goitre. The word is spelt goiter in the USA.

Graves' disease An autoimmune disorder of the thyroid gland, named after the Irish physician who described it, which causes overactivity and increased levels of T_4 and/or T_3 in the blood (see von Basedow's disease).

Haemochromatosis An inherited condition which causes excess iron deposition in the thyroid gland, as well as other tissues such as the liver and pancreas.

Hashimoto's thyroiditis An autoimmune disorder of the thyroid gland, named after the Japanese surgeon who first described it, which may induce thyroid enlargement (goitre) and later causes underactivity of the thyroid gland (hypothyroidism).

Hashitoxicosis A temporary episode of hyperthyroidism in a patient with Hashimoto's thyroiditis.

Hormone A chemical substance, made in an endocrine gland, which is secreted into the bloodstream and affects tissues elsewhere in the body.

Hormone replacement therapy (HRT) The use of a hormone given to treat a condition in which the naturally secreted hormone is deficient. However, HRT is usually used to describe the administration of ovarian hormones (oestrogens) to women during and after the menopause.

'Hot' nodule A nodule in the thyroid gland which actively takes up a tracer dose of a radio-isotope to a greater degree than does the surrounding normal thyroid tissue.

Human chorionic gonadotrophin (hCG) A hormone secreted by the placenta at the start of a pregnancy which stimulates the secretion of hormones, such as oestrogens, from the ovary. This hormone has structural similarities to TSH and may stimulate the thyroid gland in pregnancy resulting in an increase in thyroid size and in the levels of thyroid hormones in the blood.

Hyperthyroidism Overactivity of the thyroid gland, reflecting a raised level of T_4 and/or T_3 and usually a suppressed TSH level in the blood, which is commonly accompanied by certain symptoms and signs. This term is usually synonymous with thyrotoxicosis.

Hypopituitarism Underactivity of the pituitary gland. This may reduce just one, several, or all the different hormones secreted by the gland, including the thyroid-stimulating hormone (TSH).

Hypothalamus A small neuroendocrine gland located in the brain close to the pituitary. It responds to signals from the higher centres of the brain such

as stress and secretes a number of different hormones. One of these is the thyrotrophin-releasing hormone (TRH) which stimulates the TSH-secreting cells in the pituitary.

Hypothyroidism A condition in which the thyroid gland fails to secrete enough hormones. It is characterized by an elevated TSH level and a reduced level of T_4 in the blood when due primarily to a damaged thyroid. The thyroid may also fail secondary to pituitary damage (hypopituitarism).

Incidence A term used to describe the number of new cases of a disease occurring within a population group in a specified period of time.

Interferon This treatment has a strong effect stimulating the immune system and is also effective treatment against some viruses. It is most commonly used to treat viral infections of the liver (hepatitis B and C). As it has significant effects on the immune system, it can increase the risk of the development of autoimmune thyroid disease in those people who are receiving treatment.

Iodine This element is an essential constituent of the thyroid hormones and is obtained from the diet. It is present in iodized salt, sea-fish, milk and other dairy products, and some vegetables. In certain parts of the world iodine is present in such small quantities that the thyroid gland in the inhabitants, particularly women, is liable to become enlarged (endemic goitre) and they become slightly hypothyroid.

Isotope A form of an element with a slightly different atomic weight but the same chemical properties. Radioactive isotopes of iodine and technetium are used in the diagnosis of thyroid disorders, and radio-iodine is also used in the treatment of some thyroid conditions.

Isthmus The little bridge of thyroid tissue across the trachea (windpipe) which connects the left and right lobes of the thyroid gland.

Kelp extract A 'health' food product derived from seaweed and contains much iodine.

Lithium A drug used for depression and other psychiatric disorders that has an anti-thyroid effect.

Lugol's iodine An iodine preparation which has a temporary suppressive effect on the thyroid gland. It is used in people being prepared for urgent surgery. It is taken as drops added to milk three times daily for 7–14 days prior to surgery.

Lymphadenoid goitre The same as nodular enlargement of the thyroid, as in Hashimoto's thyroiditis.

Lymph gland (lymph node) A small gland which 'filters' lymph and when enlarged is most easily felt in the neck, under the arms, or in the groin. Enlargement of a lymph node in the neck is most often the consequence of pharyngitis (a 'sore throat') but may be related to thyroid disease.

Lymphocyte A particular type of white blood cell that is concerned with the recognition of foreign proteins and the manufacture of antibodies.

Lymphocytic hypophysitis A rare autoimmune condition of the pituitary which results in an expanding pituitary mass and usually pituitary failure. It may cause thyroid underactivity due to failure of TSH secretion.

Lymphoma A malignant tumour of the lymphocytes that may involve the thyroid gland.

Medullary cell cancer A cancer of the medullary, C-, or parafollicular cells which lodge in the thyroid gland and secrete the hormone calcitonin.

Metabolism The thyroid hormones control the metabolism of cells, which is their speed of activity. If there is too little hormone, the body cells work too slowly; too much results in them working too fast. Fundamentally, the thyroid hormones regulate the rate of oxygen consumption. This metabolic action influences the utilization of the main components of food: sugars, protein, and fat.

Metastases Secondary deposit of cancer cells at a site distant from the original or primary cancer.

Methimazole An anti-thyroid drug commonly used in the USA. Carbimazole is rapidly converted to methimazole in the bloodstream: 10 milligrams of carbimazole yield about 6 milligrams of methimazole.

Microsomal antibodies See thyroid peroxidase antibodies.

MRI scan Magnetic resonance imaging is based on the magnetic properties of atomic nuclei and is an important tool in the diagnosis and evaluation of diseases of the neck and chest. It has the advantage over CAT scanning of there being no X-ray exposure. The scan is contraindicated in those people with pacemakers and other implanted electronic devices and metallic material.

Multinodular goitre A goitre which contains many nodules. If a multinodular goitre is present, the person may be euthyroid currently but may become hyperthyroid or hypothyroid.

Myasthenia gravis A rare muscle disorder caused by an autoimmune disturbance which often first affects the muscles of the eyes and leads to double vision. Later, other muscles in the limbs or trunk may become involved and the weakness characteristically worsens as the day progresses.

Myxoedema An advanced form of hypothyroidism. Strictly speaking, the term applies to the thickened skin which is characteristic of severe thyroid deficiency.

Neonatal The first four weeks of a baby's life.

Neutrophil A white blood cell that very rarely is reduced in numbers as a side effect of anti-thyroid drug treatment (see agranulocytosis).

Nodule A lump in the thyroid gland.

Non-thyroidal illness A situation (previously known as sick euthyroid syndrome) in which a person is suffering from some severe illness that is not related to the thyroid gland and is found to have a depressed blood level of T_3, and sometimes also of T_4. In fact the person is euthyroid and the TSH is not raised. As recovery takes place there is often a temporary rise in TSH until all the thyroid function tests return to normal.

Oculomotor muscles These muscles control the movements of the eyeballs. They may become affected in Graves' ophthalmopathy so that there is difficulty in looking up or the person sees double when looking to one side or the other.

Oestrogens (estrogens) Female ovarian hormones. Among their many other actions they increase the level of the thyroxine-binding proteins that carry thyroxine and T_3 in the bloodstream. When increased, as in pregnancy or if taking the oral contraceptive pill, they cause elevation of the total, but not the free, thyroid hormones.

Ophthalmopathy This comprises a variety of changes in the eyes which occur characteristically in up to half of people with Graves' disease.

Ophthalmoplegia Weakness or paralysis of the oculomotor muscles that move the eyeballs. Ophthalmoplegia may cause double vision (diplopia).

Orbit The rigid bony socket in which the eye lies.

Osteoporosis Thinning of the bones which occurs in women, particularly at the time of the menopause, and in men as they grow older. It is aggravated by hyperthyroidism.

Papillary thyroid cancer Malignant change of the thyroid which originates from cells lining the thyroid follicle. It is the most common thyroid cancer, accounting for about 80 per cent of all cases. It was the form of thyroid cancer seen in children and teenagers following the Chernobyl nuclear accident and subsequent release of radioactive iodine.

Parathyroid glands Four little glands close to the thyroid which secrete the parathyroid hormone which controls the level of calcium in the blood.

Pendred's syndrome The association of childhood hypothyroidism and deafness.

Pernicious anaemia A particular type of anaemia in which the body makes antibodies against certain cells in the wall of the stomach. These cells secrete intrinsic factor which promotes the absorption of vitamin B_{12} from the intestinal tract and this is essential for making red blood cells. It was first described by Thomas Addison.

PET scan Positron emission tomography imaging is a new imaging technique which is sometimes combined with CAT scanning and which will have an increasing role in the management of recurrent or metastatic thyroid cancer.

Phaeochromocytoma A tumour of the adrenal gland(s) which secretes hormones that affect blood pressure, usually causing high blood pressure (hypertension).

Pituitary gland An endocrine gland at the base of the brain which secretes a large number of different hormones. Of particular interest in thyroid disorders is the thyroid-stimulating hormone (TSH), also known as thyrotrophin.

Plummer's disease Another name for a toxic multinodular goitre, named after the American physician who described it.

Polymyalgia rheumatica A condition characterized by pains in the muscles and joints and closely related to temporal arteritis. It often requires long-term treatment with corticosteroids in carefully controlled doses.

Post-partum After delivery of a baby.

Prednisolone A cortisone-like drug (also called a steroid) given orally to suppress an autoimmune response or disease. Methylprednisolone is another form which needs to be given intravenously.

Prevalence The number of cases of a disease present in a population group at a specific time.

Pretibial myxoedema A skin condition usually affecting the lower legs and feet. It is associated with Graves' disease in some patients. The term is misleading because it has nothing to do with *hypo*thyroidism.

Proptosis A protrusion of the eyes, the same as exophthalmos, seen in Graves' ophthalmopathy.

Propylthiouracil (PTU) An anti-thyroid drug. The dose of PTU used is approximately 10 times that of carbimazole.

Radio-iodine Three different radioactive isotopes of iodine may be used in the diagnosis of thyroid disorders. One isotope, ^{131}I, is also used for the treatment of hyperthyroidism, thyroid cancer, and other thyroid disorders. The isotopes with a shorter duration of action (half-life), ^{123}I and ^{132}I, are rarely used for diagnostic tests now.

Recombinant TSH An injectable preparation of synthetic thyroid-stimulating hormone. It stimulates the thyroid gland just prior to treatment of thyroid cancer with radio-iodine, and is an alternative to the usual practice of thyroid hormone withdrawal which also increases the blood TSH level. It is only recommended for use in certain circumstances.

Recurrent laryngeal nerves The two nerves which supply the vocal cords. They may be injured during thyroid surgery or involved by thyroid cancer. This causes huskiness or hoarseness of the voice.

Reference range The range of values applied to a blood test found in a group of individuals who are considered healthy. It is usually defined as the range of values found in the mid 95 per cent of the healthy population.

Reflexes The tendon reflexes, tested by a doctor tapping, for example, the tendon just below the knee-cap (patella) or the Achilles tendon at the heel, may be slow to relax in hypothyroidism and be unusually brisk in hyperthyroidism.

Replacement therapy Use of a hormone given by a doctor to make good the deficient secretion of one of the endocrine glands.

Reverse T_3 A biologically inactive form of T_3 which is formed from normally active T_3 and has the same atomic constituents, but the molecule is the mirror image of normal T_3.

Rheumatoid arthritis A chronic inflammatory disorder which results in a symmetrical arthritis that may lead to destruction of joints, due to erosion of cartilage and bone, and deformity.

Riedel's thyroiditis A very rare form of hardening of the thyroid gland due to fibrous tissue.

Sarcoidosis A rare disorder which may affect the thyroid. It is characterized by the presence of granulomata, which are due to an inflammatory reaction and are formed by various cells from the immune system.

Scan An examination by X-rays (CAT or CT scan), ultrasound, magnetic resonance imaging (MRI), radio-isotopes, or positron emission tomography (PET) which produces what amounts to three-dimensional pictures of the organ being studied.

Schmidt's syndrome The syndrome when a person has both Hashimoto's thyroiditis and Addison's adrenal failure.

Scleroderma The presence of thickened hardened skin which may be associated with generalized body involvement; the latter is referred to as systemic sclerosis. Raynaud's phenomenon, in which the blood vessels of the hands and feet shut down, may occur. If severe, this can result in necrosis of the fingers and toes.

Screening Identification of unrecognized disease by an investigation that can be rapidly performed to distinguish apparently well persons who probably have a disease from those who probably do not.

Sheehan's syndrome Hypopituitarism caused by severe loss of blood during or immediately after childbirth. Hypothyroidism is one component of the resulting hormone deficiencies.

Sick euthyroid syndrome (see Non-thyroidal illness).

Silent thyroiditis An episode of usually mild and temporary hyperthyroidism due to an autoimmune disorder unaccompanied by any pain or discomfort in the thyroid gland. It is important that this is distinguished from Graves' disease by an isotope scan, which in silent thyroiditis will show reduced uptake, indicating that the gland is putting out but not making too much hormone. The distinction is important because the treatment is very different.

Sjögren's syndrome A chronic inflammatory disorder characterized by diminished lacrimal and salivary gland secretions resulting in symptoms of dry eyes and dry mouth.

Subacute viral thyroiditis An inflammation of the thyroid due to a virus, often not identified, which runs a variable course.

Subclinical hyperthyroidism A biochemical diagnosis made on the basis of an isolated low or undetectable TSH with normal T_4 and T_3 levels. Symptoms are usually absent.

Subclinical hypothyroidism A biochemical diagnosis made on the basis of an isolated raised TSH with normal T_4 levels. Symptoms are usually absent.

Stridor A crowing noise made on breathing, usually when asleep. It has many causes, but in the context of thyroid disease it is due to compression or displacement of the windpipe (trachea) by a goitre.

Suppurative thyroiditis An acute infection of the thyroid gland by microorganisms which cause the formation of pus.

Systemic lupus erythematosis (SLE) A chronic inflammatory disease which can affect many parts of the body, including the skin, joints, kidneys, lungs, nervous system, blood vessels, and immune system. The ANA test is one of the diagnostic tests for SLE.

T_3-toxicosis A state of hyperthyroidism caused by increased secretion of triiodothyronine (T_3) unassociated with an increased blood level of T_4. The TSH level is suppressed. It may occur early in the course of Graves' disease or in association with a 'hot' nodule in the thyroid gland.

Technetium ^{99m}Tc, or more correctly 99m-technetium pertechnetate, is a radio-isotope with a short half-life that is used for thyroid scintiscans. Throughout this book technetium is used as an abbreviation for technetium pertechnetate.

Temporal arteritis (or giant cell arteritis or cranial arteritis) A condition closely related to polymyalgia rheumatica which causes headaches, fever, and general malaise, and which requires urgent treatment with corticosteroids.

Tetany A condition due to low calcium levels in the blood which causes a curious numb feeling round the mouth and induces spasm in the muscles of the hands, and sometimes the feet. It may occur from temporary or permanent damage to the parathyroid glands during thyroid surgery.

Thionamides The term used to describe the anti-thyroid drugs carbimazole, methimazole, and propylthiouracil.

Thymus A gland in the upper chest behind the breast-bone which makes certain white blood cells and is involved in autoimmune processes.

Thyroglobulin A protein to which the thyroid hormones are attached when they are stored in the thyroid gland. Measurement of the blood level of thyroglobulin is valuable for showing that no normal or malignant thyroid cells are left after total removal of the thyroid gland and an ablative therapeutic dose of radio-iodine has been given for the treatment of thyroid cancer. This test is also used for detecting whether any metastases have developed.

Thyroglobulin antibodies These antibodies are mainly directed against the thyroglobulin stored in the thyroid gland. Increased amounts are usually found in patients with Hashimoto's disease, but thyroid peroxidase antibodies are usually more sensitive in establishing the diagnosis. Their presence in the blood can affect the measurement of thyroglobulin (see above) which can make the follow-up assessment more difficult in some people with thyroid cancer.

Thyroglossal duct A remnant left behind as the thyroid gland descends from its origin at the base of the tongue to the neck in the unborn baby. It may become the site of a thyroglossal cyst.

Thyroid crisis or storm An exacerbation of severe thyrotoxicosis which may be fatal unless treated promptly.

Thyroid hormone resistance A rare inherited congenital disorder in which there are mutations in the gene responsible for thyroid hormone receptors on cells in the body. This results in some tissues failing to respond properly to thyroid hormone. The typical picture on testing thyroid function is raised levels of the thyroid hormones T_4 and T_3 but normal TSH level.

Thyroid peroxidase (TPO) antibodies These antibodies (previously known as microsomal antibodies) are cytotoxic, acting against the thyroid cells and destroying them. They are present in most people with Hashimoto's disease and also in some with Graves' disease.

Thyroidectomy The technical term for the surgical removal of the thyroid gland. The surgeon may remove all the gland (total or near-total thyroidectomy), the majority, such as seven-eighths (subtotal thyroidectomy), or only a lobe (thyroid lobectomy or hemithyroidectomy).

Thyroiditis An inflammatory condition of the thyroid gland that is usually caused by an autoimmune process (Hashimoto's thyroiditis) or a virus (subacute viral or de Quervain's thyroiditis). There are other forms of thyroiditis (see also 'silent' thyroiditis).

Thyroid-stimulating antibodies (TSH-receptor antibodies (TSH-RAb)) These antibodies occupy the TSH-receptor sites on the surface of thyroid cells and stimulate the cells to increase their secretion of thyroid hormones. They are also the cause of autoimmune hyperthyroidism (Graves' disease). These thyroid-stimulating antibodies can be detected in more than 90 per cent of people with Graves' disease, and also occur in 60 per cent of those people who have ophthalmic Graves' disease but who are not yet thyrotoxic. The same antibody occurs temporarily in some people with Hashimoto's disease who have a transient episode of hyperthyroidism ('Hashitoxicosis').

Thyroid-stimulating hormone (TSH) The hormone secreted by the pituitary gland which regulates the hormonal output from the thyroid gland. Its measurement is used to confirm the diagnosis of hypothyroidism (raised TSH level) and of hyperthyroidism (depressed TSH level). A raised TSH may also occur

- during the recovery phase of a thyroiditis (autoimmune or viral) or non-thyroidal illness

- in those with the rare pituitary tumour 'TSHoma'.

A low TSH level may also occur under a number of other circumstances:

- during the first 3 months of pregnancy in normal women

- in some people with eye symptoms indicative of Graves' ophthalmopathy before hyperthyroidism develops and in those in whom hyperthyroidism may never develop (ophthalmic Graves' disease)

- in those people who are in remission from, or have been cured of, Graves' disease. This happens because recovery of the previously suppressed pituitary is often delayed for many months

- in euthyroid people who have an autonomous nodule or nodules within the thyroid gland

- in people with failure of the pituitary gland

- in any person, but particularly the elderly, the secretion of TSH may be temporarily reduced by non-thyroidal illnesses, either physical or psychiatric; it may also result from certain treatments such as steroids.

Thyrotoxicosis This term is usually used in a clinical context when a patient has symptoms and signs of thyroid overactivity. The term hyperthyroidism is used to reflect the underlying biochemical abnormalities which are not necessarily accompanied by clinical features, for example when due to excessive thyroxine ingestion or a destructive thyroiditis.

Thyrotoxicosis factitia The occurrence of hyperthyroidism in a patient who is taking, sometimes undeclared to the doctor, excessive amounts of T_4 or T_3.

Thyrotrophin-releasing hormone (TRH) This hormone is secreted by the hypothalamus and increases the activity of the cells in the pituitary which secrete thyroid-stimulating hormone (TSH).

Thyrotrophin-releasing hormone (TRH) test Injection of synthetic TRH produces a rise in TSH in the blood which, in a normal person, peaks 20 minutes later. This response is absent in those people with thyrotoxicosis and is exaggerated in those with primary hypothyroidism. This forms the basis of the TRH test which is seldom required nowadays because the sensitive TSH assay reliably measures reduced levels of TSH in hyperthyroidism and increased levels in hypothyroidism.

Thyroxine (T_4) One of the thyroid hormones, which contains four iodine atoms and is often called T_4.

Thyroxine-binding globulin (TBG) Three main classes of protein carry thyroxine in the bloodstream: globulin, pre-albumin, and albumin. The most important of these is globulin, which carries about 70 per cent of the thyroxine. An abnormally low or absent, or an abnormally high, level of thyroxine-binding globulin may occur as an innocent hereditary abnormality, usually in men. When the TBG is low, the levels of total T_4 and total T_3 are also low because their main carrier protein is reduced; when the TBG level is high, the level of the thyroid hormones is raised. However, in both situations the person is euthyroid and has a normal TSH level and usually normal free T_4 and free T_3 levels.

Total serum thyroxine (T_4) level This blood test measures the total amount of thyroxine per unit of blood which comprises the T_4 bound to various proteins that carry most of the thyroxine. Because variations in the amount of the carrier proteins and the number of binding sites may be induced by hormones, drugs, many non-thyroid diseases, and genetic factors, most physicians nowadays prefer to measure the free T_4.

Total serum triiodothyronine (T_3) level This measure of the total serum protein-bound concentration of T_3 has the same disadvantages as measuring the total serum T_4 level.

Trachea The windpipe, which may be compressed or displaced by a goitre.

Triiodothyronine Colloquially known as T_3, is one of the two thyroid hormones.

TSHoma A tumour of the pituitary gland, which is usually benign and which secretes increased amounts of TSH resulting in hyperthyroidism.

Tumour A lump or nodule which, in the context of this book, is found within the thyroid gland. It may be benign or cancerous.

Turner's syndrome An important cause of short stature in girls and the absence of periods starting in young women which is usually caused by loss of part or all of an X chromosome. It is associated with an increased risk of hypothyroidism.

Ultrasound scan A technique for determining the structure of an organ. It is useful for investigating a goitre and may reveal a nodule or nodules that cannot be felt by a doctor, and shows whether the lump is solid or cystic (filled with fluid).

Units of measurement Most drugs are measured in milligram (mg) quantities. One milligram is equivalent to 1000 micrograms (mcg or μg). A dose of thyroxine of 0.1 mg is equivalent to 100 mcg (or μg) of thyroxine, and 0.05 mg thyroxine is equivalent to 50 mcg (or μg) of thyroxine.

Different units for the measurement of hormones may be used in different parts of the world. In some areas, such as the USA, traditional or conventional units of weight per unit of plasma are used; in others, such as the UK and elsewhere in Europe, the International System of Units (SI) is used in which the molecular concentration, rather than the weight, of the hormone per unit of plasma is given. Plasma is blood from which the cellular elements (the red and white blood cells) have been removed. For example, the total thyroxine level may be shown in the USA by weight as micrograms (μg) of thyroxine per unit of plasma (usually 100 mL or dL); the normal reference range is about 4.0–11.0 μg/dL. In some other countries the total thyroxine level in the plasma may be expressed as the number of molecules of thyroxine per unit volume (usually 1 litre (L)) of plasma, for example 140 nanomoles per litre (nmol/L) of plasma; the reference range is about 58–154 nmol/L.

In the case of free thyroxine the concentration as reported in the traditional system is normally 0.7–1.7 nanograms per 100 mL (ng/dL) plasma and in the SI systems 9–25 picomoles per litre (pmol/L) plasma.

The total thyroxine level expressed in traditional units (ng/dL) can be converted to SI units (nmol/L) by multiplying by 12.87.

Urticaria Defined by the presence of eruptions on the skin; chronic urticaria is associated with autoimmune thyroid disease.

Viral thyroiditis The same as subacute viral thyroiditis or de Quervain's disease.

Vitamin B$_{12}$ Failure to absorb this vitamin causes pernicious anaemia. This is an autoimmune disorder caused by the destruction of certain cells in the stomach wall which secrete the intrinsic factor that facilitates the absorption of vitamin B$_{12}$. Pernicious anaemia may occur as an accompaniment of thyroid autoimmune disease.

Vitiligo An autoimmune skin disorder in which patches of white skin devoid of normal pigment develop and which is associated with other autoimmune disorders.

von Basedow's disease The same as Graves' disease and named after the German doctor who also described the condition. It is the name sometimes used in Europe for diffuse toxic goitre.

Glossary of drugs

Throughout the text the common (generic) name has been used for each drug mentioned, names likely to be familiar to doctors world-wide. Doctors sometimes prescribe drugs of a particular proprietary brand, and this may cause confusion to a person being treated who may not know the chemical content of the proprietary tablet or its generic name.

Below is a short glossary of the drugs most often used in the treatment of people with thyroid disorders. In each instance the drug is identified first by its common name and then by its official name as it appears in the pharmacopoeia. This is followed by a list of proprietary names; this list cannot be all inclusive because different brand names are used in different countries and in different marketing areas throughout the world. Finally, a brief indication is given of the usual use of the drug.

Thyroxine (T_4)

Official names: levothyroxine sodium, L-thyroxine sodium, levothyroxine natricum, thyroxine sodium.

Proprietary names: Cytolen, Eferox, Elthyrone, Eltroxin, Euthyrox, Eutirox, Eurotroxsig, Laevothyroxinum, Laevoxin, Levaxin, Levoid, Levolet, Levothroid, Levothyroid, Levoxyl, Novothyrox, Oroxine, Percutacrine Thyroxinique, Ro-Thyroxine, Synthroid, Tetraiodothyronine, Thevier, Thyratabs, Thyrax, Thyroxevan, Thyroxin, Thyroxinal, Unithyroid

Use: As replacement therapy in deficiency of thyroid hormone; for treatment of thyroid cancer.

Triiodothyronine (T_3)

Official names: liothyronine sodium, liothyronium natricum, L-tri-iodothyronine, sodium liothyronine, triiodothyronine sodium.

Proprietary names: Cynomel, Cytomel, J-Tiron, Linomel, Ro-Thyronine, Tetroxin, Thybon, Thyrotardin, Tironina, Ti-Tre, Tresitope, Triostat, Trithyrone.

Use: As a short-term replacement therapy in deficiency of thyroid hormones in the management of people with thyroid cancer.

Mixtures of thyroxine and triiodothyronine

Official name: none.

Proprietary names: Liotrix (available in a range of strengths containing T_4 and T_3 in a 4:1 ratio), Euthyroid, Thyrolar.

Use: As replacement therapy in deficiency of thyroid hormone but without any proven advantage over thyroxine alone.

Thyroid extract

Official names: dry thyroid, Getrocknete Schilddrüse, thyroid extract, thyreoidin, thyroidea, thyroideum sicca, tiroide secca.

Proprietary names: Armour Thyroid, Naturethroid, Thyranon, Thyrar, Thyroidine, Westroid.

Use: As replacement therapy in deficiency of thyroid hormone but now superseded by thyroxine because thyroid extract is not a pure substance.

Carbimazole

Official names: carbimazole, carbimazolum.

Proprietary names: Athyromazole, Atirozidina, Basolest, Carbezole, Carbimazol, Carbotiroid, Mertiran, Neo-carbimazole, Neo-Mercazol, Neo-Mercazole, Neo-Morphazole, Neo-Thyreostat, Neo-Tireol, Neo-Tomizol, Tyrazol.

Use: For control or treatment of thyroid overactivity.

Methimazole

Official names: mercazolylum, thiamazole, tiamazol.

Proprietary names: Antitiroide GW, Basolan, Danantizol, Favistan, Frentirox, Mercaptol, Mercasolyl, Mercazole, Mercazolyl, Merkastan, Merkazolil, Metazolo, Metizol, Metotirin, Strumazol, Tapazole, Thacapzol, Thycapazole, Thymidazole, Thimazole, Tirodril, Tomizol.

Use: For control or treatment of thyroid overactivity.

Propylthiouracil

Official name: propylthiouracilum.

Proprietary names: Procasil, Propacil, Propycil, Propyl-Thiorist, Propyl-Thyracil, Prothiucil, Prothiurone, Prothycil, Prothyran, Protiural, Thiuragyl, Thyreostat II, Tiotil.

Use: For control or treatment of thyroid overactivity.

Propranolol

Official name: propranolol hydrochloride

Proprietary names: Angitol, Apsolol, Avlocardyl, Bedranol, Beprane, Berkolol, Beta-Neg, Beta-Propanolol, Betachron, Betalong, Bétaryl, Beta-Tablinen, BetaTemelits, Blocadryl, Cardinol, Cardispare, Caridolol, Corpendol, Deralin, Detensol, Dociton, Duranol, Efektotol, Elbrol, Etalong, Euprovasin, Frekven, Herzul, Inderal, Inderal La, Inderalici, Inderide, Indobloc, Innopran XL, Intermigran, Kemi, Noloten, Novoppranol, Obsidan, Oposim, Pranolol, Prano-Puren, Prolol, Pronovan, Propanix, Prophylux, Propobbloc, Propalong, Propayerst, Propranur, Proprasylyt, Pur-Bloka, Pylapron, Rapynogen, Reducor, Rexigen, Sagittol, Servanolol, Sloprolol, Sumial, Tensiflex, Tesnol, Tonum.

Use: To slow the heart rate and reduce other symptoms of thyroid overactivity.

Glossary of patient support organizations

Australia

Thyroid Foundation of Australia
PO Box 186
Westmead, NSW 2145
E-mail: Thyroid@icpmr.wsahs.nsw.gov.au
Internet: www.thyroidfoundation.com.au

Thyroid Australia
PO Box 2575
Fitzroy Delivery Centre
Melbourne, VIC 3065
E-mail: support@thyroid.org.au
Internet: www.thyroid.org.au

Brazil

Instituto da Tiroide
Rua Prof. Arthur Ramos 96, 5° andar
São Paulo – SP – CEP 01454–903
E-mail: indatir@uol.com.br
Internet: www.indatir.org.br/

Canada

Thyroid Foundation of Canada (TFC)
La Foundation Canadienne de la Thyroide
797 Princess Street, Ste 304
Kingston, Ontario K7L 1G1
Tel: (613) 544–8364
Tel: (toll-free in Canada) 1 800 267 8822
Fax: (613) 544 9731
Internet: www.thyroid.ca

Denmark	Thyreoida LandsforeningenStrandkrogen 4A 3630 Jaegerspris E-mail: lis_l@get2net.dk Internet: www.thyreoidea.dk
Finland	Thyroid Foundation of Finland Vettmossvagen 57, Narpes E-mail: ullslama@tawi.fi Internet: www.kolumbus.fi/kilpirauhasliitto
France	Association Française des Malades de la Thyroïde BP1, 82700 Bourret. E-mail: asso.thyroide@worldonline.fr Internet: http://thyro2004.free.fr/ Forum Vivre sans Thyroïde 2 avenue d'Expert, Léguevin 31490 E-mail: b_bartes@club-internet.fr Internet: www.forum-thyroide.net
Georgia	Georgian Union of Diabetes and Endocrine Associations (GUDEAS) Georgian Medical Diagnostic Centre 5 Ljubljana Str., Tbilisi 380059 Republic of Georgia E-mail: diabet@access.sanet.ge
Germany	Schilddrüsen Liga Deutschland e.V. (SLD) Ev. Krankenhaus Bad Godesberg Waldstrasse 73, 53177 Bonn E-mail: info@schilddruesenliga.de Internet: www.schilddruesenliga.de
Italy	Associazione Italiana Basedowiani e Tiroidei (AIBAT) c/o Centro Minerva Via Mazzini 6 43100 Parma E-mail: aibat@asmn.re.it Internet: www.endocrinologia.re.it/aibat.htm

Japan	Thyroid Foundation of Japan CBON Queen Building 4th floor Roppongi 7-18-12, Minato-ku, Tokyo 106-0032 Internet: www.hata.ne.jp/tfj/
The Netherlands	Schildklierstichting Nedeland (SSN) Stationsplein 6 3818 LE Amersfoort Tel: +31 900 8998866 E-mail: info@schildklier.nl Internet: www.schildklier.nl
Norway	Norsk Thyreoideaforbund Fr. Nansens Plass 9 N-0160 Oslo Email: post@stoffskifte.org Internet: www.stoffskifte.org
Russia	Thyroid Foundation of St. Petersburg 'Professor' Medical Centre 42 Chaykovsky St. St Petersburg 191123 E-mail: gasparyan@peterlink.ru
Sweden	Vastsvenska patient-Föreningen för Sköldkörtel Sjoka (VPFS) Mejerivalen 8 43936 Onsala E-mail: info@vpfs.info Internet: www.vpfs.info Sköldkörtelförening i Stockholm Skidbacksvägen 11B Se-141 46 Huddinge Tel: +46 (0)8 608 22 52 E-mail: skoldkortel@telia.com Internet: www.skoldkortelforeningen.se

UK
 The British Thyroid Foundation (BTF)
PO Box 97
Clifford, Wetherby
West Yorkshire LS23 6XD
Tel: 01423 709707
Internet: www.btf-thyroid.org

Thyroid Eye Disease Charitable Trust
PO Box 2954, Calne
Wiltshire SN11 8WR
Tel: 0844 800 8133
E-mail: ted@tedct.co.uk
Internet: www.tedct.co.uk

Association for Multiple Endocrine Neoplasia
(AMEND)
31 Pennington Place
Tunbridge Wells
Kent TN4 0AQ
Internet: www.amend.org.uk

USA
 National Graves' Disease Foundation
PO Box 1969
Brevard, NC 28712
Tel: 828 877 5251
E-mail: nancyngdf@yahoo.com
Internet: www.ngdf.org

Thyroid Foundation of America Inc
One Longfellow Place
Suite 1518
Boston, MA 02114
Tel: (toll-free) 800 832 8321
Tel: 617 534 1500
Fax: 617 534 1515
E-mail: info@allthyroid.org
Internet: www.allthyroid.org

Light of Life Foundation (for people with thyroid
cancer)
PO Box 163
Manalapan, NJ 07726
Tel: (toll-free) 1 877 LOL-NECK (565 6325)
Tel: 732 972 0461
Fax: 732 536 4824
E-mail: info@checkyourneck.com
Internet: www.checkyourneck.com

ThyCa Thyroid Cancer Survivors' Association Inc
PO Box 1545
New York, NY 10159-1545
Tel: (toll-free) 877 588 7904
Fax: 630 604 6078
E-mail: thyca@thyca.org
Internet: www.thyca.org

Useful further sources of information

Association of Clinical Biochemistry, the British Thyroid Association, and the British Thyroid Foundation (2006). *UK Guidelines for the Use of Thyroid Function Tests*. Available online at: www.british-thyroid-association.org/TFT_guideline_final_version_July_2006.pdf and http://acb.org.uk/docs/TFTguidelinefinal.pdf

British Thyroid Association and Royal College of Physicians (2002). UK guidelines for the management of differentiated thyroid cancer in adults. Available online at: www.british-thyroid-association.org/complete%20guidelines.pdf (compiled by representatives of all the major colleges and organizations (professional and patient-led) concerned with the management of thyroid cancer under the auspices of the British Thyroid Association).

Cooper DS, Doherty GM, Haugen BR, *et al.* (2006). Management guidelines for patients with thyroid nodules and differentiated thyroid cancer: The American Thyroid Association Guidelines Taskforce. *Thyroid*, **16**, 109–42. Available online via link on www.thyroid.org

Ladenson PW, Singer PA, Ain KB, *et al.* (2000). American Thyroid Association guidelines for detection of thyroid dysfunction. *Archives of Internal Medicine*, **160**, 1573–5. Available online via link on www.thyroid.org

Pacini, F, Schlumberger M, Dralle H, *et al.* (2006). European consensus statement for the management of patients with differentiated thyroid carcinoma of the follicular epithelium. *European Journal of Endocrinology*, **154**, 787–803.

Singer PA, Cooper DS, Levy EG, *et al.* (1995). Treatment guidelines for patients with hyperthyroidism and hypothyroidism. *Journal of the American Medical Association*, **273**, 808–12. Available online via link on: www.thyroid.org

Surks MI, Chopra IJ, Mariash CN, Nicoloff JT, Solomon DH (1990). American Thyroid Association guidelines for use of laboratory tests in thyroid disorder. *Journal of the American Medical Association*, **263**, 1529–32. Available online via link on www.thyroid.org

Surks MI, Ortiz E, Daniels GH, *et al.* (2004). Subclinical thyroid disease. Scientific review and guidelines for diagnosis and management. *Journal of the American Medical Association*, **291**, 228–38.

Thyroid Manager. Available online at: www.thyroidmanager.org (this site includes an updated and downloadable textbook on the thyroid).

Vanderpump MPJ, Ahlquist JAO, Franklyn JA, Clayton RN (1996). Consensus statement for good practice and audit measures in the management of hypothyroidism and hyperthyroidism. *British Medical Journal*, **313**, 539–44.

Index

➜ Published and forthcoming titles in the**facts** series

Eating disorders: the**facts**
FIFTH EDITION
Abraham

Sexually transmitted infections: the**facts**
SECOND EDITION
Barlow

Thyroid disease: the**facts**
FOURTH EDITION
Vanderpump and Tunbridge

Living with a long-term illness: the**facts**
Campling

Prenatal tests: the**facts**
DeCrespigny

Obsessive-compulsive disorder: the**facts**
THIRD EDITION
De Silva

The pill and other forms of hormonal contraception: the**facts**
SIXTH EDITION
Guillebaud

Myotonic dystrophy: the**facts**
Harper

Ankylosing spondylitis: the**facts**
Khan

Prostate cancer: the**facts**
Mason

Multiple sclerosis: the**facts**
FOURTH EDITION
Matthews

Essential tremor: the**facts**
Plumb

Panic disorder: the**facts**
SECOND EDITION
Rachman

Tourette syndrome: the**facts**
Robertson

Adhd: the**facts**
Selikowitz

Dyslexia and other learning difficulties: the**facts**
SECOND EDITION
Selikowitz

Schizophrenia: the**facts**
SECOND EDITION
Tsuang

Depression: the**facts**
Wassermann

Polycystic ovary syndrome: the**facts**
Elsheikh and Murphy

Autism and Asperger syndrome: the**facts**
Baron-Cohen

Motor neuron disease: the**facts**
Talbot and Marsden

Lupus: the**facts**
SECOND EDITION
Isenberg and Manzi

Stroke: the**facts**
Lindley

Osteoarthritis: the**facts**
Arden, Arden, and Hunter

Cosmetic surgery: the**facts**
Waterhouse